HISTORIC TALES
of UTAH

EILEEN HALLET STONE

FOREWORD BY TERRY ORME
Salt Lake Tribune editor & publisher

THE
History
PRESS

Published by The History Press
Charleston, SC
www.historypress.net

Front cover, top: Saltair Pavilion, Great Salt Lake, Utah, 1901. *Library of Congress*; *Bottom*: The Marx Brothers leave them laughing at Salt Lake City's Orpheum Theater, 1935. *Utah State Historical Society.*
Back cover, top: The most complete news wagon, Salt Lake City, 1910. *Utah State Historical Society*; *Bottom:* Carr Fork Canyon as seen from the "G" bridge, at Bingham Copper Mine, Utah. *Library of Congress.*

First published 2016

Manufactured in the United States

ISBN 978.1.46713.555.9

Library of Congress Control Number: 2015959410

CONTENTS

CONTENTS

CONTENTS

CONTENTS

FOREWORD

Utah history is a composition of countless colorful characters and narratives: the Native Americans whose ancient dwellings and expression are intrinsic to our history and culture; the Mormon pioneers who fled persecution and made the desert bloom; the continuous stream of immigrants who built the transcontinental rail, the copper, silver and coal mines and the entrepreneurial foundation of Utah's economy; the Utah men and women who left to fight America's wars abroad; and more.

For the last decade, *Salt Lake Tribune* readers have sampled the riches of the Utah story through the columns of historian Eileen Hallet Stone.

She is a writer who does the research and so much more, creating personal stories often told in the subject's own voice or that of his or her descendants.

Hallet Stone's column is titled "Living History," a proper name for vignettes from the past that, taken together, tell us who we've become and why.

TERRY ORME
Editor and Publisher
Salt Lake Tribune

ACKNOWLEDGEMENTS

I cannot believe my good fortune, being given free rein to seek out the lesser-known stories about the people, growth and development of this marvelous gold mine of a state called Utah.

I am grateful to the *Salt Lake Tribune* for giving me such an opportunity, in particular to Terry Orme, editor and publisher of the *Tribune*, and managing editor Sheila McCann.

I thank the University of Utah J. Willard Library's Gregory C. Thompson, associate dean of special collections, who has always encouraged me to take on Utah projects. I am indebted to photograph archivist Lorraine Crouse for her incredible knowledge of the library's rich archival collections and for responding kindly to every question asked and to Sara Caroline Davis and Juli Huddleston.

I thank Utah State History director P. Brad Westwood for his gentle guidance, and Greg Walz for going the extra mile tracking down many historical images.

I owe much to archivists Elaine Carr and Ellen Kiever of the Unitah County Regional History Center and to Kirby Arrive, Bureau of Indian Affairs fire management officer for the Uintah-Ouray Reservation, for their kindness and expertise.

I value the extensive help with images and Ogden insights given me by Sarah Singh, curator at Weber State University, Stewart Library Special Collections.

Among others, Jim Boyd, director of the Western Mining and Railroad Museum in Helper; Bill Rekouniotis and Dimitri Gerontis of the Hellenic

ACKNOWLEDGEMENTS

Cultural Association Museum; and Kyle Bennett of Rio Tinto Kennecott were so gracious to help broaden my cultural landscape—I am thankful.

I appreciate Jennifer Krafchik, deputy director of Seawall-Belmont House and museum, for helping me find early suffragist photos taken in Washington, and associate librarian Russ Taylor and photo archivist Tom Wells at Brigham Young University's Harold B. Lee Library in locating "A Jolly Party in the Great Salt Lake" among the Charles Ellis Johnson Collection.

I am beholden to those many people who welcomed me into their homes and offered a treasure trove of diverse stories and images many of us might otherwise never know.

With hat in hand, I thank Artie Crisp, commissioning editor for The History Press; production editor Elizabeth Farry; and senior designer Natasha Walsh for their instrumental help in bringing this book to its wide-ranging fruition.

Lastly, I thank my husband, Randy Silverman, for his wholehearted enthusiasm and absolute willingness to go on the back roads for a good story—and our son, Daniel Ian Gittins Stone, who encourages all my endeavors.

I apologize for whatever mistakes or omissions may have occurred.

INTRODUCTION

In the 1840s, land west of the Missouri River became the new frontier for courage, adventure, misadventure, freedom, industrialization and true grit. Utah, often called "the Crossroads of the West" was always in the thick of things.

As it was then and continues to be, Utah's unique stories burst with historical significance.

Most know Utah's history as a self-created homogenous state governed by the Church of Jesus Christ of Latter-day Saints, whose members are known as Mormons. Lesser known are the individual histories of those who challenged and broadened the status quo.

In 2005, I was asked to write a 650-word Utah "Living History" column for the *Salt Lake Tribune* that explores stories long hidden, lost or forgotten in the shadows cast by this vast, 84,899-square-mile territory.

Published in 2013 by The History Press, *Hidden History of Utah* was a compilation of many such stories.

Today, *Historic Tales of Utah* follows the trail deeper into the state's religious ethos, ethnic diversity and downright, down-to-earth-different tales.

Where breaking ground was not without adversity or derring-do, fifty-seven new stories, gently edited from my history column, explore the insights and fortitude that shaped the development of Utah and the settlement of the West. They define the everyday and the extraordinary contributions that make up this corner of America.

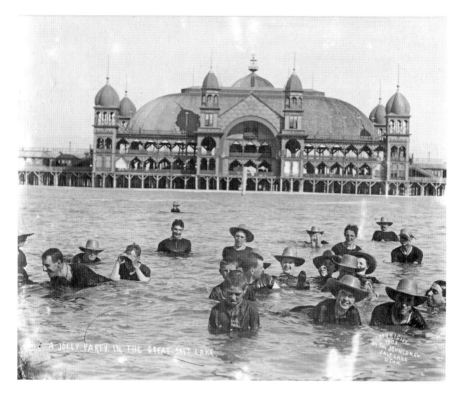

A Jolly Party in the Great Salt Lake, 1905. *Special Collections, Harold B. Lee Library, Brigham Young University.*

Many stories look at the perils of *doing*: the freed slave whose experiences epitomize western legends and lore; "greenhorns" peddling in towns where scrip trounces American currency and guns are easily drawn; the booms and busts of mining towns; brave Utah women bruised on the front lines of suffrage battles; and union men like Utah's "Big Bill" Haywood, vilified by the *New York Times* as "the most hated and feared figure in America."

Some encounter frontier law and personal inequity. Others take on range conflicts, cattle rustling, outlaw sheltering and the barbwire that fenced in the West. More exemplify stories of character in midwifery, desert crossing, creating communities, building landmark institutions and setting land speed records. And there are those that stun our senses with wartime heroics, firebrand inspirations and acts of pure generosity.

I hope you enjoy these stories as much as I thrilled in discovering the profoundly moving themes of human accomplishment, tenacity, endurance and humor that bind them together.

Part I

PERILS OF THE NEW FRONTIER

MORMON PIONEER'S ADVENTURES INCLUDED GETTING AWAY WITH MURDER

In the 1840s, Mormon convert Howard Egan was a businessman, Nauvoo City policeman, polygamist and bodyguard to Joseph Smith, founder of the Church of Jesus Christ of Latter-day Saints.[1]

Egan became envoy for the volunteer Mormon Battalion during the 1846–48 Mexican-American War. Charged to escort Mormon pioneers on the westward trek to Utah, he was appointed "Captain of the 9th group of 10 men" in 1847. And during the 1857–58 Utah War against Colonel Albert Sidney Johnston's federal army, Egan conveyed ammunition and rose in rank to major.

A skilled frontiersman credited with blazing numerous western trails, Egan was devoted to Utah territorial governor and LDS president Brigham Young. He knew how to handle a gun. According to Utah civic leader and Mormon diarist Hosea Stout, Egan was also among Young's gang of "be'hoys," along with gunslinger and church member Orrin Porter Rockwell.

In 1851, Egan took the law into his own hands and got away with murder.

Born in Ireland in 1815, Egan was eight years old when his mother died and the bereaved family moved to Canada to start anew. When their father unexpectedly passed away five years later, a married sister took in the orphan, who soon went to work as a sailor on Canada's great waterways.

By 1838, the independent voyager made his way to Salem, Massachusetts. He learned the rope-making trade, opened shop and married his beloved fifteen-year-old Tamson Parshley. Expressing kinship with Mormon theology, the couple joined the LDS Church. They moved to Nauvoo, Illinois, and in 1846 participated in the mass Nauvoo exodus. They wintered at Winter Quarters, a bustling Mormon settlement near present-day Omaha, Nebraska.

While Tamson was hearth and home to her growing family, Egan traveled extensively, and over long periods of time, for the LDS Church. His assignments were many and varied: from freighting supplies along the Missouri River to heading to Santa Fe to pick up battalion letters, packages and wages for the soldiers' families.

Reaching Salt Lake City, Egan was barely settled when he was again on the go. According to the family foundation's literature, the intrepid guide and pathfinder transported "the printing press upon which the Church published the *Deseret News*." During the gold rush days, he mapped a "primitive trail to southern California" presumably "to establish the Salt Lake Trading Company in the Sierra goldfields."

After a year spent traversing the wilderness, in 1851, Egan returned home to discover his wife, Tamson, had given birth to another man's child. Anguished and feeling betrayed, Egan was determined to rout out the scoundrel, James Madison Monroe, a former friend and teacher of Joseph Smith's children. He found Monroe in northern Utah near Bear River. It appeared the men were talking peacefully until, Stout recorded, "Egan drew a pistol and shot him in the face on the right side of the nose just below the eye."

Monroe fell "dead on the spot."

Confessing he did what he did "in the name of the Lord," Egan lamented that Monroe had "ruined his family, and destroyed his peace on earth forever."

Tried by a jury of his peers in Salt Lake City, religious conviction and frontier law saw eye to eye. On October 18, 1851, the major was acquitted. He raised the boy, William Monroe Egan, as his own.

Eventually, Egan became a cattle rancher and, claiming he could ride a mule to California within ten days, did so while blazing the "Egan Trail." In his forties, he was appointed division superintendent of the Pony Express line from Salt Lake City to Carson City. He planned home stations, including his at Deep Creek, and most likely was its oldest rider.

Egan's relationship with President Young never wavered. During the "Great Colonizer's" last illness, Egan stood in as his nurse. At his death in 1877, he stood resolute as special guard at his graveside.

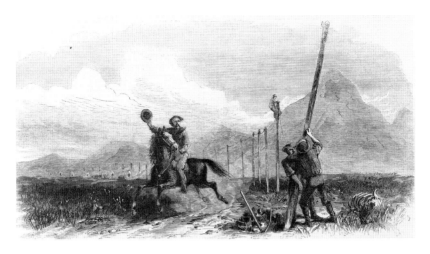

While riders switched horses in an exchange Mark Twin described as a "whiz and a hail," the Pony Express service was short lived. *Library of Congress.*

Between 1844 and 1849, Egan married three other plural wives but shortly acquiesced to their petitions for divorce. In 1878, with Tamson by his side, Egan died of pneumonia at age sixty-three—his story, a legacy.

JAMES BECKWOURTH, SON OF SLAVERY, BECAME A MOUNTAIN MAN

Looking at Utah's majestic snow-covered mountains brings to mind early nineteenth-century mountain men—those rugged fur traders, guides, Indian fighters, trappers and explorers who challenged the great western frontier and risked life and limb for profit and adventure.[2]

There were men like Jim Bridger, Jedediah Smith, Ettiene Provost, Kit Carson and Peter Skene Ogden, and there was James Pierson Beckwourth, a black mountaineer and scout who either befriended or fought the Indians and whose experiences epitomize all manner of western history, bloodshed, vengeance, legend and lore.

Beckwourth was born in Fredericksburg, Virginia, in 1798. One of thirteen siblings, his mother was an enslaved African American woman. His father, Sir Jennings Beckworth, was a white descendent of English nobility. He had served as a major in the Revolutionary War. Although he raised his children as his own, he legally owned them as master.

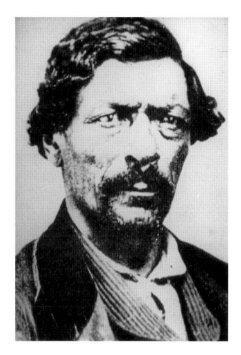

Emancipated in 1824, James Beckwourth became a mountain man. *Utah State Historical Society.*

In 1806, the family moved to St. Louis. With a sizeable interracial population, it offered a semblance of equity. They settled on nearby land between the Mississippi and Missouri Rivers.

"The whole region of country around was a howling wilderness," Beckwourth recounted in a rare autobiography dictated to friend and temperance reformer Thomas D. Bonner.

The Life and Adventures of James P. Beckworth, published in 1856, was questioned for its veracity and simultaneously heralded as a firsthand historical account of the Far West. As the late Ogden-born American historian Bernard DeVoto said, "Jim was a mountain man and the obligation to lie gloriously was upon him."

Beckwourth hunted with his father, attended school for several years and added a "u" to his surname. Although apprenticed to become a blacksmith, the daring young man yearned for adventure. Freed by his father and emancipated in court in 1824, Beckwourth worked as a hunter to feed a party of one hundred men heading upriver to open lead mines in Gelena, Illinois.

Emboldened by his experience, he then joined General William H. Ashley's Rocky Mountain Fur Company and headed westward.

Compensated $200 a year by Ashley's company, Beckwourth worked alongside his colleagues such as Bridger, Smith and William Sublette. He explored South Pass in southwestern Wyoming; traversed the Bear, Weber and Green Rivers; trapped for beaver in Cache and Salt Lake valleys; and, in 1825, attended the first Mountain Man Rendezvous held at Henry's Fork in the High Uintas.

Described as being of medium height, Beckwourth was muscular and strong. For several years, he lived among the Crows and rose in stature. He married at least four different times.

In 1830, mountain men could trap four hundred to five hundred pounds of beaver pelts a year and earn up to six dollars a pound. Within a decade, they had nearly decimated the beaver.

Beckwourth participated in the 1837 Seminole War in Florida. He was a courier for the U.S. Army during the 1847 Taos Revolt. In the California gold rush days, he opened a store in Sonoma and was a professional card player in Sacramento.

In 1850, Beckwourth guided settlers through the Sierra Nevada along what became known as Beckwourth Pass. He "expended $1,600 to improve" a Native American path into Marysville, California. Renamed the Beckwourth Trail, he "received no indemnification for [my] money and labor," he wrote, "as the town had burned to ashes."

Two years later, the mountain man semi-retired to Beckwourth Valley, located in the Far West, and opened a hotel and trading post.

"Here is a valley 240 miles in circumference, containing some of the choicest land in the world," he wrote. "When the weary, toil-worn emigrant reaches this valley, he can lay himself down and taste refreshing repose. His cattle can graze around him in pasture up to their eyes."

Unable to settle down, Beckwourth returned to trapping. He scouted again for the U.S. Army. But in 1866, he returned to the Crow Village, and it was there that the former slave and heroic adventurer succumbed to an illness and died.

The Bassett Women and "Queen of the Outlaws" Take on Rugged Brown's Park

Part One: Brown's Park—A Nineteenth Century Frontier

In a remote mountain valley extending from northeastern Utah toward south-central Wyoming and spilling into northwestern Colorado, Brown's Park (formerly Brown's Hole) was a nineteenth-century frontier.

It was the winter home to the Comanche, Green River Shoshoni and Ute tribes. Chartered in 1805 by Lewis and Clark, it was foraged by Euro-American hunters and fur trappers. In the 1830s, several mountain men built a mud-and-timber trading post, a social hub for travelers. Called Fort Davy Crockett, it was known as "Fort Misery." After an associate joined

a band of thieves, stole some horses and escaped capture, the partnership folded and the abandoned fort turned to rubble.

By the 1870s, this small but largely inaccessible and rugged territory—some six miles wide and forty miles in length along the Green River—attracted a diverse community of settlers governed by their own code of ethics and interpretation of law.

There were small ranchers, cattlemen and tradespeople; cattle barons and thieves; rustlers and outlaws. According to the Bureau of Land Management's (BLM) cultural resource series on Utah, Brown's Park was "one of three major hideouts along the Outlaw Trail, and "cattle rustling and outlaw sheltering" were common. From 1871 to 1913, nearly all the Park's citizenry were "cattle rustlers to some degree." Including, within fact and lore, the legendary Bassett women and their association with Butch Cassidy's "Wild Bunch."

Advised by his brother to seek clean mountain air to relieve his asthma, Herb Bassett with his wife, Elizabeth, and four-year-old Josephine (Josie) moved to Brown's Hole in 1877 to make a homestead, raise Durham cattle and breed horses.

In 1878, their daughter Ann was born. Unable to provide enough breast milk, Elizabeth never forgot how a Yampatika Ute mother, named Seeabaka, nursed her starving infant to life.[3]

Herb, an educated, musical and generous man, was seemingly out of place in the wilderness. He read Emerson and Shakespeare to his children, organized a public school, built a post office on his land, worked with wood and supplied beef and horses to outlaws like Butch Cassidy, the Sundance Kid, Black Jack Ketchum and Kid Curry—but let his wife have the reins.

Elizabeth took to the tough, competitive male environment. At five feet, six inches tall, the blond southern belle could ride a horse, handle a shotgun, set bones, put in stitches and, if necessary, rustle for their livelihood.

She also cultivated a cooperative working relationship with several supporters willing to help her acquire cattle and horses and fend against intimidation from empire-building cattle barons. Arriving from Texas, the exceptionally strong cowhand and former slave Isom Dart built his own herd and became an integral "mainstay" in the Bassett family history. Davy Crockett's nephew Matt Rash met the family's need for mutual conversation. And a lanky Scotsman named Jim McKnight, whose blue eyes turned green when angered, rounded out the informal "Bassett Gang."

The family prospered. Herb expanded their small cabin into a well-lit, spacious ranch house stocked with books and stringed instruments and

welcomed visitors from businessmen and neighbors to outlaws with no questions asked.

"My mother [respected, traded] and kept the treaty with the Indians with undeviating faithfulness and became a vigorous advocate of national suffrage for women," Ann wrote in a 1952 autobiography for *Colorado Magazine*. "She was noted for intrepidity in any time of danger or alarm."

Nevertheless, in December 1892, an ailing Elizabeth, thirty-seven years old and mother of five, rose from her sick bed to give chase to a favored milk cow from an intruder's herd of cattle. By morning, the force of nature died—some speculate from a burst appendix; others say a miscarriage.

Historian Grace McClure wrote that daughter Josie was often called "another Elizabeth," complementing her mother's indomitable will and "well-controlled but volcanic temper" softened by her father's kindness. The young and more mercurial Ann would eventually earn her sobriquet, "Queen of the Rustlers."

But for now, the family was devastated.

Part Two: On Their Own

A "natural" pioneer, Elizabeth was esteemed by longtime friends and enemies—cattle barons she believed in murderous pursuit to rule the range. She bequeathed a legacy of pride and ambition to all her children, especially daughters Josie and Ann.

Like her mother, Josie was excellent with a rifle. She, too, could ride, rope, butcher and bespeak individualism with the best of the cowboys. At the time of Elizabeth's death, Josie was attending St. Mary's of the Wasatch in Salt Lake City. Pregnant by Jim McKnight, the couple quickly married and had two sons.

Isom Dart was devoted to Josie and her family. Matt Rash, who became president of Brown's Park Cattle Association, managed the Bassett Ranch. Herb, grieving for Elizabeth, retreated into his scholarly books and resurrected his evangelical Christian roots. He also dreamed of leaving Brown's Park.

Eventually, the McKnight marriage collapsed into a volatile, word-sparring, bullet-spraying divorce. Subsequently, Josie married and divorced four more times.

Strychnine residue discovered in the cup of one husband prompted a court hearing and acquittal for the grieving widow. Another husband who mistreated her horse was given fifteen minutes to get out of her life. He

took five. Faring better at animal husbandry than husband selection, Josie homesteaded in Cub Creek, collected mail in Jensen and came to the aid of others but lived alone.

Ann rode bareback, handled a gun, roped and tied calves but displayed a temperament known to get in the way of common sense. She was impervious to family discipline.

"I became a specialist at evading my mother's staff of authority," Ann wrote. "With the speed of a wapiti I would race to the bunkhouse, that place of many attractions, where saddle-galled cowpunchers congregated to sing range ballads and squeak out doleful tunes on the fiddle."

When she was "expelled" by the nuns at St. Mary's of the Wasatch, it was the last straw. Her family sent her to boarding schools in the East. There, Ann found her stride and, returning to Brown's Park, fashionably outclassed everyone, spoke "east coast" and adopted her mother's fight against the cattle barons—and their encroachment on the land—with a vengeance.

Ann was beautiful, mercurial and dressed for revenge. *Uintah County Library Regional History Center.*

In 1900, these powerful cattlemen hired gunmen to rid the area of "rustlers." One such man was detective Tom Horn, who worked for the Two-Bar ranch. Postings suddenly appeared on cabin doors advising cattle rustlers to leave the Park, "or else!"

A politically motivated scheme, the warning was not taken seriously until Matt Rash was fatally shot point-blank in his cabin in July, and in October, Isom Dart was assassinated outside his cabin.

Intending to marry Matt, a furious Ann plotted revenge against the assassin's employer: Ora Haley and his Two-Bar ranch. She patrolled the divide between the cattle barons and park

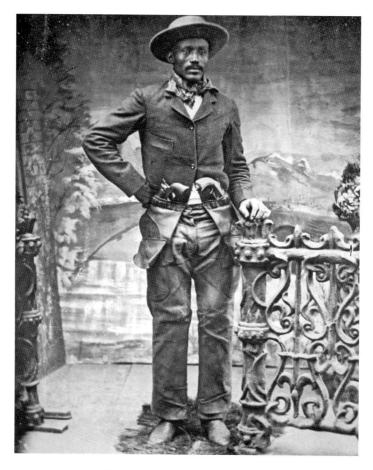

A member of the "Bassett Gang" and family friend, Isom Dart was assassinated in Brown's Park. *Uintah County Library Regional History Center.*

ranchers. Shooting any Two-Bar cattle crossing over, Ann meted out a paradoxical brand of justice by pushing others to their death in the swift-running Green River.

Part Three: Complex Stubbornness

Ann then bought a cabin in nearby Douglas Mountain. Working in concert with her brothers at the Bassett ranch, she aspired to reach goals similar to her mother's. But not wanting to do the work, the twenty-six-year-old stunned Brown's Park residents and chose (some say "entrapped")

Hi Bernard, an experienced cattleman and manager of the vilified Two-Bar ranch.

Ann pursued a business arrangement and marriage. Twenty-two years older, Hi was enraptured by Ann's striking beauty and hourglass figure. They married in 1904, and the Bassett-Bernard Cattle Co. took hold. Six years later, Bernard moved to Denver and the couple divorced.

Alone on her ranch, Ann continued her attack on Two-Bar by closing and cutting off access to the vital watering hole on her property. Retaliating, Two-Bar sent another stock detective to find evidence of rustling on her property. Soon enough, freshly butchered meat was discovered hanging in Ann's storeroom. She and her new foreman were arrested for cattle thievery.

Whether innocent or guilty, Ann's trial in Craig, Colorado, caused a sensation. A local opera house, rented for the trial, was packed with spectators waiting to see the fancily dressed, educated woman who spoke like city folk face off in a duel with the greedy cattle tycoon. It ended in a hung jury.

Set for re-trial in 1913, a credible witness for the defense was "legally" killed. The foreman disappeared. Haley was accused of tax evasion. Ann, Queen of Rustlers, paraded triumphantly through town.

How Fences Tamed the American West

Over an early-morning cup of joe in my backyard Sugar House home, I waited for Western Fence Company to put up a stronger wooden replica of what had recently been torn down. For a moment, it was refreshing to be living without boundaries and enjoying neighborly landscapes, decks and flowerpots. Then I felt ambivalent.

Fences defend and protect. They confine and liberate. In *Between Fences*, editor Gregory Dreicer wrote, "They make space into place." Some say they helped tame the American West.

When settlers arrived with their cattle, sheep and horses, farmers were required by territorial law to fence their property: to keep their animals in—and others out.

Architectural historian Tom Carter says that in 1876, in the Mormon community of Grouse Creek, Box Elder County, pole fences were made of Douglas fir or willow. Forty miles east in Park Valley, junipers (locally called cedar) were hewed to fence in meadows and build stockades.

Before there were fences in the grasslands of the Intermountain West there was open range—lots of it—free forage, unrestricted competition, loose land policy and little range science. Cattlemen, sheep men, free-range speculators and small ranchers moved herds from seasonal pasturage on both private and public lands and sometimes ran into trouble.

Sheep wars, cattle disputes, raids, stampedes, killings and conflicts over rangeland and water use, illegal fencing, land ownership and public domain discrepancies are well branded in frontier history.

According to an unpublished Park Valley manuscript, early rancher E. Ray Morris heard shots, ran to investigate and discovered "sheep men on the hills and cattlemen in the draws" who fortunately survived onslaught without injury.[4]

Clearly, lines had to be drawn.

When the Homesteader Act of 1862 came into existence and people were "legitimately tied to the land with rights on the federal range, they started fencing," Gary Rose, Park Valley rancher and past president of the Utah Cattleman's Association, told me. "Improving upon the land, they then pushed the Forest Service to divide up their land into grazing districts."

Smooth-strand wire fencing had been around for some time, but because it contracted in winter and expanded with heat, it was unsuitable for the West. Competing to create a superior product, Illinoisan Joseph F. Glidden patented the "Winner" in 1874.

His double wire with a two-point barb twisted twice around a single strand led to more than thirty adaptations. Soon, other inventors were shipping to the West hundreds of diverse barbed-wire designs, like the single-strand wire, four-point barb Reynolds Necktie; Hodge's Spur Rowel; and Brink's Vented Ribbon.

Rose, whose forebears were among the early Mormon settlers in Park Valley, attributes miles and miles of barbed wire as "the tool that put into perspective who owned what and how you ran it."

An 1870 census interpreted by the BLM tallied 4.1 million beef cattle and 4.8 million sheep in seventeen states.

The 1880 nationwide depression and decline in silver hurled former miners into ranching. By 1900, there were 19.6 million cattle and 25.1 million sheep, and prices slumped. In 1910, the western rangelands were depleted by soil erosion and overgrazing.

Under the BLM's 1934 Taylor Grazing Act, Rose's family was granted BLM rights to federal land on the northwest shore of the Great Salt Lake. It signified a shift in western attitude toward conservation. President Roosevelt

signed the act to "stop injury to the public grazing lands"; it aimed to "stabilize the livestock industry dependent upon the public range."

While grazing permits, called allotments, are issued within established districts, Rose credits stewardship for making it all work.

"It doesn't matter whether it's federal land you're leasing or private, you're responsible for putting up your fencing and developing your water," he said. "You move from pasture to pasture. You protect the land. You preserve the grass."

As for me, my fence is done—my urban piece of heaven intact.

THE STORY OF BUTCH CASSIDY IS JUST AS ELUSIVE AS THE OUTLAW HIMSELF

Steeped in Western lore, many of us know Butch Cassidy was a cattle rustler, horse thief, bank and train robber, former convict and charismatic leader of the Wild Bunch Gang who "broke ground on the Outlaw Trail," eschewed violence and apparently never killed a living soul.[5]

When it comes to his own death, though, chasing after Cassidy is a never-ending story. Not to besmirch the legendary character that embodied the truly Wild West, many accounts of his life-and-death experience are riddled with holes.

Some historians believe the notorious outlaw (along with the Sundance Kid) died of wounds sustained in a shootout following a heist in southern Bolivia in 1908. Others assert Cassidy was breathing long after his demise. Rumors flourish of his undergoing plastic surgery in Paris, assuming new identities in the States, getting married and dying in 1937.

Presumably buried in California, Oregon, Spokane, Nevada or Salt Lake City cemeteries or on a hilltop in Utah's Piute County, how can one extract fact from fiction?

The first of thirteen children, Robert Leroy Parker was born in Beaver, Utah, in 1866; raised by Mormon pioneer parents on the family ranch in nearby Circleville; and left home at twelve. Working on a dairy farm, he "fell under the spell" of Mike Cassidy, a cowhand and small-time cattle rustler, who taught him to shoot.

Whether Parker was motivated by the thrill of adventure or was merely being pursued as a cattle rustler, the eighteen-year-old moved to the mining boomtown of Telluride, Colorado. There, he worked as

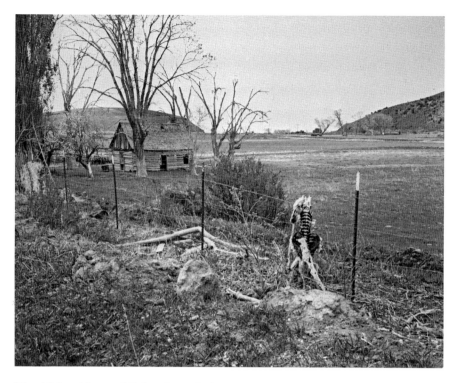

The childhood home of Robert Leroy Parker, aka Butch Cassidy. *Uintah County Library Regional History Center.*

a muleskinner driving ore down from the high mountain Tomboy mine, ranched and raced horses. Arguing about late wages, Parker left town on his horse and was promptly arrested for stealing the horse. The charges were dropped. He never forgot.

In time, Parker adopted Mike's surname, may have taken on his gang and possibly acquired the nickname "Butch" from working on a chuck wagon or in a butcher shop in Rock Springs, Wyoming. Purchasing a small ranch in nearby Johnson County, he became embroiled in range conflicts with cattle barons over grazing land and water rights and was heralded as a "warrior rather than a villain."

He also began his descent into crime. In 1889, Cassidy returned to Telluride and with three partners stole over $20,000 from the town's San Miguel Valley Bank and fled to Robbers Roost, a hideout in southeastern Utah.

Cassidy (among other outlaws) often worked on the Bassett family ranch in Brown's Park in northeastern Utah. Close to the Outlaw Trail on the way to Cassidy's Hole-in-the-Wall hideout in Wyoming, Mr. Bassett

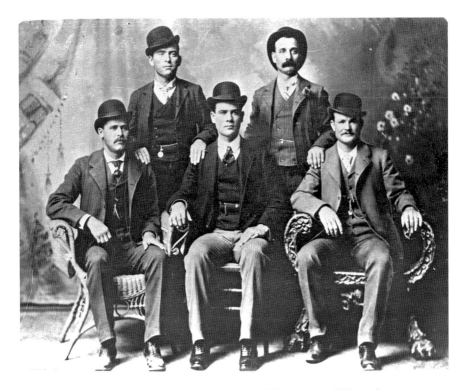

Butch Cassidy and his gang of outlaws. *Unitah County Library Regional History Center.*

supplied him with horses, and he became well acquainted with Bassett's daughters, Josie and Ann. Stories abound alleging romance but are impossible to verify.

"My father thought [Butch] was nice to talk to," Josie later wrote.

A cattle rustler also inclined to frequent Robbers Roost, Ann had little to add.

"During a horse race on one of Valentine Hoy's ranches, [Cassidy] rode the Brown's Park horse to glorious victory," she demurred. "Always well mannered, I never saw him drunk nor wearing a gun—in sight."

In 1893, Cassidy was arrested for horse thievery. He served eighteen months in a Wyoming prison and promised to "never offend" there again. Integrating a band of criminals into the Wild Bunch, he then launched a chain of well-planned, successful heists throughout the West.

Within a decade, the robbers had bounties on their heads and Pinkerton detectives on their trail. In 1901, Sundance and his companion Etta Place (who baffles historical veracity) sailed for South America. Cassidy followed while continuing a life of crime and ranching.

In 1908, two American bandits robbed a Bolivian mine payroll. Shot dead by police in San Vicente, they were buried without identification.

On a hot July day in 1941, a police officer reported pulling Butch Cassidy over for speeding in Mount Carmel, Utah. After being released, Cassidy spent the night with friends and then vanished, as was his wont, without a trace. Or so the story goes.

Postscript from Salt Lake Tribune Reader Larry DuBois

I've always thought it's safe to say that Butch made it back OK. I'll tell you why.

In 1959, when I was in high school in Salt Lake City, my grandmother Edith Corbin DuBois and I got into a conversation about the first car she ever saw when she was thirteen, which would have been 1909. She was living down near Thompson, Utah—somewhere near Robbers Roost—and heard a commotion in the street. Opening the door, she went outside and there was this car. The first one she'd ever seen. It was surrounded by a bunch of grown-ups. They were excited about the car, but even more excited because Butch Cassidy was driving it, and it was the first time they'd seen him in a few years.

We went on with the conversation but the story wasn't about Butch. It was about the first car my grandmother ever saw. He just happened to be the guy who was driving it.

A friend of mine was friendly with Butch's sister, Lula. She told him that Butch made it back, lived a long life and was buried in the Northwest in an unmarked grave.

He made it back. It was no accident that Director George Roy Hill left Butch and Sundance still on their feet in the freeze frame that ended the movie. He knew what he was doing.

Postscript from Salt Lake Reader Maxine Babalis

My mother, Ardis Fullmer Anderson, told me a story about her father, who was a federal marshal in Circleville, where Robert Leroy Parker grew up. They all lived in a tight community there, and my grandfather was a personal friend with the Parker family.

For some reason or another, my grandfather was on horseback in the wilderness area in southern Utah. Heading toward a box canyon, he saw

Butch riding out to him. He greeted my grandfather and then told him that if he continued on into the canyon, the "gang" was there and ready to ambush and kill him.

My grandfather thanked Butch, turned around and left. Some years later, the two of them saw each other at a celebration in Liberty Park in Salt Lake City. They made eye contact—but as a return favor, my grandfather didn't arrest him.

Part II

WESTERN CHALLENGES ON THE HOMEFRONT

HARDWORKING FOLK BUILT MURRAY INTO A VIBRANT CITY

Sometimes I can't help thinking about Murray, once the migratory home site of the Paiute, Shoshone and other native peoples, which evolved into a Mormon hamlet formerly known as South Cottonwood. Settled primarily by Latter-day Saints from Mississippi, it is rife with history.[6]

In the spring of 1848, pioneer residents Nathan Tanner and John Bills dug irrigation ditches—still in service today—designed to convert grasslands into fields of harvest, according to *Faces of Murray*, a 2003 centennial edition edited by Michael S. Pemberton and Mary Ann Kirk.

African American slave Green Flake, owned by James Madison Flake, was another recruit to the settlement. Loaned to work as a teamster during Brigham Young's 1847 westward trek, the nineteen-year-old also cleared trails with Orson Pratt's advance party and once in South Cottonwood built his owner's home.[7]

When the slave owner, his family and the Mississippi Company arrived in October 1849, the agricultural borough began to take shape. The following year, Madison Flake was killed in an accident in California. His widow, determined to move farther west, gifted Green Flake to the LDS Church as a tithing offering.

After two years, Green was granted freedom and given land in nearby Union.

During the next decade, the settlement's hub moved westward toward State Street. Its population, trade, homegrown stories and fame grew.

Utah folklore called Simpson David Huffacker the "Johnny Appleseed" of Cottonwood. Carrying a pocketful of seeds across the plains in 1847, he may have developed the area's first apple orchard on his 240-acre farm.

James Winchester, who ran cattle and cultivated land, was among the territory's first to hold a homestead patent. Winchester's animal husbandry was legendary. His wife, Elisabeth, while raising ten children, never hesitated to hitch horse to buggy and visit the ill.

By 1860, the Pony Express opened Station No. 9 just off South State Street, where the Overland Telegraph system was nearing completion.

Meantime, the Atwood brothers resurrected their brick trade from Philadelphia and fired up their kilns. Murray's first brick home and four subsequent smelters were constructed with Atwood bricks.

On the homefront, Lucy Bullock took care of her family, farmed the land and was a midwife to many.

In a letter to her sister-in-law in Scotland, Janet (Brown) McMillan explained, "If I don't make soap, I don't get any to wash with. If I don't make candles, we get no light."

Dugouts were in demand. Reuben Miller's family lived in an abandoned one. But his threshing machine, credited with bringing alfalfa into the area, was a steppingstone. Miller built an equipment business offering mowers, reapers and horse rakes. He opened a freight company. In 1862, he helped draft the Constitution of the State of Deseret.

Swiss-born Christian and Magdalena Berger left a comfortable home in Bern to live in a dugout for two years before acquiring more property for their children. (Later, one son, Gottlieb, would be elected mayor and see Murray through the Great Depression.)

When ore was discovered in Park City and Little Cottonwood Canyon in 1869, agriculture gave way to industry. In 1870, the Woodhill Brothers' smelter opened, producing the state's first silver bars.

By 1872, Germania Separating and Refining Company was operating on land purchased from Berger, who built twenty unpainted, unplumbed two-room houses and a recreation hall for smelter workers in nearby "Bergertown."

In 1899, the American Smelting and Refining Co. bought Germania and other such smelters. In 1902, the Murray smelter opened and sparked the city's economy, efficiency and image.

Erekson's General Merchandise, Gillen Bros. Livery and Feed, Gilbert's General Store, Utah Whip and Martin's Emporium were busy exchanges.

Milk dairies and taverns flourished. Its cultural and religious communities blossomed with Scandinavian, Yugoslavian, African American, Italian, Japanese and Greek laborers, farmers, families, suffragists and liberals. In 1903, the city of Murray incorporated.

IMMIGRANTS DRAWN TO UTAH AS THEIR EL DORADO

Some people call America a melting pot. I see it as a sumptuous stew steeped in ethnic diversity, simmered in opportunity and seasoned with a hunger for life.[8]

Savor the adventure of Polish-born Julius Brooks. In 1847, the twenty-two-year-old gathered his meager savings; packed his carpetbag, black bread, kosher sausage and cheese; collected his rifle (a departing gift from his uncle); bid goodbye to twenty-two siblings; and, tossing a straw bed and blanket over his shoulder, joined the growing ranks of sojourners sailing to the New World.

After five weeks at sea and his moldy food long since tossed overboard, Brooks landed in New York. After paying $1.50 for weekly residence in a sailor's home, his money was spent. He reluctantly sold his rifle for $100.00 and went into business. Five years later, he revisited his hometown, convinced everyone the streets were paved with gold and returned with a wife. Saying, "Fannie, let us take our few dollars and go west," they joined a wagon train heading toward Utah to become the territory's first Jewish family.

Brooks pursued his mercantile bent following mining booms and busts. Fannie opened a boardinghouse and restaurant. Her millinery and bakery shop was noted in the periodical called *Latter-day Saint's Millennial Star*.

In 1868, troubled by the influx of non-Mormon (Gentile) businesses, Utah's founding fathers called for a boycott of their stores. Without Mormon patronage, good citizens like the Brooks family suffered great losses but, determined to stay the course, waited it out.

In 1883, Brooks built the Romanesque-styled Brooks Arcade. By 1930, one hundred Gentile-owned shops lined the busy streets of downtown Salt Lake City.

Add to the stew the paradox of the gold rush days and the Chinese "forty-niners" who left behind civil unrest for the American West in search of "Gold Mountain." When discriminatory legislation squeezed them out of the gold fields, they filled this country's need for cheap labor.

The above cut represents the Mormon "Co-operative Sign"—called by the Gentiles the "Bulls Eye." At the Mormon conference, in the fall of 1868, all good Mormon merchants, manufacturers and dealers who desired the patronage of the Mormon people, were directed to place this sign upon their buildings in a conspicuous place, that it might indicate to the people that they were sound in the faith.

The Mormon people were also directed and *warned* not to purchase goods or in any manner deal with those who refused or did not have the sign,—the object seemed to be only to deal with their own people, to the exclusion of all others.

The result of these measures on the part of the church was to force many who were Gentiles or Apostate Mormons to sacrifice their goods, and leave the Territory for want of patronage. Some few, however, remained. Among whom was J. K. Trumbo, an auction and commission merchant, who procured the painting of what was known as the

"GENTILE SIGN."

This sign was placed in position on the front of his store, on the morning of the 26th of February, 1869, in a similar position to those of the Mormons. All day wondering crowds of people of all classes, little and big, hovered about the premises, and many opinions were expressed as to the propriety of the sign, and whether it would be allowed to remain by the Mormons; but at about 7 o'clock in the evening the problem was solved, by a charge made by several young Mormons, who, with ladders climbed upon the building and secured ropes upon the sign, while the crowd below tore it down, and dragged it through the streets, dashing it to pieces. This should be a warning to all "Gentiles" in future, not to expend their money in signs to be placed on their stores in Utah—*unless they have permission.*

"Holiness to the Lord" and a "Gentile sign" in retort. *Special Collections, Marriott Library, University of Utah.*

In the 1860s, twelve thousand Chinese immigrants, employed by Central Pacific Railroad, constructed the transcontinental rail line from Sacramento to Promontory Summit.

Skilled in handling explosives for boring tunnels through stone mountains, these men composed 90 percent of the railroad's labor force. They were proficient with power tools, cleared miles of trees and laid miles of tracks.

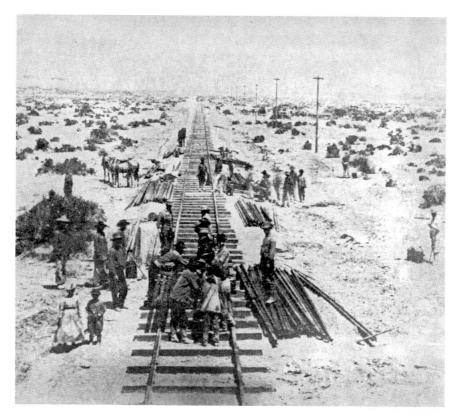

Chinese laborers working on the Central Pacific rail lines. *Special Collections, Stewart Library, Weber State University.*

Nonetheless, they were consistently over-worked and under-compensated for their labor. In the winter of 1866, they labored in snowdrifts over sixty feet in height. The spring thaw revealed corpses.

"Their monumental achievements, which required them to pour sweat and blood into Utah, have endured long after their names have been all but forgotten," historian Anand A. Yang relates in *Missing Stories.*

In a remarkable feat at Promontory Summit, these Chinese laborers constructed ten miles and fifty-six feet of rail line in one day.

Class tensions, unemployment crises and white society's fear of losing jobs to "strangers" led to the Chinese Exclusionary Act of 1882. Enacted by Congress, this law "singled out the Chinese on a racial basis." It barred immigration of Chinese laborers other than those who were already citizens of the United States by virtue of having a father who was a citizen.

"It was a very, very restrictive law," said Utah restaurateur and community leader Ed Kim in a 1984 interview for *Missing Stories*. To get around it, Chinese immigrants would travel to China and return with "paper sons" or "paper daughters" carrying fictitious certificates of eligibility.

"Many, many Chinese of my father's generation came here with these false papers," Kim said.

To pass the rigid immigration process, they would have to know the "adopted" family's history forward and backward, memorizing names, dates and descriptions of villages, streets and buildings.

"They were quite thorough in detail," said Kim. "If it were not for a brother-in-law who helped make the arrangements for my father to come here, I would probably not be sitting here today."

In 1943, the United States and China declared war on Japan. The exclusionary act was repealed, but with quotas. Not until the 1960s did Chinese immigrants taste equity.

GREENHORN PEDDLER LEARNS LESSONS IN HORSES AND POKER

It's tempting to buy an item online with a keystroke. But for me, the clarion call for local products stirs my soul. It tugs on historical purse strings. And it takes me back to the turn of the century, the 1900s, when a generation of shopkeepers like Simon Shapiro came West to make good.[9]

"My father was a city boy when he was born and a city boy when he got into the soft goods trade," said son and Salt Lake merchant Joel Shapiro in interviews archived at the University of Utah's Marriott Library. "Five-foot-eight, he was anything but the raw-boned tough cowboy."

Lithuanian-born in 1879, the young lad immigrated with his siblings to America during the mass exodus of 1891 that changed the lives of more than 110,000 persecuted Russian Jews. When his only brother contracted tuberculosis, Simon traveled with him to Colorado and to Denver's Jewish Consumptive Relief Society, the non-sectarian sanatorium founded in early 1904 to treat all stages of the potentially infections disease. Within the year, the brother died and Simon was on his own.

"His first job was selling soap door to door," said Shapiro. "When the lady of the house answered, instead of launching into his product—'two bars of soap for nickel'—he would give her a bar as a present to get the door open."

But no sooner had he started, Simon was arrested for selling without a license. His career was short, Shapiro admitted.

The young man's next line of work was packing and unpacking large trunks for traveling salesmen who displayed their merchandise in hotel rooms. Neat and orderly, Simon knew how to make stunning product displays and was in demand. He then contracted Herkert & Meisel Trunk Company. Founded in 1888, in St. Louis, Missouri, H&M is one of oldest manufacturers and suppliers of steamer trunks, luggage and leather goods in business today.

In 1910, trunks were integral to travel. "Trips were undertaken by people only with a great deal of preparation and the expectation of being away for a long time," Shapiro said. "Trunks of different sizes were the basic travel container for personal goods."

Speaking "structured English, laced with an old world perception," Simon took to the roads of Nevada, Colorado, Wyoming and Idaho. He even learned to ride a horse—although in one western town, the saloon-proffered stallion turned out to be a trick pony.

Ambling around the countryside, the rascal steed had a sudden change of mind and shot back to town "like a bullet" with its rider hanging on for dear life.

"They made a fool of him, but this is the kind of thing they did to this young, skinny Jewish kid," Shapiro said. "And my dad had to get along with them because he had come to that town to see a merchant about his wares."

In 1915, Simon relocated to Utah. Two years later, he opened Shapiro Trunk & Bag Co. on Main Street in downtown Salt Lake City. He specialized in custom handmade touring-car trunks that strapped to the back of automobiles. When innovative manufacturers built trunk space inside the car's chassis, Simon developed retail merchandising for travel, fine gifts and business.

Joel joined his father's business after serving in World War II. Years later, a third generation came on board. Opening several branches in Utah and surrounding states, the ninety-one-year-old family-run enterprise was "the" destination to reach.

Although Shapiro's Luggage and Gifts was eventually sold, its name remains the same and its history is intact. After all, Simon may have struggled with horses, but he knew his customers and he had a head for poker.

"My father lived to be ninety-one," Joel said. "He played cards one or two afternoons a week. Some of his poker 'maters' would accuse him of being 'too slow.' As he told me: he learned to play poker with both hands on the table because he was playing with guys who wore guns on their hips. Mother

Shapiro Trunk & Bag Co., on West Temple in the 1920s, Salt Lake City. *Shapiro Family*.

would yell at him during bridge games. 'You don't have to open and close the cards after every bid,' she would say."

But he did. Neither "hard-fisted nor muscular," Simon rarely raised his voice or got involved in politics—a sure bet to "mess up a business." Instead, the former greenhorn learned from the West and made good.

BINGHAM CANYON: A MINING HUB, A MELTING POT OF DIVERSITY

Before Utah Copper Co. (Kennecott) expanded the Bingham Canyon Mine into one of the world's largest open-pit copper mines and consumed the ground beneath the towns and homes of the people who helped build it, Bingham Canyon was noisy, dusty, vital and full of life.

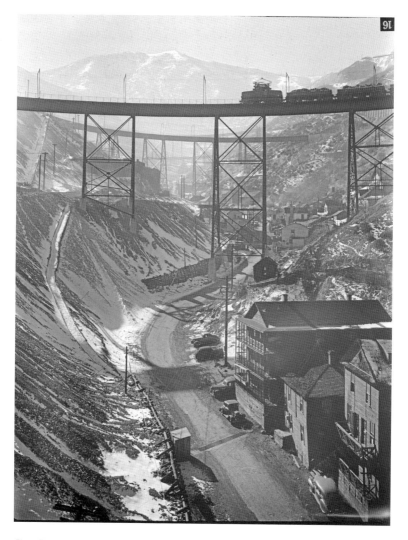

Carr Fork Canyon, seen from the "G" bridge, at Bingham Copper mine in 1942. *Library of Congress, FSA Collection.*

In 1896, Salt Lake City entrepreneur Samuel Newhouse recognized copper's future and shipped out the first copper sulfides from Highland Boy Mine in the Oquirrh Mountains.

A decade later, Utah Copper mounted steam shovels on railroad tracks to strip away seventy-five feet of surface rock to expose large deposits of low-grade ore and provide a profitable way to convert the copper-laced mountain into a copper pit.

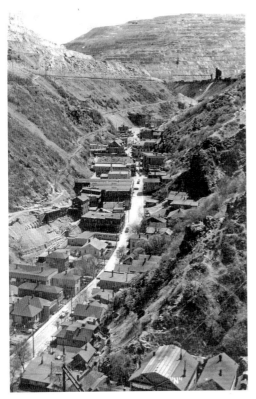

Looking down "Main Street" and beyond, Bingham Canyon. *Miller Family.*

Defined within the narrow canyon's steep walls, the town of Bingham Canyon was the hub of the mining district. According to early Bingham resident and writer Marion Dunn, Bingham was a town "attached to a mine [with] an umbilical cord [called] Main Street, a long, twisty thoroughfare that was simultaneously entrance and exit."

Flanking the lengthy but narrow, twenty-foot-wide street were mining and oil businesses, office buildings, mercantile shops and pharmacies, theaters and cafés, gambling dens, saloons and a brothel. There was a city hall and post office, a hospital, a movie house, a grade school and a high school. Wherever housing could be built, it was: from shacks and shanties, apartment complexes and bed-and-boards to wood homes and fine estates.[10]

Several miles up the canyon, Main Street forked. The right road branched toward the towns of Carr Fork and Highland Boy. The left fork, continuing on as Main Street, led to Copperfield, neighboring Dinkeyville, Telegraph, Terrace Heights and a bank of communities known as Japanese Camp and Greek Camp.

By the late 1920s, the canyon's population soared to fifteen thousand people, including 65 percent who were foreign born, representing more than twenty-five nationalities.

"It was a melting pot of diversity that built and showcased the West," June Holmes Garrity said from her Millcreek home. "In Carr Fork, my grandparents lived among Finns, Swedes and Norwegians. Highland Boy housed Austrians and Italians. In Copperfield, where my father, a

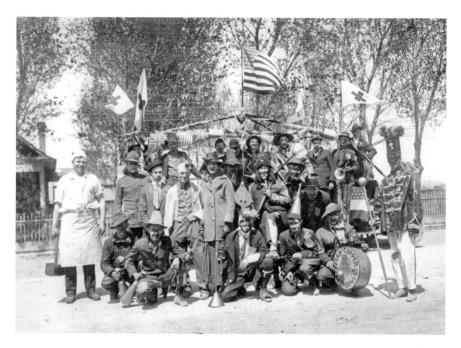

Bingham Canyon's Utah Copper Company Band. *Rio Tinto Kennecott*.

A matter of narrow roads, at its peak, Bingham was seven miles long and less than a city block wide. *Utah State Historical Society*.

manager of the U.S. Smelting, Refining and Mining Co., was given a company-owned home, our neighbors were Italians, Greeks, Japanese, British and Scandinavians."

Born at Bingham Canyon Hospital in 1929, Garrity attended the Swedish Lutheran Church. "There were so many Scandinavians," she said, "we had a full live-in pastor."

She remembered union troubles that gave her father ulcers and strikers "standing in the cold snow with their wives bringing them food." She harked back to the sound of blasting and whistled warnings that sent her scurrying to nearby shelters to wait out the flying rocks. She recalled mining disasters, train accidents, avalanches and floods that plagued the place.

But she most fondly recollects her childhood, when her friends were as diverse as the township she grew up in and Bingham was a wonderland.

"Copperfield was a community where everyone left their doors open and the lights on. In the wintertime, after a hard snow, we would get our sleds and 'belly boost' all the way down to the heart of Bingham's business district, a mile away. Then we'd wait to see if Dad would drive down in his car and pull us back up the road," she said. "When Kennecott built a vehicular tunnel under the mountain joining Copperfield to Bingham, we'd put on gloves and roller-skate down the sidewalk clear through the mile-and-a-half-long tunnel."

In the summertime, they played Andy-I-Over, kick-the-can and hopscotch with a treasured taw. They picked chokecherries for pies, went down to the tunnel to sell pieces of galena (fool's gold) to tourists and scoured the hillside, where wildflowers bloomed, the air was clean and no one told them when to come home.

To deepen the pit, in 1958, Kennecott demolished Copperfield. The other towns vanished, and in 1971, crews wiped Bingham Canyon off the map. Nothing left now but memories.

Postscript from Salt Lake Tribune Readers Leon and Mary VaLeta Miller

What a privilege and opportunity we both had to live and associate with our friends and neighbors while growing up in Copperfield. Our best friends then (and now) came from many different countries seeking work in the mining industries to better their lives. Language, color, last names did not enter into our lives. We trusted and loved one another and today if we run

into a person from Copperfield it's like meeting a special member of our family. No, we never witnessed the discrimination that goes on in the world today. We are all different and wish our children and grandchildren had the opportunity to be part of such a wonderful experience.

GREEK IMMIGRANTS BUILT A STRONG COMMUNITY IN UTAH

Years ago, shepherd, miner and businessman Peter George Condas summed up the American myth: "You don't have to work hard to get rich. All you got to do is go out in the fields, pick up some flowers, especially roses, sit down on a street corner and [a] man with his wife or girlfriend will buy your flowers."

Born in 1897 to a family of impoverished farmers in central Greece, Condas's three elder brothers fled to America, leaving their mother, he said, to die of a broken heart. Every day, his father worked the land with a hoe and for dinner set out a bowl of vinegar, garlic and "dried corn bread so hard," Condas said, "you couldn't put a bullet through it. That's the kind of life it was."[11]

In 1916, father and son sold off what they could to buy passage to America and reunite with the three brothers who lived in lower Bingham, where uncut mountain wildflowers bloomed freely and roses were scarce.

In 1900, three Greek-owned shops opened on Ogden's now historic Twenty-fifth Street and Washington Boulevard. In downtown Salt Lake City, the *kaffenio* (coffee house) at the Athenian Bachelors Club welcomed immigrants into the southwest area called "Greek Town." Soon, one hundred Greek-owned establishments were contributing to the economic growth of Utah; by 1916, that number would triple.

In 1910, Utah's mining and railroad expansion culled four thousand Greek immigrants as laborers. Young, male and unmarried, they worked on railroad-track gangs throughout the Intermountain West, in the coal camps of Carbon County, the copper fields of Bingham Canyon and the mill-smelter towns of Magna, Garfield, Murray, Midvale and Tooele.

Separated from American workers, historian Helen Zeese Papanikolas said they were "given the poorest accommodations" and, to keep their jobs, "forced to pay bribes, not only to their own padrones, but also to the bosses."

Working ten-hour days, six to seven days a week for $1.50 a day, they were challenged by poverty, prejudice, isolation—and loneliness. There were only twelve Greek women living in Utah at the time.

Greek men holding a meeting at a fraternal order. *Utah State Historical Society.*

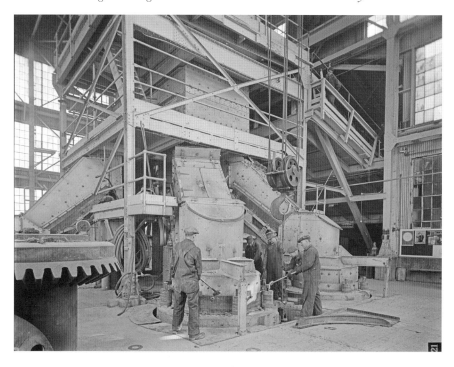

Short-head cone crushers used for reducing coarse copper ore to smaller sizes at Utah Copper Co. at the Magna mill. *Library of Congress, FSA/OWI Collection.*

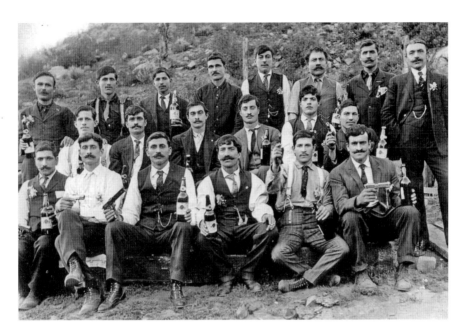

Carbon County Clear Creek Cretan Miners, 1911. *Hellenic Cultural Association Museum.*

When one woman asked John Speropoulos to deliver a present to her sister in Greece, there was more to the wrapping.

Speropoulos was sixteen years old when he arrived in America to work with his countrymen in Bingham Canyon's copper mines. When Greece declared war on Bulgaria in 1913, he felt it his duty to go back and serve his country. A year later, he delivered the gift to the home of Petros Apostolopoulous and met their daughter Efstathia. Smitten, they courted and, to her sister's delight, married and returned to Utah.

"I guess you could say I was started in Greece and completed in America," their son, Ted Speros, told me years ago at Lamb's Café, his restaurant in downtown Main Street.[12]

From 1905 to 1920, thousands of Greek women came to this country as picture brides in arranged marriages made popular because they didn't require dowries. Alien and isolated, they reached out to one another to build homes, families and a strong Greek community. They resurrected Greek cuisine; placed icons, saints and holy light in their homes; entered children's name saints into little books; cured pain with herbs; and taught Greek school and religion.

Some buried their husbands.

The Castle Gate Mine No. 2 explosion of 1924 killed 172 American and immigrant miners, who symbolized the strength, character and international

The Lingos and Burascano wedding (1918). *Hellenic Cultural Association Museum.*

The Zolintakis family. *Hellenic Cultural Association Museum.*

"The Minos" outing at Big Cottonwood Canyon, 1930. *Utah State Historical Society.*

ethnicity of Utah's early coal mining industry. Among the dead were 49 Greeks, 22 Italians, 8 Japanese, 7 English (Yugoslavs), 2 Scotch, 1 Belgian and 76 Americans, including 2 African Americans.

Among the many grieving widows faced with raising boys without fathers, Greek women keened laments over open caskets. They observed fasts, celebrated feast days and renewed customs that had fallen away.

Years passed. Company houses became their own. Number three tubs gave way to bathtubs. Outdoor plumbing came inside. Their children, Greek American youths, went on to make their mark.

Peter George Condas died in 1994. Theodore John Speros and George C. Furgis died in 2006. Greek leaders in commerce and community, three of the valley's wildflowers and history remain. *Zoé sé sás*: life to you.

IN GREECE AND UTAH, MAGEROU FOUND HER CALLING AS A MIDWIFE

In the early twentieth century, streams of Greek men as young as fourteen poured into Utah to work the mines, smelters, mills, rail yards and road beds. Hoping to earn steady wages and return to their homeland, these immigrants lived in tents, powder-box shacks, railroad cars and crowded boardinghouses. By 1910, they numbered more than four thousand. There were fewer than twelve female Greek immigrants. Among them was a midwife known as Magerou.[13]

Georgia Lathouris lived in a small Peloponnesian village in southern Greece. One afternoon while walking into a mountain pasture where her family was tending goats, the fourteen-year-old heard a woman shouting. The woman, pregnant, was harvesting wheat, experienced contractions and was unable to get down the mountain. Taking the mother-to-be into a nearby cave, Georgia delivered a healthy baby and discovered a profession.

Georgia assisted many pregnant women in her village but with no dowry was resigned to be single and childless. Then she met Nikos Mageras, a tall Austrian sent to build bridges in their region. Smitten, the Roman Catholic and Greek Orthodox couple relinquished the traditional settlement and married.

Raising families in the 1890s amid national instability was tenuous. The country's resources were drained, exports dwindled, construction faltered and employment was impossible to find. In 1901, Nikos traveled alone to the American West. Reaching Utah, his efforts to open a boardinghouse were thwarted—he was burned out three times. But in 1909, the family reunited in neighboring Snaketown, west of Magna. There, Nikos opened a saloon and Magerou assessed their new surroundings.

There was widespread disease, unsanitary housing conditions, poor medical care, greedy labor agents and hostility toward immigrants. Company doctors were feared.

"A dollar a month was deducted from their wages for medical care, [but] the men felt they were coldly treated, like animals, not human beings," historian Helen Zeese Papanikolas wrote in *Magerou: The Greek Midwife*. "Amputations were hastily performed, and as uneducated as the laborers were, an amputation was the end of self-reliance and the beginning of descent into penury."

Magerou treated ailing workers relaying advice first through her husband until they (Greek, Italian, Austrian and Slav men) trustingly asked for her counsel. When she saved a baker and a judicial officer from medically recommended leg amputations, her reputation soared.

By the 1920s, immigrant communities swelled with weddings and births. Industry improved both housing and medical care. But women wanted only Magerou.

"Scream! Push! You've got a baby in there, not a pea in a pod!" the midwife, with seven children of her own, was known to shout. She prescribed mothers butter to regain strength and bathrobes and ample coal to keep warm. She insisted on cleanliness.

Early on, the midwife blended specific aspects of modern medicine with folk healing. She warmed olive oil and baby blankets in coal ovens and sterilized cloths in boiling water. She trimmed her fingernails, thoroughly scrubbed her hands and wore gloves. Detecting birthing abnormalities, she'd call for a doctor and willingly assist.

Magerou also had favorite remedies: store-bought leeches used for bleeding cured most maladies, soap scraps pressed into wounds stopped bleeding and crosses cut into swollen flesh drained off "bad" blood.

Magerou, a midwife who also set broken bones with powdered resin and egg white. *Utah State Historical Society.*

She treated pneumonia and bronchitis with cups of heated red wine and cloves or whiskey and tea and applied mustard plasters on backs, chests and soles of feet. She alleviated rickets by touching patients' joints with the stem remains of a burnt bay leaf during three separate, moonless nights. She used whiskey as an anesthetic and set bones with a powdered resin, egg white and "cleaned sheared wool" cast bound over with cloth.

Magerou practiced midwifery par excellence for over sixty years. She never lost a mother or a newborn child.

The Steres Family Made Their Way in Utah

At two o'clock in the morning on October 10, 1911, a hurricane struck the city of Vernal. Strong winds sheared the tops of buggy sheds, carried off horse blankets and shattered windows. According to the October 13 *Vernal Express*, the bluster "played pranks on the premises of Isaac Steres in the east part of town," where "everything moveable was shifted about promiscuously."

For all the wind's ferocity, no one was harmed. The broken was mended, a blanket was found wrapped around telephone pole wires and the family had reason to celebrate. Several weeks earlier at the Fourth Judicial District Court, Jewish immigrant Isaac Steres became an American citizen.

Narrowly missing conscription in the Russian army, Isaac left Ukraine for Canada and immigrated to Utah in 1905. His wife, Rose, and their three children remained in Odessa until he saved enough money to send for them.

"Mother always talked about surviving the Cossack pogroms," her American-born daughter, Claire Steres Bernstein, said in a 1972 American West Center interview.[14]

"One time, the Cossacks made a [deadly] sweep of the Jewish section," Claire said. "A Gentile man suddenly grabbed my mother and the children. He hid them in his lumberyard and saved them from that pogrom."

Rose struggled for months to feed and keep her children safe. When she was finally able to book passage, the young family sailed from Germany to New York. They went by train to Ogden. Reunited with Isaac, they headed to their new home in Vernal.

"It was a long journey for Mother," Claire said. "She always kept an Orthodox home and had never eaten non-kosher food. In Utah, she ate no meat at all until my father learned how to ritually kill a chicken [following Jewish dietary law]."

Living in a small log cabin, Rose was puzzled by the cook stove. "She had never seen nor worked one before," Claire said. "Fortunately, a kind neighbor taught her how to open and close a damper to regulate the temperature. From then on, Mother would get up in the middle of night, set the dough, and bake bread two or three times a day."

With financial backing from Salt Lake City Jewish merchants, Isaac traveled to the Uintah and Ouray reservation to buy furs and hides. He placed ads in the *Vernal Express* ("I. Steres. Phone 41a") and sold J.J. Watkins household items.

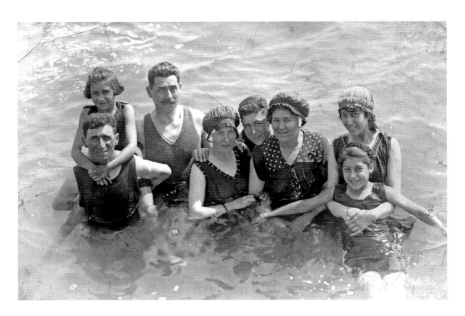

The Steres clan soaking in the Great Salt Lake nearby the popular Saltair Pavilion (*right:* Clair floating). *Gail Bernstein Ciacci.*

"He barely eked out a living," Claire said. "To help support our growing family, Mother raised vegetables and baked this gorgeous bread; the best we ever ate."

Claire was born in Vernal in 1907. An early reader, she attended the Congregationalist school.

"It was a wonderful, warm community," she said. "I went to Sunday school for several years. But when I was told Jews killed Christ, I came home crying and my father wouldn't let me go any more."

Rose suffered from high blood pressure. Around 1914, the Steres family relocated to Salt Lake City's lower elevation. Eventually, they built a large brick home with an attached grocery store on the corner of 300 East and 900 South.

"Mother worked there for years while my father traveled, sometimes for days, buying hides and furs," Claire said.

Finding unity at Congregation Montefiore, on 355 South 300 East, the six Steres children went to Hebrew school. As teenagers, they developed ties with Ogden's Jewish community. It was there in the foothills that Claire experienced an "incident that affected me because of what it represented."

Hiking on a trail with friends, they spotted the Ku Klux Klan burning a cross on the hillside. Stunned into youthful curiosity, they hid.

"They were protesting against Catholics and blacks," she said. "They were naming Jews, too. And there we were, just kids, unseen, and hearing terrifying things. It wasn't until later I understood how dangerous it could have been had they taken notice."

Part III

CAPTAINS OF COMMERCE

THE AUERBACHS: FROM TENT STORES TO A SALT LAKE INSTITUTION

Part One: The Long Road to America

Among the myriad challenges of beginning a new life in a new land, just getting there is a story in itself. Take, for instance, Samuel H. Auerbach, who clocked over ten thousand miles before turning east to Utah.

As a young boy living in Fordon, Prussia, Samuel often stopped along the riverbank to watch sailing vessels navigate the long and busy Vistula River.[15]

"Those boats, barges, and log rafts outfitted with straw-thatched shanties floating down the muddy waters of the great river to the Baltic Sea held a wonderful fascination for me," the German Jewish pioneer merchant wrote in early, unpublished memoirs.

"The sailors were stout, robust men who told stories of great adventures and I wished I might go on a sea voyage to faraway lands."

Samuel, born in 1847, was one of seven siblings. His beloved father was a horse and cattle buyer and a teacher at a local college. When Samuel was four years old, he awakened temporarily blind. At the same moment, his father died from injuries sustained in a wagon mishap.

To help support the bereaved family, Auerbach's elder brother Frederick immigrated to New York in 1854. Riding the crest of California's gold rush,

he sailed around Cape Horn to San Francisco, the state's northern mother lode and the mining boomtown of Rabbit Creek. He opened a tent store for miners, partnered with another emigrant brother, Theodore, and sent money and letters home instructing Samuel to learn English.

"English was in truth a magic language for me," Samuel recollected. In early June 1862, he got his wish to join his brothers.

Promising to write and heed his mother's advice to "leave drink, cards and women alone," the adventurous fifteen-year-old headed to Hamburg. Dazzled by the harbor's "thousands of high masts and riggings," he boarded the *Borussia* liner bound for America.

"The steerage quarters were congested, dark, dingy, dimly lit by faint-flamed lanterns, poorly ventilated and ill smelling," he wrote. "When the boat rocked and pitched during rough weather, it was a terrible ordeal to remain below deck."

Landing in New York City was breathtaking.

"The Civil War was in progress. New York was a martial city dotted with tents. Soldiers marched up and down the streets to the fife and drum of military music. Emigrants were offered $1,000 to enlist in the Union Army," Samuel recorded. "Slave trafficking was unknown to me. The matter of buying and selling human beings like cattle made a profound impression."

After taking in the lights and sounds of Broadway, Samuel continued westward. He sailed on a side-wheeler crammed with hundreds of hopeful gold miners and merchants toward the Isthmus of Panama—the steamboat captain wary of Confederate ships.

They docked in Aspinwall (Colòn), Panama, where Samuel discovered yellow fever was rampant and most water undrinkable. He also tasted his first sugar cane and in high spirits rode the newly built Panama Railway across the fifty-mile isthmus to the Pacific.

"The roadbed was in poor condition, the ground low and swampy, and water rose to the rails, but the dense jungles were more beautiful than anything else I had ever pictured," he wrote. "Orchids bloomed in hues. Monkeys played and parrots, macaws, and toucans of every conceivable color abounded."

Reaching Panama, the passengers embarked on the 1,450-ton steamboat *Orizaba* and dined at tables mounted overhead with iron rods. Samuel ate hardtack. He drank coffee sweetened with brown sugar resembling sand.

Warned of the Confederate steamship *Alabama* in proximity, the *Orizaba* sailed safely and without lights at night. Passing close to Costa Rica and El Salvador, they loaded coal and fruits in Acapulco, hoisted beef cattle for

fresh meat and buried a body at sea, "far away in a place never to be visited by family or friends."

On August 17, 1862, a thoroughly exhausted Samuel sailed into San Francisco's Golden Gate Bay. Boarding a coach to Rabbit Creek, he greeted his brothers at the shop and went to bed.

Part Two: Gold Dust

While running the lively mercantile, the Auerbach brothers set their sights on Utah. But first, they gleaned the vicissitudes unique to Western lore.

Rabbit Creek was the trading headquarters for thousands of gold-struck miners within a twenty-mile radius from Marysville and Poker Flat to Brandy City and American House. Gold yields escalated into the millions. Robberies along the major stagecoach route were common.

The Auerbachs' store became a gathering place for many prominent miners, businessmen and freighters. Frederick often helped the men with business dealings and trade. His acumen earned their trust. Many left their gold dust, nuggets and bullion with him for safekeeping.

Strong and adventurous, Theodore transported gold dust from Port Wine to Rabbit Creek. Riding a large mule with a Mexican-style saddle, he'd secure a safe box in front of him with pistols strapped on each side. On some occasions he was accompanied by guards—rough men armed with sawed-off rifles.

"Paper money was frequently used but was not worth face value," Samuel wrote. "Gold dust was current. Every merchant had a pair of scales sitting on the counter. A pinch of gold dust—as much as could be held between the thumb and index finger—was worth two bits, or twenty-five cents."

Auerbachs' carried a general line of dry goods from clothing and mining supplies to blankets, drugs and snowshoes. Come winter in Rabbit Creek, miners from miles around would compete in snowshoe speed racing. They packed hotels, gambling halls and saloons. Excitement ran high. Liquor flowed. Bets were made. Merchants prospered.

"But storing large amounts of treasure in our safe always gave me apprehension," Samuel wrote.

One night after minding the store—his brothers away on business—Samuel fell asleep in the back of the shop. Awakened by noises, he saw two intruders and the barrel of a pistol pointed at him.

"The size of a cannon," he wrote, "it was blacker and deeper than I had ever imagined a pistol could be. The men appeared eight feet tall."

Ordered to open the safe, Samuel pleaded ignorance. "I told them I didn't know the combination. That my brother would never trust anyone with it," he wrote. "They threatened to shoot me. They cursed profusely. Tied my feet and hands. Fastened a bandana handkerchief across my mouth. And started drilling the safe door for what seemed like hours."

It was mere minutes.

"A group of late home-goers stopped to talk near the store entrance where we kept a lantern burning all night," Samuel explained. Fearful of detection, the safecrackers dropped what they were doing and fled.

Samuel wriggled free and found the sheriff. An investigation ensued. The men were never found. It was days before Samuel could get a good night's sleep.

Almost simultaneously, the Auerbachs opened a series of stores. They sold merchandise on commission throughout the western states, including Virginia City and Helena, Montana, and Fort Bridger in Wyoming. They grubstaked miners, held mining interests and purchased a sawmill and a thirty-pack mule train.

"Some investments were disastrous from a financial standpoint," Samuel wrote. "But they carried with them a heap of education and valuable experience, which in later life was of great benefit to us."

In 1864, the Auerbachs left the California gold fields for Utah.

"We accounted for our losses, paid our bills and established our credit and reputation," Samuel wrote. "Fred drove a mountain schooner to Great Salt Lake City in March and upon arriving was favorably impressed."

Self-taught and articulate in English, the pioneer merchant brothers, who developed one of the first department stores in the West, were not only primed for Utah but also prepared to take on its challenges.

Part Three: Salt Lake City Success

Arriving in Salt Lake City in 1865, Samuel was greeted by a mud wall fringing the city, another family store and a view that profoundly stirred him.

Designed in 1853 with auxiliary gates and bastions, the city's bulky fortification was meant to surround sixteen miles of territory and protect folks from potential marauders but stopped short of six miles.

"The wall was broken in many places," Samuel wrote. "Yet when we passed beyond it into the sacred city, never did I behold a more beautiful or welcome sight."

Samuel recalled "streams of crystal clear mountain water rippling down ditches alongside the sidewalks," planks that bridged ditches and "stoops that assisted ladies alighting from carriages, buggies, or wagons." The 132-foot-wide dirt-packed streets raised dust in dry seasons, bogged down when wet and accommodated oxen teams and covered wagons turning around without causing mayhem.

"It left a vivid impression upon my mind," Samuel wrote.

While looking for shop space, Frederick became acquainted with Brigham Young, president of the Church of Jesus Christ of Latter-day Saints, and with his help leased a small adobe cabin on the west side of Main Street. Frederick repaid the Mormon leader's generosity by contributing an entire stock of much-needed medicine to an ailing congregation.

The brothers quickly reinvested in their store, moved to larger accommodations and built the formidable retail establishment F. Auerbach & Bro. They worked predawn hours to midnight and carried a mixed stock of goods from hardware, fare and furnishings to hoop skirts. They traded in furs and hides, sold gourmet salt in signature bags and

F. Auerbach & Bro. in the mid-1870s. *Utah State Historical Society.*

cornered a market by marking down calico yardage from eighty cents to fifty cents. Outside the store, they displayed modern tin bathtubs long before there was plumbing and hung "produce" signs for teamsters seeking consignments for westward destinations.

"When out-of-town customers came in, it was customary to permit them to sleep in store aisles or on counters," Samuel wrote. "Wearing boots and clothing, they'd [wrap themselves] in blankets taken out of the stock and return them after they had risen."

Business was rarely accomplished with cash. "It was mostly charge, due-bill, or barter," Samuel explained. "I remember Fred impressing upon a clerk to 'make out a charge, even if the store is burning!'"

From the start, Frederick and Brigham Young formed a lasting friendship that endured the bitter struggle between Mormons and Gentiles and the dreadful 1866–69 boycott sanctioned by LDS Church officials that threatened the future of Gentile-owned businesses.

Some LDS leaders perceived increasing numbers of non-Mormons in the Utah Territory as a threat to Mormon autonomy. They adopted a

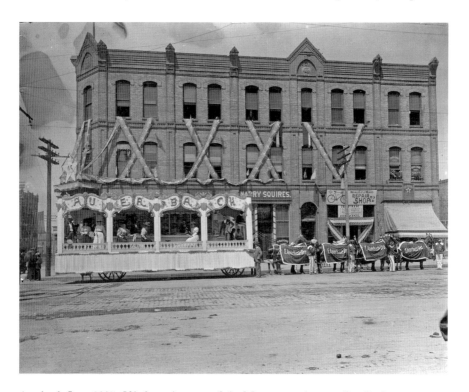

Auerbach float, 1897, fiftieth anniversary of the Mormon settlement. *Stan Sanders.*

resolution pledging its members be self-sustaining and shop only at LDS-sanctioned stores.

After the murder of two non-Mormons—an ex-army chaplain married to an apostate's daughter and a doctor who managed a non-LDS Sunday school—Gentile merchants were overwhelmed with concerns about business and personal safety. Some felt forced to carry guns; backed to the wall, some fled the territory; most moved to the booming Gentile city of Corinne in northern Utah.

The brothers operated branch stores throughout the state, including Corinne and Promontory. They purchased real estate and invested in other holdings. They also eliminated their logo from boxes and bags so no one could trace orders back to their store.

"Loyal Mormon customers, threatened with excommunication, shopped secretly at night by way of the back entrance because they dared not be seen," Samuel wrote.

Challenging the prevailing adversity, F. Auerbach & Bro. became one of the oldest department stores in the West. Only after 120 years did the doors finally shut, leaving fond memories for those fortunate to have shopped at Auerbach's on the corner of State Street and Third South.

THE ROSENBLATTS: MINING MORE THAN GOLD

Part One: Another Mouth to Feed

In the Russian industrial town of Brest-Litovsk—a Polish center of Jewish trade, administration and rabbinic teaching during the fifteenth and sixteenth centuries—most general businesses were forbidden to Jews other than those employed in lumber and transportation.

The Rosenblatt family, who owned a small mill, made a living by stockpiling and selling lumber. But pogroms were common and widespread. Horrific too was the forced conscription of Jewish lads as young as twelve into the Russian army. Few ever made it back.

In 1880, the elder Rosenblatt booked passage for his fourteen-year-old son, Nathan, on a ship bound for America.

"My grandfather literally pushed him out the door saying, 'I don't know what's going to happen to you by leaving. I do know what will happen if you

stay,'" said Nathan's son, Joseph Rosenblatt, in interviews from University of Utah's Marriott Library and University of California's Bancroft Library.[16]

Carrying a letter of introduction from his father to a landsman he had helped immigrate to Colorado, Nathan bypassed New York and traveled on to Denver. It was winter. Work was scarce; the fellow countryman and his family were struggling to survive.

"Having another mouth to feed must have been overwhelming," Rosenblatt said.

Nathan went next to Salt Lake City, where he was advised to seek help from the Auerbach brothers, German-Jewish entrepreneurs who developed one of the West's first department stores, F. Auerbach & Bro., and dealt in gold dust, greenbacks, tithing script and shinplaster currency printed by Salt Lake City. They gave Nathan a pushcart filled with merchandise from their store along with a list of items and prices.

"If language was a handicap, it was simply something he had to get over," Rosenblatt noted. "Peddling in the city, he slept wherever there was a place to wrap a blanket around him, and eventually he made a success of the pushcart."

A few years later, Nathan married young Tillie Scheinbaum, who, unescorted, crossed the ocean in steerage. Their marriage, the result of "the well-respected custom of matchmakers," produced sons Simon (1888), Morris (1890) and Joseph (1903).

By the late 1800s, mining enterprises were carving frontier niches in the Intermountain region. Salt Lake City became a hub for economic development, immigrant workers flooded the mines and Nathan was intrigued.

Nathan broadened his business plan. Selling dry goods to miners, he collected scrap metal and rags and learned how to purchase, repair and recondition old mining machinery for resale. By 1893, he founded the Utah Junk Company behind the family home on 800 South and State Street.

The following year, while selling a wagonload of mining supplies and goods in the lead and zinc belt in northern Idaho, the Pullman Panic hit. A national crisis ensued: banks shuttered, money sources dried up, scrip was issued and Nathan was stranded in Idaho for nearly a year.

"I remember hearing it was a difficult time for Mother raising two boys on her own," Rosenblatt said. "But returning through Cache Valley, he sent her a message saying, 'This is so beautiful, I just have to stop a day and enjoy it.' Apparently, she greeted him not too kindly."

Nathan specialized in brass, iron and copper. He shipped the metals to eastern states for recycling. It was an expensive process, and he looked for

and found local markets for his scrap iron. He built a brass foundry. With his eldest sons, he established the American Foundry and Machine Shop and purchased a smelter for steel production. He leased land to store agricultural machinery and car bodies to be cut to size and used in the smelters.

Some ventures were costly. Some failed. But from 1890 to 1920, the Rosenblatts were at the forefront of the region's mining and smelting expansion. Reinvesting their profits back into the business, they continued to grow.

In 1925, Nathan bought out the Silver Brothers Metals Co. and moved in. The next year, he offered his youngest son, twenty-three-year-old Joseph, an offer he couldn't refuse.

"My father said, 'Look. Here's this little thing I picked up called Eastern Iron and Metal. It's yours. Go ahead and see what you can do with it,'" Rosenblatt said. "And 'out you go,' he said."

Thus began, for the Rosenblatts, another chapter of diversification, risky challenges, success and a legacy that epitomizes the American dream.

Part Two: Building a Scrap Metal Business into EIMCO

With family backing, young Rosenblatt acquired a storage yard filled with abandoned mining equipment.

"There were pneumatic drills, ore cars and metallurgical equipment for recovering metals such as crushers, ball mills, concentrating tables and sand pumps," he said.

Once reconditioned and made operable, he sold them to small mining companies and, as the Rosenblatt wont, tackled larger projects. The first involved purchasing the Kennecott-owned Arizona Hercules property adjoining the big Ray Mines in Ray, Arizona.

"It was a substantial investment," Rosenblatt said. Meticulously salvaging the site, Rosenblatt not only transported the machinery for repair and resale but cleaned up enough concentrates that when smelted yielded $14,000.

He then sold the Ray Mine buildings with the caveat to dismantle, move and reconstruct the "huge operation" to house a mill in northern Washington State.

"The task of going into a mill and picking up and moving a fifteen- to twenty-ton ball mill, well, you didn't do it quickly, but you did it safely," he said.

It was a two-year, profitable project. When it was finished, they decided to design and build new equipment. After acquiring patents for a new

EIMCO Corp. plant in Salt Lake City. *Special Collections, Marriott Library, University of Utah.*

mucking machine invented by John Finlay and Edwin Royle at Eureka's North Lily gold mine in Utah, they got that chance—and changed their name to EIMCO.

The innovative, mechanized, underground mucking machine was a rocker-shovel powered by Ingersoll-Rand motors. It could lift a load in its bucket and deposit it overhead within limited headroom. EIMCO produced hundreds of the machines. In 1944, the Rosenblatts built a new plant and developed their own designs, models and air-driven motors that reduced the

risk of gaseous air causing explosions in the mines. They changed the course of hard rock mining and sold countless shovels domestically and overseas.

They also made advances in the vacuum-filtration products used for separating liquids and solids in the smelting process; built "custom, exotic" filters; and entered the uranium-filtration business.

From a yard filled with old equipment to the 1953 recession that stalled economic development, EIMCO steadied Utah's economy by selling locally made products to markets all over the world and kept on going.

Part IV

THE STAIN OF BIGOTRY

CHINESE MIGRANTS FOUND UTAH WAS NO "GOLDEN MOUNTAIN"

Several years before the 1943 repeal of the Chinese Exclusion Act—an 1882 scourge of legislation that "temporarily suspended the immigration of unskilled Chinese laborers and prohibited the naturalization of any"—Helen Ong Louie pretended she was "somebody else" and sailed to America.

"Yee is my passport name, because there was no way my father could bring me over legally," she said in interviews archived at the University of Utah Marriott Library.[17]

Until naturalization rights were given to people of all races in 1952, many Chinese entered the country as "paper sons and daughters" of fictitious relatives. Family names were bought and sold. Biographical information was learned by rote; village scenes memorized. Interrogations were arduous and long.

Questioned repeatedly about her surname, Helen dug in. It was her mother's, she said, and they finally let her go—but her fear remained. Thirteen years old, Helen worried. "The United States discriminated against Oriental people. If you did something wrong, you were afraid they might deport you."

Her father was quick to advise. "He taught me the government's got ears. So whatever they ask, don't let the outside know. He knew this because he'd been through it with his dad."

Helen's father was a teenager, the third son, when he and his father first traveled to the United States, called the Golden Mountain. "My grandfather came on a businessman's adventure," Helen explained. "The impression was you could bend down and pick up all the gold you wanted."

Living in Salt Lake, they spent time in Plum Alley between First and Second South and State and Main Streets. "Plum Alley was full of old men, gambling joints and opium dens," Helen said. "My grandfather smoked opium and since they slept in the same room, the smell went right into my dad's clothes. Teachers would ask him about it at school."

One of Utah's earliest Chinese residents. *Utah State Historical Society.*

Helen's father went to West High School but wasn't allowed to swim in public pools or sit downstairs at theaters. Taunted with disgraceful epithets, like "Chink, Chink, Chinaman," there was no comeback. "That's when he learned to keep things to himself," Helen said. "He was afraid of being deported."

At the onset of World War I, Helen's father traveled to China, married and returned to the States alone. "As soon as he saved a little money, he would go home and visit his family," Helen said. "I was born during one of those visits; my brother during another." When he brought his wife and son back with him, Helen was left behind.

"I went from relative to relative," she said. "Of course, my father always sent money. At the time, one American dollar might equal forty dollars in China, so relatives fought to have me stay with them."

When war broke out with Japan in 1937, Helen took her assumed name, joined her family in Utah, "skipped over grades in school," worked in the family store and grasped the value of a dollar.

"In the United States, a dollar is a dollar and everybody has to work. The Chinese have a saying, 'If I can't make it in eight hours, I can put in sixteen hours and make it.' And few go broke."

In 1950, Helen married Harry Louie. "Did I love him? Americans talk about love at first sight. But I don't think there's such a thing." She said that love comes after. "You live with him, and you learn to love him."

Maintaining old country ways, the newlyweds lived with Harry's family for thirty-six years. "As our children came along—eight in thirteen years—the biggest problem was space," she said. "But eating was fine. We'd just go to the restaurant."

In those days, downtown Salt Lake City was abuzz, and the family's King Joy Café was open to diners 364 days a year.

"If you closed for more than a day, you worried about losing a customer. That's how it was," Helen said.

COON CHICKEN INN SERVED TASTY FOOD, TASTELESS BIGOTRY

In 1925, Maxon and Adelaide Graham's Salt Lake City eatery—one of the nation's earliest food franchises—was famous for its fine goods, "popular prices" and home-style atmosphere.[18]

By 1930, the couple added live music, catering and a most peculiar two-story contrivance depicting the winking caricature of a black man's face, a porter's cap atilt on a bald pate and an enormous set of thick, red lips.

To enter the restaurant on Highland Drive, one walked into the mouth of this face and past twenty-four larger-than-life teeth, fourteen of which spelled out "Coon Chicken Inn."

Though the eatery was named after raccoons and their proclivity in stealing chickens, the word "coon" was used to denigrate African Americans as thieves or shady characters. But Salt Lake City's predominantly white diners failed to recognize the restaurant's advertising as offensive. Rather, they saw snappy colors, an engaging face and a novel invitation to roadside dining.

In 1860, thirteen years after the Mormon pioneers arrived in the Salt Lake Valley, about sixty African Americans lived in the Utah Territory, and most of them were slaves. By the time the all-black Twenty-fourth Infantry was stationed at Fort Douglas from 1896 to 1899, the black community had

Salt Lake City's African American community at Calvary Baptist Church, founded in 1892. *Special Collections, Marriott Library, University of Utah.*

grown large enough to establish its own churches, newspapers and social and fraternal organizations.

These successes were achieved in the face of prevailing racially based discriminatory practices and attitudes. As University of Utah professor and historian Ron Coleman explains in *Missing Stories*, "Black Utahns were in a position similar to that of other African Americans throughout the United States: They were residing in a nation in which the majority white people believed in white superiority and black inferiority."

Utah law prohibited interracial marriages, African Americans were often denied access to public services, black shoppers couldn't try on clothes before buying them, black moviegoers were segregated to balconies and prejudice sorely limited job opportunities.

Preparing for a career in nursing, Doris Frye of Salt Lake City remembered being told in the 1930s that she could train to be a nurse but that she would never work as one "in any hospital or nursing home in Utah."

In 1939, Lucille Bankhead and neighbors went to the state capitol to take issue with a Utah senator who wanted to relocate all blacks into one district.

"We had no intention of moving," she said, and with her baby on one side and her neighbor Mrs. Leggroan in her starched white apron and dust cap on the other, they stood vigil until the proposal was defeated.

The Coon Chicken Inn. *Utah State Historical Society.*

Neither woman ever set foot in Coon Chicken Inn.

The restaurant served a ham and melted cheese sandwich, called the Dutch Great, for seventy-five cents. The daily coon chicken special ran for $1.60. Double-thick malts were thirty-five cents and beer came in quarts or pints. From plates and glasses to silverware and napkins, everything was branded with the "walk-through head" logo. Sometimes the trademark looked more like a monkey than a man.

Before 1943, Coon Chicken Inn hired only white employees, and blacks and other people of color weren't welcome. By the end of World War II, blacks were employed as cooks and waiters, but those who worked the dining room were ordered to deny service to black customers.

Black waiter Roy Hawkins, hired at age fourteen, rose to headwaiter by the late 1940s.

"People have asked me how I accepted working at Coon Chicken Inn, [but] back in those days, coming from every part of the country, it wasn't nothing to see mockery. You know, like *Little Daisy* and *Sambo* on the lawn with the water bucket. After a while, you build up immunity."

In its heyday, Coon Chicken Inn was one of the most successful restaurants in town. People lined up for hours to get in; pay was good, tips even better.

"[We could] make $200 a night," Hawkins said, pocketing his pride and "laughing all the way to the bank."

In 1956, the twenty-five-foot-tall head was dismantled, the racist memorabilia put away and the inn closed down. Hawkins moved on, leaving behind a restaurant with a reputation for good food and a nasty aftertaste of the racism of the day.

DISCRIMINATION AGAINST BLACKS WAS ONCE RIFE IN UTAH

In 1929, Howard Browne was a pre-med student at the University of Kansas. His parents were long divorced, and the nineteen-year-old African American had just married Marguerite, his college sweetheart, when the Great Depression cut short his education and his mother's call for help in Carbon County, Utah, redefined his future.

Browne's father was a lawyer in Kansas. His stepfather was a miner, a strikebreaker brought to Utah in 1922 by the coal mining industry. His mother took in laundry, sold home-brewed beer and, in 1929, bought forty acres of land in Carbonville.

"Her husband suddenly fell ill and couldn't work the farm," Browne said in interviews archived at the University of Utah Marriott Library. "I jumped on a freight train and came out to help her."[19]

The young man built a "dugout" for his mother, who hadn't a house to live in. In the summer, he grew alfalfa in her fields. In the winter, he worked the mines.

For a decade, he raised his family in a home fashioned from old chicken coops because "no one would rent to blacks." He walked into mines, "never knowing if you'll live to see daylight again," and witnessed a mountain move, which meant "something [bad] was going to happen in the mine"—and it did. Browne said he'd had enough.

In 1939, Brown moved his family to Salt Lake City, landed a job with the railroad and looked for a home that "wasn't near railroad tracks or under a viaduct." Using his 1936 Ford for collateral, he purchased a $1,200 house by the Jordan River and, barely settled in, quelled a housing petition intended to keep blacks out of his neighborhood.

"I told them, if you want to get rid of me, you could buy me out but you'd have to meet my price. Not another word was said," Browne recalled.

In Salt Lake City, Sheldon Brewster, a Mormon bishop and realtor, brokered a more formidable demand.

In 1939, "Salt Lake City commissioners received a petition [initiated by Brewster] with one thousand signatures asking that blacks living in Salt Lake be restricted to one residential area," historian Ronald Coleman wrote in Helen Zeese Papanikolas's book *Peoples of Utah.*

"This area would be located away from the City and County building [so] visitors would not come in contact with a sizeable number of blacks."

Brewster even hired a local black resident to pitch lots in a designated neighborhood closer to the stockyards of North Salt Lake, but no one in the black community was buying.

"Blacks rose up in indignation and marched to the Capitol to protest Brewster's action," Coleman wrote. "When the petition failed to get the approval of the commissioners, a restrictive covenant policy was used to limit black opportunities in housing."

Browne recalls seeing the white-only covenant embedded in a real estate contract when he sought to buy a house in the Canyon Rim area.

"Tolerating what they called 'undesirables' already here, they were not encouraging any more to come," he said.

"I never noticed any restrictions when we bought our first home," he said. "But in closing on our next house…I saw the clause. I wouldn't sign the contract until it was stricken from the page."

Although restrictive housing prohibitions were ruled unconstitutional in 1948, racism was commonplace and affected every walk of life. Changes were a long time in coming.

In 1946, President Harry S. Truman established a committee to "strengthen and safeguard the rights of the American people," declaring that everyone is "equal and free to be different."

Charged to investigate discrimination against minorities in Utah's industry in 1947, the Senate-approved Selvin Committee reported ethnic groups were denied "equal rights to gainful employment" and advancement.

A veteran porter for the Union Pacific, Browne remembers the inequity of "segregated unions, restaurants, hotels, businesses, and discriminatory passengers" who traveled by rail.

"They'd address us as *Sam, George* or *boy.* I'd tell them my name is Howard. I'd say if you can't say that, call me 'Redcap.'"

Part V

FIGHTING FOR EQUITY

JILL OF ALL TRADES PUSHED EQUALITY IN FRONTIER UTAH

Long before Ellen Brooke Ferguson landed in Utah in 1876, she was imbued with the spirit of the American West and its women who were independent, frank, focused and dedicated to women's rights and family welfare.[20]

Born in Cambridge, England, Ferguson received a comprehensive education at home with private tutoring by university professors only to discover few vocations were open to women.

In 1857, she married Dr. William Ferguson and, an avid pupil, studied medicine. In 1860, before the onset of the Civil War, the Fergusons immigrated to Eaton, Ohio. They purchased a weekly newspaper called the *Eaton Democrat*. Ferguson worked as editor but, as employees left for battle, expanded her responsibilities by furnishing copy and setting type. Taken with politics, she included articles on women's suffrage.

"Knowing that it would probably take years before women would be recognized as the political equals of men, she felt every opportunity of extending woman's influence into politics should be used to the utmost," historian Orson F. Whitney wrote in the 1904 *History of Utah*.

After the war, the couple sold their paper. Although she had no formal medical accreditation, Ferguson skillfully worked alongside her husband.

Elected vice-president of the Northwestern Woman Suffrage Association, she also lectured on the women's rights movement and raised a family.

In 1876, Ferguson learned of her husband's interest in the Utah Territory. They traveled westward, joined the LDS Church and opened their practice in Salt Lake City.

Three years later, Ferguson established the Utah Conservatory of Music above David O. Calder's music store downtown. An 1880 advertisement in the *Salt Lake Herald* recommended the conservatory's "refined, expressive and intelligent interpretations of classical music" and "advanced studies in English, German and Italian singing."

That same year, William Ferguson died. His widow devoted herself to studies in modern medicine. She went to New York, enrolled in hospital clinics and attended classes in obstetrics, gynecology and surgery. Returning home, she developed a plan to build a hospital.

"An institution greatly needed in the community, when the plan was presented to [LDS] President John Taylor and counselors, it was approved by them, and all possible aid given to help put it into practical operation," Whitney wrote.

The Deseret Hospital was dedicated in July 1882. One of President Brigham Young's wives, Eliza R. Snow, was appointed president of the institution. Ferguson was hired as resident physician and surgeon. Patients were charged three dollars a day.

Two years later, Ferguson's name was "dragged through the mud." She was accused of being demanding, dictatorial, incompetent and an "opium eater, drunkard, and thief." The hospital board requested her resignation, but hands of fellowship were finally extended. In 1890, the hospital, burdened with financial debt, was shuttered.

Ferguson was a Democrat and suffragist who defended polygamy. In 1886, she was sent among others to Washington, D.C., to protest the punitive Edmunds Anti-Polygamy Law. She worked on numerous campaigns to see the women's suffrage provision incorporated into the new 1895 Utah Constitution.

On January 4, 1896, Utah, having recanted polygamy, became the forty-fifth state admitted into the Union.

In July, Ferguson was elected alternate to the National Democratic Conference held in Chicago. The 1896 *New York Times* reported, "The fact that Utah sent [a woman] to the convention has provoked much interest, and many opera glasses have been turned upon the tier of seats given over to the Utah delegation."

The paper concluded, "[She] is a quiet little woman who dresses very modestly and conducts herself decorously, but is prepared to discuss finance, tariff, or Jeffersonian Democracy with intelligence."

Following the convention, Ferguson organized and led the Salt Lake Women's Democratic Club, an auxiliary of the County Committee. Fostering the study of the "fundamental principles of government," the club later withdrew as an auxiliary and went forward on its own.

As had Ferguson.

In 1897, the doctor embraced Theosophy. In 1898, she was excommunicated.

"BIG BILL" HAYWOOD: A CAPITALIST'S NIGHTMARE

Part One: "Deadeye Dick"

A youthful scrapper born in Salt Lake City in 1869, William "Big Bill" Haywood grew into a pugilist for the Western Federation of Miners and a founding member and voice of the Industrial Workers of the World (the Wobblies). Haywood organized strikes. He agitated for industrial unionism, fair wages and an end to child labor. He was arrested, often jailed and accused of sedition. In 1917, the *New York Times* vilified him as "the most hated and feared figure in America."[21]

"Big Bill" didn't start life as a radical. His father, Bill Sr., was a Pony Express rider and prospector who, in 1869, heeded the call for industrialized mining. Working away from home for long stretches, the miner returned to celebrate his son's third birthday with a fashionable velvet suit and pants. Shortly after, the miner was working in the Camp Floyd Mining District when he succumbed to pneumonia, leaving his child inconsolable.

In time, the widow Haywood remarried and moved the family to Ophir, a remote mining town in Oquirrh Mountain's East Canyon. While Haywood's stepfather worked in silver mining, young Haywood relished exploring canyon trails, collecting fool's gold and investigating shuttered mineshafts.

Once, when whittling a slingshot, the nine-year-old's knife slipped and injured his right eye. According to author Peter Carlson, in *Roughneck: The Life and Times of Big Bill Haywood*, the boy "spent months lying in a darkened room, waiting for the eye to heal. It never did." Returning to school, Haywood trounced any classmate daring to call him "Deadeye Dick."

Ophir's boom quickly went bust, and the family moved back to Salt Lake City, where Haywood quit school. Indentured to a farmer for six months—a miserable experience that led to a youthful and unsuccessful strike— Haywood next bellhopped at Walker House Hotel and ushered at Salt Lake Theatre, where Oscar Wilde had recently lectured.

Tending a fruit stand in 1883, the fourteen-year-old witnessed a frenzied mob lynch Sam Joe Harvey, a black man accused of murder, and drag his corpse in front of a cheering crowd. Horrified by such depravity, Haywood feared his presence alone might have contributed to the mob murder.

The following year, the youth left home. Boarding a train for Winnemucca, Nevada, he made his way to Eagle Canyon and the Ohio mine where his stepfather, a superintendent, got him a job.

Hard-rock mining was backbreaking, primitive work. But Haywood was taken under the wing of mine assayer John Kane as an apprentice and found camaraderie among the miners. A voracious reader, he followed reports of the 1886 Haymarket Riots in Chicago. He gleaned lessons on class struggle and labor.

When the Ohio mine closed, Haywood remained as a guard. He met and married Nevada Jane Minor, became a homesteader (working the mines to prove up his land) and proudly moved in his family.

Feeling secure while building their future, Haywood received an alarming form letter from the U.S. government in late 1893. Their 160-acre homestead had been repossessed and reassigned to Indian land. No compensation was provided. The family lost everything. Haywood was devastated, angry and broke. Not until 1896 did he regain steady work, and that, too, was short-lived.

Cutting rock deep inside Blaine tunnel in Silver City, Idaho, Haywood was riding an ore car when a large rock hit a vertical chute and upended the car, crushing his right hand.

Twenty-seven-year-old Haywood staved off amputation but learned a miner's lot was transient, work hours were long, wages low, absentee mine owners rampant and safety an inherent issue. From 1880 to 1910, mine explosions, fires, roof collapses, poor ventilation, gases and other accidents claimed thousands of lives.

"If a miner worked ten years in the hard-rock mines of the West," Peter Carlson wrote, "he stood one chance in three of suffering serious injury and one in eight of being killed on the job." Most mine owners offered nothing but pay for a day's work done. There was no health insurance, sick leave pay or workman's compensation.

Unable to work, his fellow miners collected funds to help the family survive. Haywood never forgot their solidarity.

Part Two: One Big Union

Unemployed, with his bandaged hand in a sling, Haywood ventured into the crowded Silver City courthouse on August 8, 1896, to hear thirty-four-year-old Irish immigrant Ed Boyce champion the newly founded Western Federation of Miners.

A radical labor union, WFM was conceived in jail after the 1892 Coeur d'Alene miners' strike turned into a brutal "labor war" with more than six hundred strikers arrested. Industrial unionism, achieved by organizing hard-rock miners and smelter workers, was at its core. Intrigued, Haywood quickly joined.

"All of [our] struggles were for the men underneath, the lower paid men, as we came to learn that when the unskilled worker got a wage upon which he could live decently there was no danger of the skilled men falling below this level," he wrote in *Big Bill Haywood*.

Haywood rose in rank to become an unflagging organizer for WFM. In 1900, he secretly traveled to the Coeur d'Alene mining district, where another strike failed, sounding the death rattle of unions that resulted in martial law and the incarceration of hundreds of men.

"These men [confined] in squalor were fighting my fight," he wrote. "Their lives, the living of their wives and children were in jeopardy. Their appeals to the corporations went unheard. The only answer I could find in my own mind was to organize, to multiply our strength."

Colorado's 1903 Cripple Creek district strikes proved disastrous. At home in Denver, Haywood printed, "Is Colorado in America?" above a "desecrated flag poster." He added protest statements within each stripe, was arrested and irrationally punched a military man. Bludgeoned and bleeding, Haywood was taken to jail, sewn up and given a desk and telephone to conduct union business.

By 1905, Haywood wanted to create a "universal working-class movement" providing equity, he wrote, "for all, regardless of race, color, creed, sex, or previous condition of servitude."

"Haywood blew the breath of life into the most militant, romantic and legendary union in American history—The Industrial Workers of the World," Carlson wrote.

That same year, Haywood was implicated in the murder of ex-governor Frank Steunenberg, who devastated the Coeur d'Alene miners' union in 1899. Opening the front gate at his home, Steunenberg triggered an explosion set by former WFM bodyguard Harry Orchard—an assassin willing to make a deal.

Big Bill Haywood, a powerful union man. *Library of Congress.*

Haywood spent one and a half years in jail, "charged," he wrote "with killing a man I had never seen, in a town I had never been, and was 1,000 miles away at the time of his death."

Taking over his case, renowned attorney Clarence Darrow secured Haywood's acquittal by proving the state's key witness had committed perjury.

Haywood severed ties with WFM in 1908. He traveled countrywide for the IWW and successfully recruited millions of factory, mill and mine workers into "one big union."

"Tall, broad-shouldered and strong, with one dead eye and a black Stetson cowboy hat perched atop his scarred and scowling face," Carlson wrote,

"[by 1917] Haywood seemed the very personification of proletarian rage, a capitalist's nightmare come to life."

In 1918, he and other IWW leaders were convicted of violating the Espionage Act by organizing strikes during wartime. Sentenced to twenty years in Leavenworth, Haywood jumped bail while on appeal in 1921 and fled to Moscow for a hero's welcome.

William Haywood died in 1928. Half of his ashes were buried under the Kremlin Wall; the remaining were sent to a Chicago cemetery and buried near the Haymarket Martyrs Monument.

UTAH'S WORKING WOMEN FOUGHT FOR THEIR RIGHTS

At the turn of the twentieth century, American industrialism brought Utah women out of their homes and into the workplace. Whether on the farm or in the home, western women have always shared labor responsibilities. However, when innovations such as ready-made clothes, commercial laundries, factory-processed foods and industry production of domestic items relieved many of household chores, women found themselves with job opportunities.

"Agriculture and mining dominated the economic life of [Utah]," historian Miriam B. Murphy wrote in *Gainfully Employed Women*, "but manufacturing, retail and wholesale trade, banking and services were growing rapidly. The success of many ventures depended on women."[22]

Women served as teachers, bakers, stenographers, telegraphers, waitresses and midwives. They ran boardinghouses and worked in department stores. Talented, self-employed women became dressmakers, tailors, seamstresses and milliners.

Textile mills, clothing factories and processing plants hired the majority of women. They sewed on the production line, did "light work" in canneries, rolled tobacco leaves in cigar factories, washed and pressed cloth items in commercial laundries and, as a product of the state's thriving sugar beet industry, produced a lot of candy.

Children, as young as twelve, also entered the workforce to help their parents. Single women relied on earning a living wage. Divorced mothers labored to support their children, and married women supplemented their husbands' income.

Some female workers were successful, such as Annie Bywater. Educated in Manchester, England, Bywater purchased material for overalls and jumpers at the ZCMI clothing factory. She supervised one hundred power-driven sewing machines and led the wholesale order department.

"Whether she received compensation comparable to male manufacturing executives is not known," Murphy wrote, "but most female factory workers did not."

In 1900, 13 percent of Utah women worked outside their home, faced wage disparity and endured workplace inequity.

Having secured employment, most women could not afford to stop working yet were perceived as selfish, uncaring of their families and open to sinful temptation. These myths encouraged employers—even the government—to lower their wages and limit their climb up the economic ladder. Female workers also risked being stereotyped by male counterparts and were discouraged from joining male-dominated unions.

"[Women] had to defy ideas that working outside of the home and on behalf of their rights as workers was unwomanly," contributor Mary Reynolds wrote in *Women, Work and Industrialization*. One way was to form unions that permitted women, such as the Chocolate Dippers' Union of Utah No. 1.

On January 21, 1910, the *Salt Lake Telegram* reported, "Declaring they were not paid enough for their work, and considering the high price of living at the present time, a number of girls employed at J.G. McDonald Company requested an advance on wages, as follows: On 1½-cent goods, 2 cents; small box lemon and small box vanilla, 2½ cents."

Later that week, five Chocolate Dippers' Union delegates led by president Sarah Rindfleish met with the Salt Lake Federation of Labor. Endorsing the newly organized union, the federation planned a fundraising dance to assist the striking women seeking a "flat" ten-dollar-per-week salary for eight-hour workdays.

"While they were organizing," Murphy wrote, "girls ages twelve to fifteen who were helpers at the factory replaced the striking women."

In April 1911, two thousand people in Salt Lake City championed for better working conditions by marching in support of striking laundry workers. Described in the Utah Bureau of Immigration, Labor and Statistics 1911 report, the laundry workers—many of them women—struck "principally for a recognition of their union and for a signed agreement respecting a wage scale [and an eight-hour workday] to remain in force for a number of years."

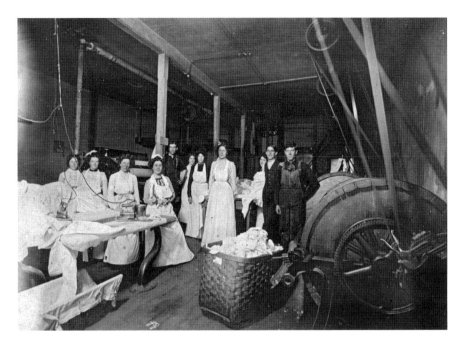

Laundry workers at American Linen, Salt Lake City. *Utah State Historical Society.*

The strike seemingly "died a slow death" until further negotiations led to a settlement and the Laundry Workers' Union was recognized.

Today, there's more work to be done. Hats off to those many wage earners who laid the groundwork for equity.

Unions and Strikes Were Part of Life in Bingham Canyon

In the summer of 1912, labor organizers, "Wobblies" from the Industrial Workers of the World, agitated for industrial unions and equity in the culturally diverse town of Bingham Canyon, where Utah Copper Company was one of the country's leading copper producers. In July 1912, 250 miners signed on to the federation's roster. Within three months, the numbers soared to 2,500. Grievances were many, and according to Utah historian Philip Notarianni, "Strikes became almost a way of life for most workers and company personnel."

The Bingham Strike of 1912 was no exception.

Bingham Canyon had been designated a mining district as early as 1863. In the 1870s, it was a boomtown. When Daniel C. Jackling established Utah Copper Company in 1903 and introduced large-scale, open-pit copper mining, it opened the door to thousands of immigrant workers seeking to improve their future.

In 1910, Utah Copper produced nearly 64 million tons valued at $16 million. By 1912, five thousand workers—including four thousand foreign-born—struggled to survive on their wages.

In "Toil and Rage in a New Land: The Greek Immigrants in Utah," historian Helen Zeese Papanikolas wrote, "The pay scale was $2.00 per day for surface men, $2.50 for muckers (diggers) and $3.00 for miners."[23]

The federation intended to negotiate with mine officials for a fifty-cent daily pay raise for all workers and recognition of their union. Greek miners, who made up the largest number of workers, wanted something else: an end to the *padrone* system and its exploitative labor agent, Leonidas G. Skliris.

Known as the "Czar of Greeks" abroad and in newspaper advertisements, Skliris recruited Greek labor for the mining industry. He usually charged immigrants twenty dollars each to find work and then billed the company one or two dollars a month for each employee hired. That same amount was often deducted from the worker's monthly paycheck.

"They bitterly resented their suave, well-dressed countryman, Skliris, who lived [luxuriously] on the money he extracted from them," Papanikolas wrote. "If they did not trade at [his] Pan Hellenic Grocery Store, he threatened them with discharge."

On September 17, 1912, while most American-born workers stayed away, one thousand immigrant miners crammed into the Bingham Theatre. They listened to federation president Charles W. Moyer address the trials of striking, the uncertainty of winning and the need for more negotiation. They unanimously voted for a walkout.

In a statement made to the *Salt Lake Tribune*, Moyer said he "almost begged them to consult with the mine operators before taking the final vote."

R.C. Gemmell, Utah Copper assistant general manager, countered, "We do not treat with the officers of the union regarding any matters connected with the mines. We do not recognize the federation."

"Now there is nothing to do but await developments," Moyer concluded.

On September 18, the town was shuttered. Floodlights illuminated railroad crossings and mines. National Guard sharpshooters from Fort Douglas in Salt Lake City and twenty-five Salt Lake County deputy sheriffs carrying Winchesters were dispatched to Bingham.

Fully five thousand miners went on strike. Some, carrying blankets and guns, took to the hills.

"With eight hundred foreign strikers armed with rifles and revolvers strongly entrenched in the precipitous mountain ledges across the canyon from the Utah Copper Mine raking the mine workings with a hail of lead at every attempt of railroad employees or deputy sheriffs to enter the grounds, the strike situation has reached its initial crisis," the September 19, 1912 *Salt Lake Tribune* reported.

Governor William Spry called for peaceful solutions.

"Father Vasillios Lambrides, wearing his black robes and *kalimalkion*, climbed the mountain to exhort the men to refrain from violence," Papanikolas wrote. "The Greeks took off their caps to him in respect but became enraged when Utah Copper manager Gemmel steadfastly upheld Skliris."

Strikebreakers, some organized by Skliris, were brought in. The protest endured. On October 31, 1912, Utah Copper increased daily wages by twenty-five cents. Unions went unrecognized. Skliris resigned. The strike died.

WOMEN PLAYED A BIG ROLE IN UTAH'S SOCIALIST PARTY

When the Socialist Party of America was founded in 1901, it built a strong following among trade unionists, reformers, populists, farmers and immigrant communities. At its high point, over the next twenty years, the SPA published newspapers, ran columns in local papers and influenced American politics. It twice supported presidential candidate Eugene V. Debs, elected two members of Congress—socialist journalist Victor Berger and labor lawyer Meyer London—and helped more than one thousand candidates into state and local office.[24]

From the onset in Utah, chapters opened in cities from Logan, Ogden and Salt Lake to Bingham, Sandy, Manti and Eureka. Since the national organization platform supported the voting rights of women, socialism attracted Utah women.

Sympathetic to the "plight of the working class," many female Socialists hoped to achieve "economic democracy" and equal rights with men. They wanted lessons on leadership and policy. And they were willing to work within the largely male-dominated party that, despite the platform's stance on suffrage, maintained a Victorian bias against women.

Others chose to support the organization through separate but allied association. According to historian Mari Jo Buhle, they would then relinquish "political decision-making and participation to their husbands."

When the party pledged full equity and created a Woman's National Committee, membership among Socialist women—housewives, mothers, teachers, journalists, professionals and poets—increased.

"They played roles in the development of the party in Utah," historian John R. Sillito wrote in the 1981 *Utah Historical Quarterly*. Former populist Kate S. Hilliard and professional organizer Ida Crouch-Hazlett served as delegates in the 1901 state organizing convention. Lucy Hoving joined the fray.

A newcomer to Utah in 1888, Hoving converted to the Mormon faith, taught in Ogden's public school system and opened a free kindergarten and instructional school for teachers. After completing a correspondence course offered by the International School of Social Economy, she evolved into a Socialist orator—and apostate.

"Hoving believed Mormon theology taught men they were superior to woman, and any opposition to priesthood authority by church members was blasphemy," Sillito wrote. "The tone of her attack on "priesthood sexism" seems to suggest [she saw] the Socialist party as the true champion of women's equality."

Called an "ardent worker and state organizer," the August 8, 1902 *Ogden Standard* reported her untimely demise. Crossing the street close to her home, Hoving was "struck by the shaft of a low-wheeled 'bike' carriage [and] instantly killed." Her funeral took place at the home of her friend Hilliard.

In 1908, Hilliard addressed Ogden's Congregational church. In her critique, "Why I Belong to No Church," printed in the March 23 *Ogden Standard*, the prominent leader claimed any church "as a whole is either silent or against efforts of the working class to free itself from wage slavery."

The majority of Utah's early Socialist women, however, represented a broad spectrum of diverse religious, economic and cultural diversity offering few if any impediments to working with one another or moving forward.

Eureka's eclectic Socialist Ladies Club organized soirees for cards, conversations and repasts. They advocated education, espoused electoral politics, pursued the votes of women and were influential in the women's auxiliary of the miners' union. They supported a series of lectures. In one, Mother Jones spoke about unionizing miners; in another, Coloradan Luella Twining delivered on the perils of capitalism and the emancipation of the working class.

In 1910, Socialist Olivia McHugh of Murray ran for superintendent of public instruction, a position considered the "bastion" of men. Fully qualified, she lost the vote but not her zeal. In 1915, McHugh helped create the Utah Women's Peace Party and shared her views.

Joined by others committed to equal rights and opposed to capital punishment, Virginia Snow Stephen, the daughter of LDS president Lorenzo Snow, advocated for labor activist and songwriter Joe Hill, accused of murder. Convinced of his innocence throughout his trial and martyrdom, the true Socialist spoke in his defense.

UTAH WOMEN WERE ON THE FRONT LINES OF SUFFRAGE BATTLES

Forty-one National Women's Party members picketed outside the front gates of the White House on November 10, 1917, demanding Congress pass the national suffrage amendment enfranchising women.

Called the "Silent Sentinels for Liberty," these women of protest included R.B. (Minnie) Quay and C.T. Robertson of Utah. They wore gold, white and purple tri-colored sashes and brandished oversized banners and placards that read, "Mr. President, How Long Must Women Wait for Liberty?"

By nightfall, they were arrested—for obstructing traffic.

The NWP was the militant wing of the suffragist movement guided by firebrands Alice Paul and Lucy Burns. According to Library of Congress records,

Mrs. R.B. Quay, of Salt Lake City, Utah, was one of the members of the National Women's Party who served a thirty-day sentence at the government jail for picketing the White House gates. *Library of Congress, NWP.*

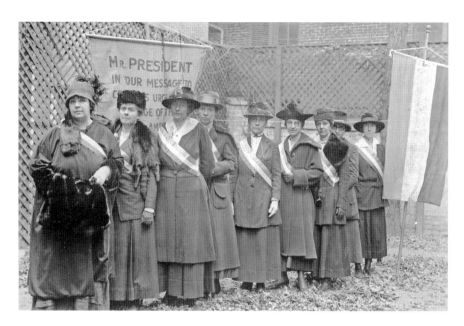

Suffragists on the picket line, November 10, 1917. *Left to right*: Mrs. Catherine Martinette, Eagle Grove, Iowa; Mrs. William Kent, Kentfield, California; Miss Mary Bartlett Dixon, Easton, Maryland; Mrs. C.T. Robertson, Salt Lake City, Utah; Miss Cora Week, New York City; Miss Amy Ju[e]ngling, Buffalo, New York; Miss Hattie Kruger, Buffalo, New York; Miss Belle Sheinberg, New York City; Miss Julia Emory, Baltimore, Maryland. *Library of Congress, NWP.*

Firebrand Alice Paul was jailed and forcibly fed. *Library of Congress, NWP.*

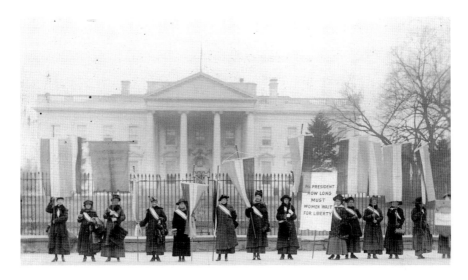

Suffragists on the picket line, 1917. *Library of Congress.*

NWP sought equity by picketing, petitioning, marching and, if necessary, going to jail.[25]

They had been protesting with impunity for several months when, in March 1917, more than one thousand women suffragists marched around the White House during President Wilson's second inauguration. Eventually, the picketers ran into trouble.

In June, Burns and fellow suffragist Katherine Morey were arrested for displaying a banner printed with Wilson's war message: "We shall fight for the things which we have always held nearest our hearts—for democracy, for the right of those who submit to authority to have a voice in their own governments."

Soon after, the first 6 of 168 picketers were jailed. Those still on the line were assaulted by mobs, including servicemen. Arrests became commonplace.

Paul, charged in October, was given a seven-month sentence. She insisted on political prisoner status to no avail. Abusively bullied, she began a hunger strike, was put into a "psychopathic" room and was forcibly fed with tubes until she vomited.

The November 10 incarceration of these suffragists from California to Maine sparked public attention—but prison officials remained mum, and lawyers were denied access.

In a 1917 *Salt Lake Tribune* article, Quay wrote, "Every woman [was] prepared to die for the cause, if necessary."

The article described forty-nine-year-old Quay as "quite a scrapper [who] dared policemen and an Army officer to wrench a suffragist banner from her hand before the White House gates."

Unwilling to pay fines, seeing it as an admission of guilt, and refusing bail, some picketers were sent to the district jail. Most were transported to the Occoquan Workhouse in Virginia. There, on November 15, they endured what has become known as the "Night of Terror."

The notorious workhouse superintendent, W.W. Whittaker, allowed his men to beat, punch and choke the women.

In *Jailed for Freedom*, author and former suffragist prisoner Doris Stevens recorded how frail Dorothy Day was "lifted and violently banged into the arm of an iron bench." Miss Lincoln was thrown to the ground. Mary Nolan, seventy-three, was "jerked" off her feet. Mrs. Cosu, pushed by guards, "struck the wall."

In a December 1917 *Salt Lake Tribune* article, Quay stated, "We were dragged across a dark courtyard by a mob of men and thrown into dungeons—punishment cells. Across the hall was Lucy Burns, whose hands were pulled through the bars and handcuffed high above her head. Another girl had been so mistreated I thought she would die. Many times in the night I arose to see if she was living."

Mrs. Robertson collapsed and was taken to the workhouse hospital. A November 25, 1917 *Salt Lake Tribune* special edition reported that her breakdown was "believed to be due to lack of nourishment."

The article noted that Quay was "decidedly haggard and has lost considerable weight…due to her participation in the hunger strike."

Stevens wrote that suffragists joining Paul's hunger strike were placed in solitary confinement. Sickly, pale and abused, they endured, believing in their constitutional right to protest. Letters, smuggled out, incited public outcry. Finally, a court-ordered hearing exposed the horrific events. On November 27–28, the suffragists were released.

"Would I go there again?" Quay asked. "Yes, many times, yes, just as often as my services are needed."

The NWP persisted. On August 26, 1920, the Nineteenth Amendment became law.

Postscript from Sewall-Belmont House & Museum

For the last two hundred years, the Sewall-Belmont House has stood strong on Capitol Hill keeping watch as the United States government rose

around it. In 1929, the National Women's Party purchased the house as its headquarters, rededicated as the Alva Belmont House, and it soon evolved into a center for feminist education and social change. For over eighty years, the NWP utilized the strategic location of the house to lobby Congress for the Equal Rights Amendment and become the leading advocate for women's political, social and economic equality.

Today, the Sewall-Belmont House & Museum tells the stories of Alice Paul, Doris Stevens and the community of women who dedicated their lives to the fight for women's rights. The innovative tactics and strategies they created became the blueprint for women's progress throughout the twentieth century.

Part VI

THE POLITICS
OF CHANGE

BASKIN FOUGHT THE FUSION OF
CHURCH AND STATE IN UTAH

In the 1860s, growing numbers of non-Mormons arriving in the Utah Territory posed a threat to Mormon autonomy. Retaliating against this new population they believed amoral, and to safeguard temporal unity among Mormon people, LDS church leaders adopted a resolution pledging its members be self-sustaining. By 1866, the ensuing acrimony between Gentiles and Mormons reached such heights that Gentiles feared for their safety and their lives, as late nineteenth-century attorney Robert Newton Baskin quickly discovered.[26]

Born in 1837, raised Protestant and educated in law, Baskin stopped in the Utah Territory in 1865 en route to California. He toured Alta's silver and gold mines, saw mining's potential and decided to settle in Salt Lake City and open a law office.

According to Baskin's memoirs, *Reminiscences of Early Utah*, an early client was Dr. John King Robinson, retired assistant-surgeon with the California volunteers and a non-Mormon married to the daughter of former Mormon apostate John Kay.

Robinson planned to build a public hospital on vacant land near Warm Springs at the north edge of Salt Lake City. Shortly after constructing a small workshop, "a police force tore it down and warned

the doctor it would not be healthy for him to renew his operations there," Baskin wrote.

Although non-Mormon friends feared reprisal and advised him against seeking counsel, Robinson met with the attorney to recover damages and sue for the land.

"I did not believe it possible anywhere in the United States that a citizen would jeopardize his life by applying to the courts for an adjudication in any case," Baskin wrote.

But he underestimated the risk.

Several weeks later, on October 22, 1866, Robinson was called out at midnight to assist a severely injured man. The doctor was assassinated on the corner of Main Street and 300 South.

Nearly twenty-five years later, an article in the November 5, 1893 *Salt Lake Tribune* recalled, "Baskin took a solemn oath over the bier of his dead friend that the remainder of his life should be dedicated to the purpose of bringing his murderers to justice."

The killers were never identified or brought to trial, but courageously, Baskin did devote his life to helping develop Utah's future. He scrutinized the territory's law, its theocratic society and the challenges of petitioning for statehood.

Baskin was an active Mason and Liberal Party leader, and his associates were "a tight band of non-Mormons mostly Civil War veterans and federal civil service appointees, dubbed by the Mormon leaders as the conspiring 'Utah Ring,'" historian John Gary Maxwell wrote in *Robert Newton Baskin and the Making of Modern Utah*.

Far from being clandestine, Baskin's group openly opposed polygamy and, Maxwell wrote, "the entrenched government that fused church and state."

Baskin was measured among the most hated Gentiles of Utah. Apostle George Q. Cannon thought him "a cruel and unrelenting enemy." Joseph F. Smith prayed he would be "made blind, deaf and dumb unless he would repent his wickedness." LDS historian Orson Ferguson Whitney described him as the "human mainspring of nearly every anti-Mormon movement that Utah has known."

Baskin wrote the anti-polygamy Cullom Bill of 1870. He became the "dominant force in Washington," Maxwell wrote, "that placed the LDS Church upon the procrustean bed of the [1882] Edmunds Act and the Edmunds-Tucker Act with dissolution of the incorporation of the church and seizure of its assets and property."

Despite enmity, Baskin's efforts helped the territory qualify for statehood by abandoning polygamy. Twice elected Salt Lake City mayor, Baskin

improved the city's infrastructure, supported construction of the Salt Lake City and County Building and practiced equitable employment. He served in the Utah legislature, championed for public education and civil rights and ultimately was elected chief justice of the Utah Supreme Court.

On August 25, 1918, Baskin died and was buried in an unmarked grave in Mt. Olivet Cemetery. On July 30, 2014, he was remembered with a proper headstone and the honor he so richly deserves.

WHEN PARLEY CHRISTENSEN STEPPED INTO THE LEFT-LEANING LIMELIGHT

After days of political brouhaha at the National Convention of the Farmer-Labor Party in Chicago in July 1920, a little-known maverick from Utah named Parley Parker Christensen stepped into the left-leaning limelight as the newly organized party's swing vote for the nominee for president of the United States.

The FLP movement engendered social reform, promoted relief from farmers' price imbalance and trade wage inequity and advocated for "democratic control of industry," including railroads, utilities, natural resources and the right to strike. Members came from nineteen diverse agrarian organizations, including League of Women Voters, Veterans Association, NAACP, Triple Alliance and Socialists.[27]

Held in a poorly ventilated conference center, the assemblage often unraveled into a hurly-burly hotbed of disparate issues.

According to Gaylon Caldwell's *Utah's First Presidential Candidate*, Christensen was selected to be the convention's permanent chairman to restore order. Introduced as "one of the defenders" of the Industrial Workers of the World (Wobblies), he received a standing ovation and exercised a hammer instead of a gavel with "such determination and vigor," Caldwell wrote. "He could not have known it [then] he was pounding his way to the nomination."

Christensen was born in 1869 in Weston, Idaho, but grew up across the state line in Newton, Utah, where his father drove freight wagons cross-country from the recently completed Transcontinental Railroad terminus into remote parts of Idaho, Montana and the Dakotas. Graduating from the University of Deseret in 1890, Christensen taught school in Murray and Grantsville and was elected superintendent of the Tooele County schools.

He then earned a law degree at Cornell University, set up office in downtown Salt Lake City and took on politics.

A bachelor, Unitarian and member of the Independent Order of Odd Fellows, Christensen was elected twice as Salt Lake County attorney. He served as chairman for Utah's Republican Party and three times unsuccessfully sought the party's nomination for Congress. By 1912, disillusioned by their rejections of his reforms, he made an abrupt political turn. He joined the Utah Progressive Party and served one year in the U.S. House of Representatives.

"Between 1915 and 1920, Christensen became [increasingly] involved with various left-wing and labor groups in Utah," historian John R. Sillito wrote in the *Utah History Encyclopedia*. He helped pull together the Utah Labor Party in 1919, defended several radicals jailed at Fort Douglas for opposing America's involvement in World War I and was president of the Popular Government League advocating for Initiative and Referendum in Utah.

With the minor party's endorsements, Christensen campaigned against Ohio governor James Cox, a Democrat and Progressive reformer, and Republican senator Warren G. Harding, whose slogan-rich speeches included provisos such as "America's present need is not heroics but healing; not nostrums but normalcy; not revolution but restoration" and "not the dramatic but the dispassionate."

Although Christensen started late in his presidential run, the six-foot-four, 260-pound politician known for wearing crisp, white linen suits was surprisingly light on his feet.

"Mr. Christensen seems to have an especial delight in whacking the Republicans over their head," Charles Willis Thompson wrote in the August 1, 1920 *New York Times*.

"When he's not making speeches or writing telegrams, he is making statements and the moment Senator Harding's speech of acceptance has been made, Christensen sprang to the typewriter with a statement that the 'venerable oration was bunk.'"

To reach the masses, Christensen pledged a 24/7 open campaign. "Compared with him, Harding is as idle as [the incarcerated Eugene V.] Debs, and Cox is a slowpoke," Thompson concluded.

Harding won. Christensen, garnering more than 265,000 votes from nineteen states, moved on politically and out of state.

Trailblazer Reva Beck Bosone Goes to Washington

Part One: Going Where Laws Are Made

Utah native Zilpha Chipman Beck advised, "If you want to do good, you go where the laws are made because a country is no better than its laws." Her daughter Reva took her words to heart and put them into action.

Born in American Fork on April 2, 1895, Reva Beck Bosone was a Democrat, a trailblazer some would call a firebrand and others an inspiration.[28]

Among the first female attorneys in Utah (1930), Bosone served twice as a member of the Utah House of Representatives (1932, 1934) and rose to the post of majority floor leader. She helped obtain passage for the women and children's wage and hour law. In 1936, she became the first woman elected to a judgeship in Salt Lake City and served three terms. By 1948, she was sent to Congress out of Utah's Second District. Nearing the end of her political career, she was appointed chief judicial officer for the United States Postal Service.

Bosone's parents, Christian and Zilpha Beck, owned and managed American Fork's Grant Hotel (referred to as Mrs. Beck's), a livery stable and the Pioneer Opera House. Engaging nationally renowned theatrical companies, the house was equipped with an adjustable floor that rose to accommodate dancing or lowered to seat an orchestra.

According to author Beverly Beck Clopton, in *Her Honor, the Judge*, the Becks were of Mormon stock. Early on, though, Zilpha left the church and did not have her children baptized. Instead, she encouraged them to attend any church of their choice that emphasized moral values.

Mrs. Beck stressed also the importance of education for both genders—"too many women have to make their own way and rear children who are not prepared to do so," she was known to say—and championed women's abilities.

Growing up with three brothers who shared in such equity, Bosone later declared, "Generally speaking, men who refuse to recognize a qualified woman on their staff or as their opponent or in public office suffer from an inferiority complex. Show me an intelligent man and I'll show you a fair-minded one."

Tall, with blazing red hair, green eyes and a face framed in freckles, Bosone was spirited and dramatic. At age twelve, she filled in for one of the leads performing at the opera house in *Pygmalion*. She memorized

"Her Honor, the Judge," Reva Beck Bosone. *Special Collections, Marriott Library, University of Utah.*

her lines and stunned the audience with a performance that sparked theatrical opportunities.

"Nine years later, Reva lost her faculty for quick memorization," Clopton wrote, "influencing her choice of another career." Jumping forward, Bosone would revisit the spotlight. During a 1940s weekly KDYL-Radio broadcast, called *Her Honor, the Judge*, Bosone offered case studies and personal philosophies on human conduct.

In a 1952 televised program, *It's a Woman's World*, she focused on contemporary issues, receiving critical acclaim and increased sponsorship, along with a fair amount of grumbling. No sooner debuted, Republican women held meetings to strategize how to sway sponsors and kill the program.

In 1917, twenty-two-year-old Bosone graduated from Westminster Junior College and in 1919 from the University of California at Berkeley. Following a seven-year stint teaching high school debate, oratory and drama classes, she charted a new course by enrolling in the University of Utah College of Law, which was then the bastion of men.

There, Reva became one of two women to graduate and the third woman admitted to the Utah State Bar. And there, she fell in love and married fellow

An advocate for youth, Reva Beck Bosone conducts a KDYL interview in prison. *Special Collections, Marriott Library, University of Utah.*

law student Joseph Bosone, the son of Italian immigrants from the mining town of Helper.

Welcomed wholeheartedly by in-laws, and embracing the Italian culture, the newlyweds moved to Helper; hung their law shingle; had a daughter, Zilpha; and braced themselves for the future.

"The biggest need in politics and government today is for people of integrity and courage, who will do what they believe is right and not worry about the political consequences to themselves," Bosone said. She would know.

Part Two: A Woman's Place

Utah's Reva Beck Bosone came from a long family line of Republicans but bolted from the GOP in 1932. "Perhaps life would have been easier for me had I become a Republican," she said in Clopton's *Her Honor, the Judge*. "But I couldn't do it and be honest."

Growing up around a dinner table infused with broad political views, Bosone was deeply influenced by Utah coal miners and their precarious role during the Great Depression. "To be true to myself," she said, "there was only one other thing to do: be a Democrat!"

The unconventional go-getter and two-term member of the Utah House of Representatives addressed not only disparity among female workers but also worked to revise antiquated laws regarding labor, unemployment insurance and taxes.

"If you're a fair-minded person, you have to be for equality," Bosone said in a 1977 KUTV documentary. "Not only fair to the women but fair to the men because the men have had a bad deal in this life, too."

In the January 1, 1935 issue of the *Salt Lake Telegram*, Bosone helped pave the way for progressive legislation.

"An amendment to the state constitution under which the Legislature is given the right to pass laws for the benefit of all employees is directly credited to her," the paper reported.

When Bosone was elected to a judgeship in Salt Lake City the next year, the *Telegram* described her arriving at police court wearing a "russet brown dress with an orange neckpiece," carrying a brown purse and replacing "her shell-rimmed glasses in favor of rimless spectacles."

"A lot of people say [police court] is not a place for women," Bosone said in a 1936 interview with the paper. "But I think a woman is peculiarly fitted to preside there. I hope to be fair and impartial and let facts be the judge."

Serving three terms in traffic court and the criminal division, Judge Bosone leveled stiff fines to traffic violators and had a role in improving the city's traffic-safety record. Her approach to alcoholism as a disease emphasized the benefits of Alcoholics Anonymous and led to a government program for rehabilitation. In 1947, she became the first director of the Utah State Board for Education on Alcoholism.

In 1948, Bosone ran for Congress as a "Fair Deal" Democrat and campaigned with President Harry S. Truman during his "whistle stop tour" through Utah. Supported mostly by women's organizations, Bosone never asked for large donations.

"I didn't want to be indebted to anyone, even subconsciously," she recalled in Clopton's book.

Challenging the one-term incumbent Republican representative from Layton, Bosone personally spent $1,250 on her campaign and won to become the first woman to represent Utah in Congress (1949–51).

In another first, Bosone was appointed to the Interior and Insular Affairs Committee. She introduced a bill to grant American Indians "control and management" of their own affairs (it failed to pass) and promoted initiatives on reclamation and water and land conservation. She supported expanded coverage in Social Security, national healthcare and public housing for the military.

"We must abide by laws and when we think some are wrong, seek to change them—by law," the congresswoman said.

In 1949, according to U.S. House of Representatives archives, Bosone was among four who opposed the "Central Intelligence Agency (CIA) Act on the grounds it invested too much power in an agency that operated under minimal congressional oversight."

It bit her. Running against William A. Dawson again in 1952, Bosone was accused by her opponent of being a Communist sympathizer. She lost the election—but not her integrity or courage.

In 1961, the Utah woman who said, "There isn't a darn bit of difference between men and women except for biological differences," became the judicial officer of the U.S. Post Office and carried on.

Part VII

ARCHITECTURAL BONES

SANDY'S OLD MANSIONS ARE MONUMENTS TO EARLIER TIMES

Just when you think you can never go home again, it's time to pay a visit to Sandy City's historic district; glean the industrial endeavors that put Sandy, Utah, on the map; and explore the landmarks and notable designations of its diverse past.[29]

Located in high desert atop prehistoric Lake Bonneville's delta, Old Sandy was a farming community settled by Mormons in the early 1860s. By 1870, mining booms and the arrival of the railroad displaced agriculture, phased out the Pony Express and blazed an emigrant trail for Utah's ethnic population with a promise of employment.

On one square mile sequestered between State Street and 700 East, 8400 (Pioneer Avenue) and 9000 South Streets, the town's population grew from one thousand to five thousand during the 1880s, by virtue of large numbers of Scandinavians and a modicum of Italians and Greeks.

In its heyday, carloads of rich ore from Bingham and Little Cottonwood Canyon mines traveled down steep mountains on narrow-gauge rails toward Sandy's productive smelters and sampling mills. Dubbed the "railroad junction" for all mining town railroads, Utah Central Railroad built the town's station house, freight and passenger depot and eatery.

Employing 500 to 1,200 laborers, the Mingo Smelter became Utah's largest producer of gold, silver and lead. Its neighboring Flagstaff Smelter introduced a one-of-a-kind technique that used hot air instead of cold to purify silver and lead. Farther east, Pioneer Sampling Mill coursed ore through rollers and crushers to assay metal content before shipping their product to the West Coast en route to Europe.

For years, Sandy was a picture-perfect mining town with numerous saloons—including the "Damifino"—two barbershops, a blacksmith, a tinsmith, a mercantile, a social hall, a funeral parlor, a café, a hitching post and a watering trough.

By 1881, students purchased their own books, slates and chalk and paid fifty cents a month to attend the town's first wood-frame schoolhouse.

On Main Street, Jensen and Kuhre Lumber and Hardware Co. boasted the latest in "hardware, wagons, and implements." Bateman's Hay and Feed Company fed, watered and tethered teams of horses between ore runs from Alta to Sandy.

Every year, the sampling mill was decorated for the highly anticipated Annual Masked Ball and on weekends held dances. From Salt Lake City, couples traveled by train to attend.

Arthur J. Cushing, the mill's night manager and Sandy's first mayor, promoted Utah's mineral exhibit at the 1893 Chicago World's Fair. His wife, renowned for her meat pies and plum pudding, was an expert quilt maker. Their Victorian home on Pioneer Avenue stands trim today as it did in 1893.

According to the *Walking Tour of Historic Sandy*, "Mr. Cushing was very fussy about his home and especially his yard. It was not unusual for him to pay his grandsons fifteen cents to clean the entire yard, making certain not one leaf was out of place."

The impressive 1890 Victorian-style Kuhre home, on the National Register, represents Sandy's only two-story, four-square style structure with exposed, rounded rafters supporting the iron rail-topped roof's broad overhang.

On Main Street, overland freighter and merchant Ezekiel Holman built Sandy's first mansion earlier in 1888. The two-story Victorian-eclectic home was clad in hardwood floors, beaded oak columns and stairway. Hand-hewn double-sliding oak doors separated his wife's music room from the rest of the house.

Purchasing the home in 1910, Dr. Robert Born set up practice in the conservatory. Lerona Carpenter, who was "named after a lady who died and came back," told me she would never forget Dr. Born lancing an infected finger in "the elaborate music room with the beautiful wood carving."

The smelters and mills are gone. TRAX has replaced the trains. Tree-lined parks escort the light rail system through town. New streetlights brighten Main Street. The Kuhre house is a bed and breakfast, and talk of revitalization is in the air.

But community memory doesn't waver. History has roots. Going home is a good thing—even when it's not your own.

HOME TELLS THE TALE OF A WESTERN BUILDER

In Ogden's historic district, a grand house on Eccles Avenue, affectionately called "Watermelon Park," gives rise to the accomplishments of Edmund Orson Wattis Jr., a venerable builder of the American West.

The Wattis story goes back to early 1849, when eighteen-year-old Edmund Wattis Sr. left Omaha, Nebraska, to seek his fortune in the California gold rush. It didn't take long for him to be homeward bound. He headed northeast when a stopover in the Utah Territory hamlet of Uintah gave him pause. An agricultural town, he settled in, married Mary Jane Corey and built the family's farm.

Edmund Jr., born in 1855, was the second child of seven. Family lore has it that as soon as he could walk he pitched in doing chores. At twelve, he earned fifteen dollars a month driving oxen for the Union Pacific. By age twenty-one, he graded rail beds for the Colorado Midland Railway, the first standard gauge railroad to cross the Continental Divide. Collaborating with his father and brother William, they freighted goods from Kelton, Utah, into Central Idaho toward the northern markets of Montana and Oregon.

When he was twenty-four, Edmund married Martha Ann Bybee and moved to Ogden. They raised a family of eight. All the while, Edmund set sights on western expansion, track by track. In the early 1880s, he and William formed the firm Wattis Brothers and went full speed ahead—until they ran smack into the Panic of 1893.

Instead of economic prosperity, a full-blown nationwide depression triggered by the proliferation of railroads, risky financing and an over-flooded silver market set off a series of bank failures and shuttered businesses. Nearly 19 percent of America's workforce was left idle.

Edmund worked the brothers' sheep ranch in Weber Valley and saved money; William made new contacts. In 1900, they were at it again. With

Western home gives rise to accomplishments of Edmund Wattis. *Special Collections, Stewart Library, Weber State University.*

Edmund at the helm, they founded the Utah Construction Company and landed a $60 million contract to build the Western Pacific Railroad from Salt Lake City through Feather River Canyon to Oakland, California. For five years, they built spindly looking track bridges on narrow rock ledges, picked, graded and tunneled. After 942 miles, they became one of the largest contracting firms in the West.

When the railroad boom subsided, the brothers diversified. They built dams, traversing the region with projects such as the controversial Hetch Hetchy (O'Shaughnessy) Dam in Yosemite National Park that supplied San Francisco's culinary water, the Deadwood Dam in Montana, the American Falls in Idaho and the Guernsey in Wyoming.

Meanwhile, in 1914, Edmund contracted local architect Eber Piers to build his Ogden prairie-style home with low horizontal lines, overhanging eaves and open interior spaces.

"Piers imbued the house with a vernacular flare using variegated colors of red iron-oxide brick, sculptural horizontality of brick coursing, and the

contrast of material and tone between darker brick and roughly textured stucco," explained Steven Cornell of CRSA, an architectural firm in Salt Lake City.[30]

Its appearance with cascades of windows, leaded glass and woodwork was one of "pleasure, unity, and taste." Four daughters were married in this house and garden. Grandchildren reigned. A family man often away on business, Edmund would later regale them with astounding tales. In 1931, it was a whopper.

Spearheading the formation of Six Companies, composed of the industry's hard-hitting elite, Utah Construction joined forces to build the massive Hoover Dam spanning the Colorado River. At 725 feet high, 1,244 feet long and containing more than four million cubic yards of concrete, it was the U.S. government's largest construction project of its time. But Edmund did not live to see its 1935 dedication. A year before, he died at home.

In 1944, the Wattis house was sold. Sixty years later, it came home. Purchased by four descendants, the family gathering place on Watermelon Park has been modernized in restoration and remains resplendent in its past.

Elegant Boston, Newhouse Buildings Were First Skyscrapers in Beehive State

When you look up at the Boston and Newhouse Buildings on Exchange Place just off Main Street between 300 and 400 South Streets, there's more than meets the eye.[31]

In 1910, these Beaux-Arts twin structures were considered Utah's first skyscrapers. Financed by one of the state's wealthiest mining magnates, Samuel Newhouse, their presence represented the historical polarization between the north-end (Mormon) and south-end (non-Mormon) businesses that formed separate commercial districts within downtown Salt Lake City—and Newhouse's determination to create a "Wall Street" in the West.

Son of Russian-Jewish immigrants, Newhouse left an unsuccessful law practice in Pennsylvania and went westward in the early 1880s in search of opportunity. He landed in Leadville, Colorado; met and married sixteen-year-old Ida Stingley; and purchased a hotel. When Ida nursed an ailing English guest back to health, the grateful gentleman became Samuel's friend and financial backer.

The Boston and Newhouse Buildings—Utah's first skyscrapers. *Utah State Historical Society.*

Newhouse was a flamboyant promoter and speculator. He developed contacts on the East Coast, in England and in France. He hired a tutor to educate his wife in the manner of European high society. After acquiring numerous mines in Ouray, Colorado—and selling them later for millions—the couple moved to Denver to further his entrepreneurial leanings.

By 1896, he had turned his attention to Utah.

From the Highland Boy mine in Bingham Canyon to the copper smelter in Murray, Newhouse's acquisitions and partnerships grew into multi-million-dollar investments. In 1905, he bought the Cactus Silver Mine and mill in the San Francisco Mountains of Beaver Canyon. He then spent more than $2 million to rebuild the nearby mining town, called Newhouse, replete with cottages, homes, boardinghouses, stores, restaurants, a hospital, a school, a park, a livery, a hotel, a dance hall and the "Cactus Club."

Newhouse hobnobbed with British royalty. He was involved in the creation of New York City's first steel-frame skyscraper, the Flat Iron Building, and gained and lost mineral rights in China.

He owned Long Island and London estates, a chateau in France and an extravagant home on South Temple in Salt Lake City flush with opulent Persian carpets, Italian marble floors, velvet upholsteries, copper railings, stained-glass windows, silk tapestries and an underground men's sitting room stocked with 1,400 bottles of wine and imported liquors.

In 1906, Newhouse hired well-known Chicago/New York architect Henry Ives Cobb (a relative of outspoken Utah suffragist Charlotte Cobb Ives Godbe) and in 1907 began construction of the Boston and Newhouse Buildings.

Each stone-faced, fireproof building was steel framed with rounded corners and eleven stories and divided into three horizontal sections emphasizing the "main floors, vertical office floors, and a massive cornice which imitates the base, shaft and capital of a classical column."

Distinctive though similar in style, a dentil band of cartouches (coat-of-arms shields) spreads beneath the second-story cornice of the Boston Building and was replicated below the building's cornice along the top. Other ornamentation included elaborate lion head stonework.

The Newhouse Building gleamed with a copper-plated door and window trim. Stone pairs of cornucopias, agricultural and industrial symbols and an enormous buffalo headstone were fixed in place. The interiors were drenched in fine woodwork, terrazzo floors, marble stairs, floor-to-ceiling handcrafted mosaic tiles and extensive glass.

Newhouse developed thirty other properties, including the Newhouse Hotel. He donated Exchange Place land for the sumptuous Commercial Club building and the Salt Lake Stock Exchange, where Utah's stockholders, bankers and mining kings held business, traded and negotiated. His plans were to build up the south-end commercial district.

Shortly before World War I, Newhouse's financial fortunes unraveled. Unable to obtain domestic or foreign loans, he went bankrupt.

In 1914, the Newhouses' marriage also dissolved. Ida, who had spent much time in Europe, eventually moved to the Beverly Hills Hotel in California. Relying on the charity of friends, in 1937, she died penniless.

Newhouse lived with his sister in their French chateau. He continued in the world of finance but could not recoup his staggering losses. He died in 1930, his legacy to Utah standing tall.

DESPITE GHOSTS, OGDEN'S BEN LOMOND REMAINS THE GRAND DAME OF UTAH HOTELS

When the Central Pacific and Union Pacific Railroads drove the last spike at Promontory, Utah, on May 10, 1869, they connected East to West and put Ogden on the map as a bustling metropolis.

One of the state's early "grand ladies," Ben Lomond Hotel, Ogden, Utah. *Special Collections, Stewart Library, Weber State University.*

Called "Junction City" for its extensive network of railroads and short lines, the former farming community was a hub of trade teeming with agricultural, livestock and industrial activity. It also was home to one of the state's earliest skyscrapers.

"Among the 'three grand ladies' built during the state's heyday, Ogden's Bigelow/Ben Lomond Hotel is the only one still operating as a hotel," said Sarah Langsdon, Weber State University Special Collections curator.

In Salt Lake City, a second grand dame, the Hotel Utah, was shuttered in 1987 and later converted to offices and meeting space for the Church of Jesus Christ of Latter-day Saints. In 1983, demolition charges razed to rubble the third: the Newhouse Hotel.

The Bigelow/Ben Lomond Hotel began its history as a five-story brick and stone structure called the Reed Hotel. Built in 1891 on the corner of Ogden's Twenty-fifth Street and Washington Boulevard, it was run by two Missouri hoteliers and catered to businessmen and tourists. In 1916, shops and the Ogden State Bank, owned by H.C. and A.P. Bigelow, occupied

A dinner party for the Southern Pacific Railroad Old Timers Club, 1947, at the Ben Lomond Hotel. *Special Collections, Stewart Library, Weber State University.*

the ground floor. Expansive windows in the fifth-floor dining room offered panoramic vistas of the Wasatch Range and the Great Salt Lake.

In 1926, A.P. Bigelow purchased the old Reed and with three hundred stockholders constructed a "community-backed" luxury hotel from the ground up. Designed in the Italian Renaissance Revival style by the Salt Lake/Ogden architectural firm Hodgson and McClenahan, the renamed Bigelow was made fireproof, modernized and dressed up to illuminate Ogden's symbol of prosperity.

An eight-story L-shaped tower featuring ornamental terra cotta was constructed for 350 well-appointed guest rooms. Exquisite antique chandeliers hung from the ceiling. Its dining room accommodated one thousand guests.

The coffee shop reflected Arabian themes. The ballroom was gilded like a Florentine palace. The businessman's club offered a glimpse of Old Spain. Dark wood paneling in the English Room waxed nostalgically of Britain's Bromley Castle. Murals by Utah artist LeConte Stewart paid homage to

Ghosts, cigars and candy stand at Ben Lomond Hotel, Ogden. *Spevcial Collections, Stewart Library, Weber State University.*

Macbeth in the Shakespeare Room, and neoclassical interior designs defined the Georgian Room in the sumptuously detailed mezzanine.

In 1933, Marriner S. Eccles purchased the hotel and changed its name to Ben Lomond. Although it changed hands often, Ben Lomond remained a hotel for some forty years, was briefly repurposed and then restored.

With Ogden's boom-and-bust past, the hotel's eclectic style and sheer volume of guests, Bigelow/Ben Lomond was fodder for tales.

Some say Ogden's infamous system of underground tunnels created under Twenty-fifth Street's sidewalks went from Union Station to the hotel's basement and that during Prohibition, alcohol, gambling and prostitution were easily accessible. Langsdon and others question the feasibility of an underground tunnel making it across the street without collapsing.

"It's a good story, and tunnels do exist between the hotel's three basements," she told me, "but I doubt they went beyond that."

Tales about ghosts are a different matter, according to Langsdon.

"There was a story about a Mrs. Eccles who was living in the hotel waiting for her son to return from the war," Langsdon related. "When Mrs. Eccles learned he was killed in an accident on his way home, she killed herself. It's been said she haunts the hotel by randomly pushing the elevator buttons. People sense her presence by her perfume smell."

Pausing slightly, Langdon drove closer to home. "My ex-husband worked night security at the hotel. Patrolling the halls, he often saw ghostly figures. On the second floor, he felt something grab his leg even though, he insisted, no one else was in the room."

But then, what grand hotel doesn't have a tale or two to tell?

INDUSTRIAL INNOVATIONS

Coffee? You Bet!

There's no doubt, I like a good morning cup of coffee. Nothing fancy. A dark roasted brew, straight up with no room for cream or sugar, suits me just fine. I'm not alone.

According to various coffee surveys, more than 59 percent of Americans imbibe enough coffee to financially nourish a thriving industry.

That means a lot of coffee consumption. And I can't help but think about the infusion of coffee in Utah's early days when the manufacturing industry's motto was akin to "keeping the dollar home with Utah-made goods" and caffeine was a booming commodity.

In 1887, Hewlett Bros. Co. operated its spice, coffee, jelly and extract business in a simple, one-room frame structure in Salt Lake City. Considered one of the oldest manufacturing firms west of Chicago by 1917, the firm quickly expanded its product line, updated equipment, fabricated its own tin cans—printing signature labels on an in-house press—and provided employment to numbers of local folk. In 1920, the plant championed its "Luneta" brand of steel-cut, fresh roasted coffee as a "Utah product that has stood the test of time."

In 1920, Gibson Commercial Co. launched its first vacuum-packed coffee called "Early Dawn." Within months, more than one thousand coffee tins and copious amounts of bulk roasts were sold. Formed by retail merchants

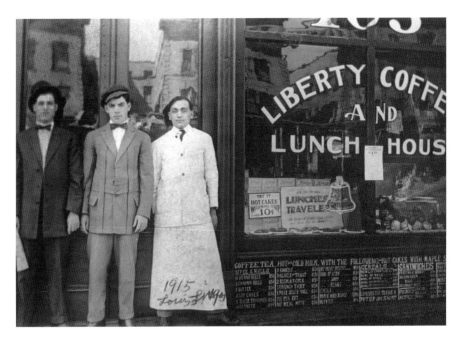

Utah coffees have stood the test of time. *Special Collections, Marriott Library, University of Utah.*

from Bingham Canyon, Gibson employed fifty people. They distributed their coffee and other products throughout the state and beyond the Western territory.

Tempting brand names and images were tantamount to taste. Olympic flames flanked the "Luneta" coffee tins. Davidson-Lake Tea & Coffee Co. saluted its "Capitol" brand. Murphy Wholesale Grocery Co. pitched "Hotel Utah" and "Old Faithful."

John Scowcroft & Sons Co. was no exception. Prominent among Utah manufacturers since 1880, the modern, Ogden-based plant took coffee to new levels. A plump pine tree boasting a coffee "full of favor" was emblazoned on the five-inch-tall "Blue Pine Coffee" tin. The perfected grounds were sold with "the unusual guarantee to suit every individual taste," an independent reporter wrote in the June 1922 issue of the *Utah Payroll Builder*, a monthly journal published by the Utah Manufacturers Association.

"Only five or six of the 135 different kinds of [world market] coffee beans taken from known highland groves and seasoned for several months are the kinds blended to make Blue Pine Coffee," the writer explained. "After receiving at the plant, they are skillfully graded and

cleaned by a process that constitutes the unique features of the Scowcroft Coffee plant."

Air pressure systems shot the green coffee beans from one floor to the next "through a series of galvanized chutes," during a "journey upwards with all the foreign substances blown into side chambers," the reporter observed.

On the top floor, rotating drums and hot-air roasters produced aromatic medium or dark roast blends. After they were ground, the batches were again processed to remove all traces of chaff.

"This results in an exceptionally clean coffee, entirely free from even the small percentage of chaff which is left in many [other] brands to make bulk," the reporter wrote.

Checking for quality, taste, density and flavor, each Scowcroft coffee brand was compared with other Utah-roasted coffees. Once the brew met the company's compact of quality, it was signed off with "Scowcroft Made It."

In the 1923 Church of Jesus Christ of Latter-day Saints' *Relief Society Magazine*, the purchase of Blue Pine olive oil was sanctioned. Blue Pine Coffee was not.

"The serving of tea and coffee at socials and weddings and Relief Society entertainments, and the sale of tea and coffee at socials or luncheons where the Relief society is raising funds, are heartily disapproved," the magazine's Word of Wisdom cautioned.

Warnings noted, coffee production had taken root in Utah. And in 1930, Scowcroft & Sons' Blue Pine Coffee took on soccer. Sponsored by the firm, the renamed Ogden Blue Pines team—long on a losing streak—won the Daynes Cup.

Speaking of cups…

IMMIGRANTS' SWEET CANDY CO. STILL ROLLING TAFFY

In 1917, electric streetcars and gasoline-powered Buicks, Dodge Brothers and Chevrolet sedans lined the busy streets of downtown Salt Lake City. On the corner of Broadway and State Streets, Auerbach's display windows wowed strolling pedestrians with the newest in fashion from above-the-ankle tiered skirts and walking suits to poke bonnets and French-heeled shoes.

And atop the old Walker Bank building, cascading neon lights flared like bejeweled water fountains announcing Sweet Candy Co.'s distribution "from Alaska to Australia."[32]

"That my grandfather happened to get into the candy business and that our last name was Süss, which is German for Sweet, is purely coincidental," third-generation candy maker Tony Sweet told me some time back.

In the late 1840s, Tony's great-grandfather Simon and Simon's brother Saul left Germany for New York and Chicago. When gold was discovered near Sutter's Mill in California in 1848, the Jewish immigrants headed west to sell merchandise to miners in the Aqua Fria mining camps of Mariposa County. Later, they moved south to Visalia, California; opened a mercantile store; and settled down to raise their families.

Simon's son Leon was a teenager when he struck out on his own. Funded by Mr. Saroni, a financial backer and entrepreneur in the sugar and rice business, the nineteen-year-old was sent to Portland, Oregon.

In 1892, he opened the original Sweet Candy Co. and, joined by his brother Arthur, satisfied the sweet tooth with lollipops, jawbreakers and licorice candies. Eight years later, the company moved near 79 South Main Street in Salt Lake City.

"They probably came to Utah because of the ready supply of sugar beets," said Tony. Not to mention Utah's love affair with sweets. In 1900, more than eight hundred Utah farmers grew sugar beets for Utah Sugar Co. By 1902, Amalgamated Sugar processed about 100,000 tons of sugar beets annually into nearly 10,000 tons of sugar.

In 1910, when Tony's father, Leon, known as Jack, was born, the company moved to 224 South 200 West, doubled in size and then did it again. Candy making is a competitive business requiring ample space, custom machinery, wide distribution, transportation and science.

Early on, Arthur delivered goods in a horse-drawn wagon. Corn syrup came by railway, and chocolate was made from scratch. Between 1911 and 1920, 175 employees were on the payroll—many adept at hand-dipping chocolates.

"To make cordial cherries," Tony explained, "women started with a cherry dipped into a fondant, the creamy sugar paste that is the basic building block of candy. After it set up, the cream-covered cherry was hand-dipped into chocolate, causing a chemical reaction. The acid in the cherry would break down the fondant almost entirely, turning it into a semi-liquid."

Caramel was poured onto six-foot slabs, run through a cutter and sliced into squares or oblong shapes. "Machines would wrap individual candies in waxed paper. People would bundle them in a wicker tray, starting on

"Enrobers" and chocolate making at Sweets. *Utah State Historical Society.*

Sweet Candy Co. employees boxing saltwater taffy. *Utah State Historical Society.*

the outside and working toward the center," Tony said. "It was a beautiful packing process set in hand-made wooden boxes embossed with our name."

Amid an opulence of chocolates and nuts, hard candy and jellied confections, Leon made a strategic business decision in the late summer of 1920. He took on taffy.

Before air conditioning, there were few options for storing, transporting or keeping chocolate from melting. Most candy makers would delay chocolate production. Sales would fall flat, and workers would leave.

"But saltwater taffy doesn't easily melt in the heat," Tony said. "So my grandfather developed saltwater taffy for summer production and to keep our work force stable."

In 1936, when Jack added egg whites to the taffy mix, sales soared.

After 120 years, and with more than three hundred varieties of kosher-certified American-made candies and confections (including chocolate-covered orange sticks), a fourth generation continues to lead one of the oldest family-owned candy companies and largest manufacturers of saltwater taffy in the United States.

TOMATOES, BEANS AND PEACHES MADE OGDEN A CANNING CAPITAL

Last Sunday I felt a change in the air and thought about canning. You know, the old standby canner and covey of Mason jars—those glass jewels with the square shoulders, threaded screw tops and watertight, rubber rings that Philadelphia tinsmith and glassblower John Landis Mason invented in 1853.

Superior to the unthreaded flattop bottle that required sealing wax to prevent bacteria from forming inside the jar, Mason's reusable alternatives revolutionized home canning and helped influence the commercial canning industry, particularly in Ogden.

Ogden and surrounding areas had been long noted for their rich delta soil, fine climate and farming diversity from vegetables to livestock. But when the last spike was driven at Promontory Point in 1869, completing the Transcontinental Railroad, the small community developed into a bustling transportation and distribution center for both agricultural and industrial expansion.

Ogden, tagged "Junction City" or "the Minneapolis of the West," was a major railroad hub for the Union Pacific and Central Pacific Railroads and subsequent tie-ins with other railway systems.

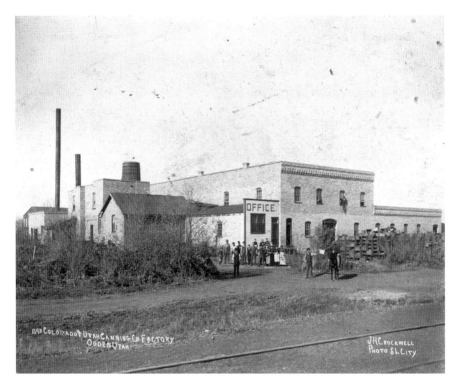

Colorado & Utah Canning Co., Ogden, Utah. *Special Collections, Stewart Library, Weber State University.*

In 1886, Alexander C. McKinney and Robert Lundy opened the Colorado-Utah Canning Co. in a former pickle plant on Twenty-ninth Street property owned by merchant entrepreneur Fred K. Kiesel, who became the city's first non-Mormon mayor.

During the cannery's first and only season, workers produced and packed 1,800 cases of tomatoes. The men, dissolving their partnership, went on to open different canneries.

McKinney opened Ogden Cannery near the Union Pacific tracks and sold his shares of another enterprise, Salt Lake Valley Canning Co., to William W. Craig. Both men became major figures in Utah's canning industry. For years, they produced and shipped canned fruits and vegetables, including pumpkins, string beans, ketchup, berries and peaches.

Lundy established Utah Canning Co. in 1889. Working with Isaac N. Pierce, they introduced a new product called Pierce's Pork and Bean. (In the 1933 Depression days, the innovative meals in a can sold for five cents each.)

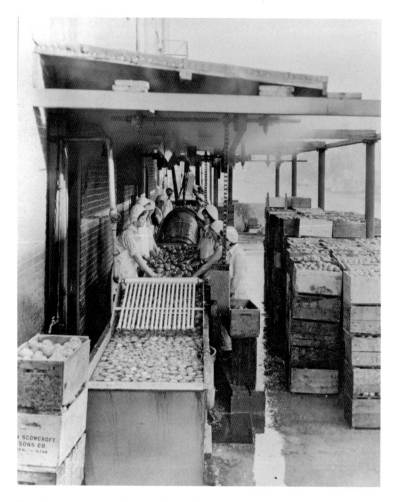

Canning tomatoes in Ogden. *Stewart Library, Weber State University.*

In 1897, Ogden builder Thomas Dee and the industrialist David Eccles reorganized Lundy's company, implementing modern processing methods and developing a year-round big business.

Most canneries began as small, independent operations. Production was done by hand. Female workers were in great demand. Loosening tomato skins with hot steam jets and cold sprays, women easily peeled sixteen bushels a day. Processing tomatoes was a top priority, while "Those Good Peas" came from Morgan Canning.

By 1910, progressive canneries processed one thousand cases per day. In 1914, Utah was recognized as fifth in the nation among the canning industry.

In 1927, the state supported thirty-six canneries in Weber, Davis and Cache Counties. Eighteen were in Ogden.

Automatic production lines, fillers and soldering machines replaced the repetitious handwork, speeded the process and increased canning capacity. Sanitary cans—open top cans that could be sealed without using solder or acid methods—replaced older versions.

But from the outset, local farmers had to be convinced that selling their produce to canneries was profitable. Consumers had to learn that preserving food in cans rather than in bottles (or jars) was safe and healthy and that sterilization by heat was an effective way to destroy germs.

In the 1927 *Utah Payroll Builder*, Ogden Chamber of Commerce member Jesse S. Richards noted all Utah canning factories were "under the Inspection Service of the National Canners' Association."

Daily reviews determined "conditions and quality of raw material, proper handling, packing and processing as well as the sanitary surroundings, conditions and operation of the canneries." Passing muster garnered an association seal of "purity, cleanliness, wholesomeness and quality."

When American Can Co. and Keichefer Box Co. opened manufacturing branches in Ogden, they fabricated thousands of cans and packing cartons. They also saved the time and expense of having them shipped in from the East.

In 1926, the *Builder* noted that Utah's canning industry's annual total pack was more than three million cases valued over $10 million. The future looked bright until fresh frozen food—and Birdseye—came calling.

ITALIAN IMMIGRANT BECAME UTAH'S PASTA KING

After working in the mines of Pennsylvania, Colorado and Mercur, Utah, at the turn of the century, Italian immigrant Antonio Ferro opened a small market at 562 West 200 South in Salt Lake City, married his sweetheart, Giovannina Calfa, and found his true calling.

In 1906, the young entrepreneur managed—owned and incorporated—the Western Macaroni Manufacturing Co. He helped bring epicurean cuisine to the tables of the masses, boosted Utah's agricultural economy and became known as the Pasta King of the Mountain West.

With a nod to royalty, Ferro marketed his products under the label "Queen's Taste." He oversaw the production of more than forty-five

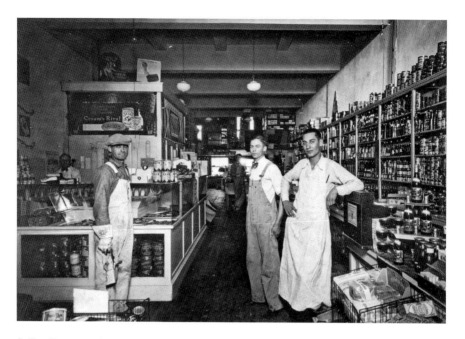

Selling Ferro's and worldwide Italian products in Helper, Utah. *Left to right*: John Vieta (behind the counter), a delivery man, Tony (JA) Vieta and Rudy Rebol. *Special Collections, Marriott Library, University of Utah.*

types of pasta, from the tiny beads of acini di pepe, coiled capellini, corkscrew fusilli, elbow maccheroni, wide linguini and flat pappardelle to spaghetti, ribbons of tagliatelle and tube-shaped ziti noodles. Carloads of pasta were also shipped throughout California, Washington, Montana, Oregon, Wyoming, Idaho, Nevada, New Mexico and Colorado.

According to an April 7, 1916 *Deseret News* article, the pasta company was "in every sense of the word a Utah concern, and said to be largest plant of its kind west of Chicago. One point of interest to the housewife is that no artificial coloring is used."

Dried pasta is made of wheat and water; fresh pasta requires eggs. Ferro used unleavened dough composed of 80 percent hard durum wheat (semolina) flour from Minnesota and 20 percent hardy winter Turkey Red grown on dry farms in Idaho and Utah. Daily, ten thousand pounds of pasta rolled off the production line; annually, more than 150,000 locally purchased eggs were added to the fresh mix.

Ferro's factory occupied five floors of a large building at 242 South 400 West, a Salt Lake City area of residential and commercial diversity. He employed twenty-five to thirty men and women full time.

In his expansive, well-ventilated plant outfitted with electricity, Ferro's modern manufacturing equipment consisted of commercial mixers, kneaders, various pressing machines, cutters, driers and packagers—a far cry from early pasta making in the United States that once relied on horse-drawn power.

Reporters described the pasta making in detail in the 1927 edition of the *Utah Payroll Builder*.

From a reservoir box built above an industrial mixer, three hundred pounds of blended flour were released into the enormous bowl below and mixed with warm water until the two ingredients turned into dense, stiff dough.

The reporters said the dough was taken out and transported to two heavy cog-kneading machines; a "conveyance between the kneaders rolled the flattened dough on edge in order to allow more perfect mixing as it [went] from kneader to kneader."

Once the dough's texture became pliable, it was fed into the pressing machines that resembled large double-cylinder pumps, each one holding nearly "two bushels" of paste. The reporters noted that 1,500 pounds of hydraulic pressure pushed an extruding piston slowly down the cylinder and squeezed the paste through a number of small holes in the bottom.

Different machines and dies (metal discs with specific holes and needles) shaped the dough into numerous sizes, lengths and forms, including stars, alphabet letters, bow ties, cylinders and shells.

Cut and trimmed, the pasta traveled to one of eleven rooms where critical evaporating techniques ensured the right amount of moisture was retained.

Thousands of racked spaghetti strands required a two-step drying process that took up to four days in Utah's arid environment. Short noodles on wire trays were stirred every ten hours for even drying.

Plant employees, working day and night shifts, monitored room hydrometers and regulated dampers and fans to control the drying cycle—too much toughened the pasta; too little made it brittle.

For thirty-six years, Ferro's company produced near-perfect pasta. "There is none better made than the famous 'Queen's Taste' brand," the reporters concluded.

Ferro closed shop in 1942 and died two years later. His legendary pasta is now a tasty memory.

HOW THE CRACKER INDUSTRY CAME TO BLOOM IN UTAH

Whether they were called biscuits, pilot breads, or crackers—with maritime roots in the form of hardtack—small, flat and crisp baked goods have been a longtime staple of New England larders. In Newburyport, Massachusetts, Theodore Pearson rolled out his version of biscuits in 1792. In 1801, Boston baker Josiah Bent burned his batch with such a crackling, the very sound may have given birth to the American moniker: crackers.

By 1885, the ubiquitous cracker industry had settled in Utah.

That year, confectioner Henry Wallace and business partner George Husler, who owned one of the territory's first flour mills, opened the Utah Cracker Factory. In 1915, V.A. Tracy arrived from Denver to showcase his modern soda cracker firm and its wide-ranging relationship with Utah.

"The Purity Biscuit Company will be a Utah concern," the firm's vice-president said in the June 7, 1915 issue of the *Salt Lake Telegram*. "Every bit of the work that can be done by Utah people will be given [to] them. Every line of goods we require that can be had in Utah will be purchased within this state."

Designed by local architects Walter Ware and Alberto Treganza, the well-lit and sanitary six-story cracker plant was located on the corner of 400 West and 500 South Streets in Salt Lake City. Its biscuits were made from Utah-grown wheat ground in Utah flour mills, shortened with lard from Utah hogs, salted with Great Salt Lake salt, sweetened with Utah-Idaho sugar, cut on machines run by Utah's power and light, baked in commercial ovens heated with Utah coke and packaged in "sealed-tight, moisture-proof" design-printed paper containers or tins. They were then packed and shipped in crates die-cut by Utah paper box factories and adorned with "Made in Utah" labels.

"Last but not least," Tracy reported at a monthly meeting of the Rotary Club of Salt Lake and reprinted in the April 1919 *Utah Payroll Builder*, "our product is mixed, baked, packed and shipped north, east, south and west, by Utah sons and daughters who spend their annual payroll of about $125,000 in this village."

Unlike traditional flat-racked bread ovens, soda crackers were placed in immense specialty ovens equipped with reels containing twelve shelves each that went round and round, like a Ferris wheel, and baked the crackers in a "flash heat" process.

"The crackers are peeled on to the oven shelves about ten feet above the fire," Tracy explained. "The reel is then set in motion and [as it]

Purity Cracker helps the war effort with hardtack and modern equipment. *Special Collections, Marriott Library, University of Utah.*

revolves downward, the cracker comes in contact with the heat below almost immediately."

Motion cracker machines replaced rolling dough out by hand and accelerated the plant's capacity. Continuously revolving cracker ovens daily baked some fifty barrels of flour and produced more than sixty-eight thousand soda crackers every forty-five minutes.

During World War I, America's soda cracker industry was called on to aid the war effort by making hardtack for overseas shipment. Inexpensive and long lasting, hardtack was known to survive extreme temperatures, travel and handling.

"Packed in moisture-proof, dirt-proof, rat-proof and mustard-gas proof tins," hardtack, as described by Tracy, was an essential food source for entrenched soldiers. In September 1918, the country's soda cracker industry pledged copious bake runs, revolutionized its baking methods and churned out more than "32 million 8-ounce tins and 10 million 8-ounce cartons of hardtack to feed the boys over there."

Purity's baked goods brands were sold throughout the Intermountain West and from New Jersey to California. Among its products were Sodacks, Fig Newtons, Graham Crackers and Poinseta Sodas.

In 1919, the company offered a fifty-dollar prize for the best advertising slogan chosen for its Poinseta biscuit product. Some twenty-one thousand suggestions poured in, but fourteen-year-old Charles Johnson, of Salt Lake City, won with his description: "Bloomin' Good."

"I just couldn't help putting down on paper the way I felt about them," the beaming youth said in the March 19, 1919 *Salt Lake Telegram*. "They're just so bloomin' good."

Part IX

TRUE ESCAPES

From Business to Pleasure

Part One: A Narrow Gauge Electric Railway Tackled Steep Terrain to Sandstone Quarries

In midsummer, driving up Emigration Canyon's mountainous defile to catch a breath of fresh air, I thought about turn-of-the-century canyon railways and rusticators. You know, the era when Emigration Canyon was rife with migratory birds, blooms, tall grasses, scrub oak, fir trees and rich, black soil. Its creeks ran clean. Fish and wildlife were plentiful. And boundless landscapes—rising in elevations from 4,870 feet at the canyon bed to 8,954 feet at Lookout Peak on the north ridge crest—were accessible and stunning to behold.

Emigration Canyon—long associated with the emigrant trail, Donner-Reed Party, the forty-niners, Johnston's Army and the Pony Express—was early on abuzz with commerce from timber rights to sandstone quarries. From 1880 through the early 1900s, Salt Lake City's population had doubled and was experiencing a building boom. Contractors eagerly sought foundation stones. Investing in rock quarries and freighting looked promising.[33]

In the Canyon's upper regions, Burr Fork (in an area called Pinecrest) and Brigham Fork quarried red- and white-colored Nugget sandstone. Loaded into mule wagons, the heavy rocks were hauled down the ravine's narrow and

steep dirt road into the city. The wagons, supported on wheels approaching ten feet in diameter, were custom-built to handle such weight but proved cumbersome and slow moving.

In 1907, Utah pioneer jurist and entrepreneur LeGrand Young envisioned a transportation alternative that would keep up with the city's growing demands and increase his profits. Gathering other like-minded businessmen, Young organized the Emigration Canyon Railroad Company (ECRR). The company's goal was to construct a fourteen-mile, narrow gauge electric railway up the canyon with spurs to the sandstone quarries. Setting tracks thirty-one inches apart, switchbacks were sliced into the steep terrain to help level the run. Overhead power lines connected to utility poles stretched along the railway. Former trolley cars were reconfigured into four-wheeled, flatbed freight cars capable of carrying heavy payloads. And two electric box cab locomotives were assembled to pull the cars in the canyon and to the rail yard near Fifth South and University Street for unloading.

Successfully delivering on their promise, the business of transporting lime, cut stone and rock was a seasonal one. The railroad could never pay for itself and was costly to maintain. The electricity bill alone ran into thousands of dollars. When an inexpensive product, Portland cement, was introduced to builders, it easily became their product of choice and sandstone orders waned. Despite Young's ambition, he was in debt and his railroad was racing toward financial ruin. To stay in business, he would have to diversify.

Several times, Young noticed that when the emptied freight cars wended back up the canyon they often carried hitchhikers. These were city folk yearning to trade the local clime's sweltering heat for cool mountain breezes. By 1909, four handsome passenger cars took to the rail and Young increased his profits.

Among the cars, the motorized Red Butte and Wanship were fashion statements. Painted a "Pullman green" color with elegant gold trim and triple-arched windows, they offered plush interiors. The non-motorized, open-air trailers, called Wasatch and Oquirrh, were guaranteed to thrill the young and adventurous.

Tickets ranged from two bits to fifty cents. Excursions began early in the morning, with as many as ten crowded runs each day. Stopping at numerous spots for sightseeing, the last trip often ended before midnight. Some passengers rode the one-hour, eleven-mile train trip up Burr Fork to enjoy picnics by a running stream. Others who were more daring boarded trains bound for a series of switchbacks, steep heights and dizzying sights.

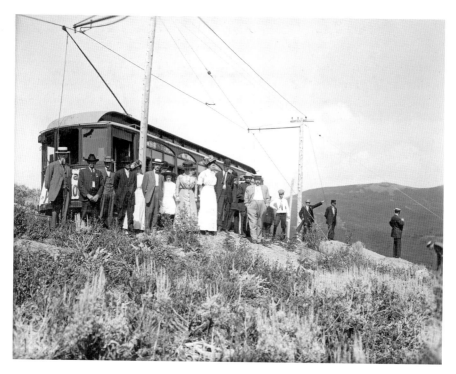

LeGrand Young's railroads went from conveying sandstone to transporting city folks to new heights. *Utah State Historical Society.*

Promoting such high-ridge destinations, an early advertising campaign puffed, "Up, up, up it goes in zigzag fashion, following the foaming brook of crystal waters; through open glades, carpeted with beautiful wild flowers of every tint and hue; along the edge of the craggy precipice; up above the timber belt, 3,000 feet higher than the city—finally reaching the summit of Point Lookout, unfolding to view a panorama worthy of the artist's pencil or the painter's brush."

Sensing a future in tourism, and a possible reprieve for his trains, Mr. Young added five more deluxe passenger cars to the line. His thoughts then turned to other venues for dining, dancing, outdoor activities and maybe even an inn. Such investments looked promising—providing tourists, hikers, families, sweethearts and rusticators myriad reasons to ride his train to Emigration Canyon for a breath of fresh air and more.

Part Two: The Railroad Inspires Pinecrest Inn

Taking railroad passengers on day trips throughout the canyon proved profitable but limiting. Other venues were needed. When Young learned that Charles N. Strevell and James H. Paterson, principals of the National Real Estate & Investment Company, wanted to build a resort in the canyon, they met. When they asked for his help, he agreed.

Following the railroad tracks to the end of the line in the high mountain district in 1913, Strevell and Paterson began construction of the $65,000 Pinecrest Inn on land donated by Young.

Young pinned his hopes on tourism and increased passenger traffic. He also donated free transportation of building supplies, workers and employees. Pinecrest Inn was designed by Salt Lake architect Frank Winder Moore as an outdoor resort with the conveniences of a modern home equipped with steam heat, electric lights, telephone and running water. Its substantial structure contained seventy-five rooms (twenty-five with baths), spacious dining and living rooms, a commercial kitchen, stone fireplace, large ballroom, meeting rooms and a 112-foot porch overlooking the canyon.

"No more charming hostelry could be imagined than in this beautiful place set in a veritable hill forest of giant pines and stately birches, silver-barked quaking asps and pretty maples," enthused a June 13, 1913 *Salt Lake Tribune* advertisement flanked by Emigration Canyon Railroad's seven-days-a-week summertime schedule. "The view from Pinecrest will be magnificent—unfolding a scene of grandeur and enchantment to all lovers of nature."

Out-of-door lunchrooms, verandas, a spring grotto and a stone bridge residing alongside rustic benches, shady niches, rock work and landscaping exuded natural elegance. Live orchestras and dance bands entertained weekly. Tennis courts and a children's playground enticed. Streams were stocked with trout, trail guides were attentive, a zip-line cable ran across the creek and ponies thrilled children with rides.

Ideal for summer-long or weekend visits, enthusiasm ran high, and land speculation became an investment reality. In nearby Pinecrest, cottages were built for sale. Subdivisions of land, provided by Young, started to sell. The resort was packed. Young ordered five more passenger trains for the one-hour ride.

It was a beautiful place in a perfect locale with increasing clientele, but it still wasn't enough to save Young's railroad. He needed significantly more lot sales and passenger fares to stay afloat.

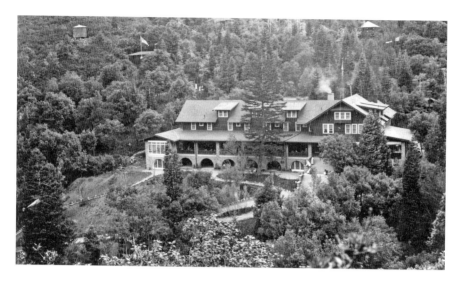

The elegance of Pinecrest Inn. *Utah State Historical Society.*

When Strevell and Paterson asked Young for another year of free railroad transportation—the cost of maintaining the large, well-appointed inn in the mountains was beyond exorbitant—the entrepreneur declined.

In 1916, the railroad closed and its parts were sold to an army base in Tacoma, Washington. Pinecrest Inn struggled to survive. Sold in 1919, and many more times after, the once-beckoning destination was unceremoniously stripped for salvage in 1949.

Yet even in failure they succeeded. Through the development of tracks, roads and residences, they had opened Emigration Canyon for business.

Part Three: Remembering the Last Days of the Pinecrest Inn

The once-elegant Pinecrest Inn, which offered cool breezes and a warm welcome at the end of the line, also stirred unforgettable memories. Recently, I learned about Gordon A. Christenson's boyhood adventures and his father's attempts to save the inn.

"Emigration Canyon was where my father could easily escape the summer heat and, since he was a rebel at the time, find refuge from his daily life," said Christenson, an eighty-year-old retired law professor, from his home in Cincinnati, Ohio.

His father, Gordon B. Christenson, was a well-known Salt Lake City lawyer and public servant. During World War II, he worked for the

Office of Price Stabilization rationing products ranging from rubber tires, automobiles, gasoline, sugar and metal typewriters to coffee, butter, meats, shoes, processed foods and bicycles.

"It was about then Dad bought a cabin high up the mountain overlooking the Pinecrest Inn with Emigration Creek running between us," Christenson said. "Without question, he loved the southern view, and it was within driving range on rationed gas. I remember us piling into his 1939 Dodge filled with enough gas to get up the thirteen miles to the cabin and then coasting all the way back down the road to the city."

Christenson described the road to Pinecrest as a steep, roughly graded, rarely oiled, often flooded narrow dirt lane. "You had to be careful nearing the top to avoid hitting a car that might be coming around the bend," he said.

In 1919, Pinecrest Inn changed ownership. Purchased by Bishop Joseph Glass of the Catholic Diocese of Salt Lake City, it was converted into a summer retreat for the Sisters of the Holy Cross. Acquired next by the LDS Church, it was rented out as a winter resort, summer inn, restaurant, nurses' training center and refuge for children suffering from polio.

In 1947, the elder Christenson negotiated a lease with the LDS Church to restore the inn to its pristine quality.

"Dad thought it was a good way to celebrate the 100th anniversary of the pioneers coming into the valley and revive the once magnificent structure," Christenson said.

The lease required a new parking lot and road improvements. Eventually, the grand lodge opened with sterling service, exquisite landscaping, deluxe suites, live bands, ballroom dancing and wonderful dinners of fresh mountain trout, thick T-bone steaks and mouth-watering fried chicken.

It was a gracious operation with a promising future. It also required a lot of work.

Earning forty cents an hour, sixteen-year-old Christenson weeded the driveway, washed dishes and mopped the extensive flooring. The ballroom alone extended beneath the two-hundred-foot-long veranda.

When the resort was closed for winter, the lad would shovel paths through the snow to the coal drop-off site below the inn and with others relay back buckets of coal to stoke the furnace.

For all its beauty and popularity, Pinecrest Inn was impossible to maintain. Its restrictive lease, prohibiting beer licenses and "set-ups" for mixed drinks, crippled its competitive edge and profits.

"Dad thought the realty arm of the church, having leased the property, should help with the winter upkeep and maintenance of the wooden water

pipes," Christenson said. "When he offered to buy the inn, they refused to sell it at a fair market price. He lost his shirt."

Shouldering his responsibility, the elder Christenson repaid every cent owed. From their cabin across the way, they watched in sorrow as the inn was demolished, scavenged and finally, in 1951, burned to the ground.

"It was tragic," Christenson said. "But my father had the courage to attempt to restore a wonderful part of the canyon's past during an era of elegance. I was fortunate enough to be part of it when coming of age."

HOT SPRINGS: A ONCE AND FUTURE

Whether one risks a raucous plunge in the pool or eases body and soul into the soothing eighty-two-degree water heated by the earth's mantle, mineral-rich geothermal waters have long been touted to possess healing powers.

In the 1880s, they were part and parcel of Como Springs Resort in Morgan City. Immigrant pioneers Samuel and Esther Francis arrived in Morgan Valley in 1862 to take up farming in what is now Morgan City. Although the surrounding land was used for raising livestock, the couple was charmed by its natural hot springs and small, unusually warm lake.

In a nod to Esther's birthplace in Italy and the glacially formed Lake Como she well remembered, they called the fishing and swimming hole Como Lake. In 1883, Francis and neighbor Richard Frye acquired eighty acres of land, including the geothermal springs, from Union Pacific Railroad. The partners paid $200 for the property but at the time did not recognize the full value of their "water" mine.

Not until several years later did Dr. Frederick Kohler from Indiana's Rush Medical School move to the county, analyze the water's chemical and physical properties and begin promoting its therapeutic benefits. Morgan resident Dr. Thomas Wadsworth was also in accord.

In 1889, Francis, Fry and Wadsworth formed a company to create a swimming resort. Dr. Kohler became the project's general manager. According to Morgan County historian Linda H. Smith, forty acres went toward the building of Como Springs Resort.[34]

"Dense underbrush was cleared from around the large cottonwood trees," Smith wrote in *A History of Morgan County*. "A large pond was excavated on the east end of the lake. A lumber partition filled with soil was built to separate the swimming area from the lake."

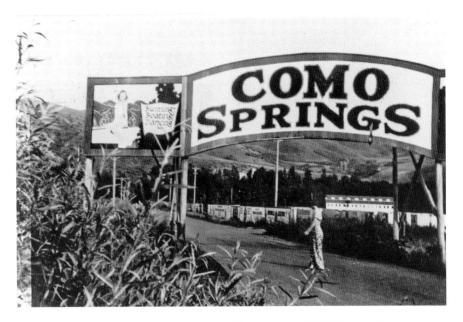

Como Springs in Morgan City. *Morgan County Historical Society/WSU Stewart Library.*

Among its facilities were dressing rooms and a small store. A large pavilion was built for roller skating, musical tours, choirs, brass bands and dancing. Fifty-cent round-trip railroad tickets from Salt Lake City to Morgan were offered to performers and friends. Picnic areas were groomed. A footbridge was built across the Weber River for easier access. By late August 1889, when the resort opened, business boomed.

Several years later, Como Springs Resort took a downturn. The country's economic crisis in 1893, unemployment, bank failures and the Pullman Strike of 1894 had crippled the nation. The resort slipped into disrepair.

In 1921, Como Springs Resort was resurrected. Its new owners, members of the Heiner family and a gentleman named Sumner Nelson, expanded the resort to include grand scale sites for entertainment, recreation, dining and amusement activities.

A 112-foot by 116-foot concrete pool was poured. Numerous pipes transported hot sulfur water into the pool and lake. More than thirty summer rental cabins were built, and a long, slippery slide and high-dive invited competitive and casual swimmers into the bathing pool.

On June 22, 1921, Como Springs Resort reopened its gates to more than 1,500 visitors. By July, a boathouse and café had opened on the banks of Lake Como. A newly improved footbridge spanned the Weber River, and for

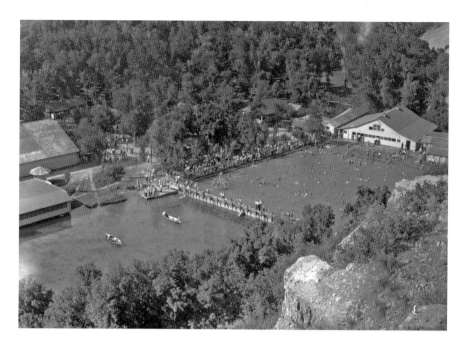

Mineral-rich Como Springs Resort. *Morgan County Historical Society/WSU Stewart Library.*

those arriving by train from Salt Lake City, the resort was a mere ten-minute walk from the depot.

The resort then installed a merry-go-round pulled by Shetlands and a covered pool for those seeking respite from cool canyon breezes.

It seemed unending: those pool tables, bowling lanes, roller rink, shooting gallery and bowery; those swimming lessons, summer jobs, walking trails, water park, campsites and zip-line; and those thousands of eager visitors, conventioneers and concertgoers.

But it did end. When the last remnant—the resort's public swimming pool—closed in 1986, only ancient hot springs were left in wait for the next go-around.

Part X

AN INDEPENDENT
STREAK

IN 1910, AN ENGLISH IMMIGRANT FOUND A NEW LIFE ON UTAH'S PROMONTORY

In the summer of 1910, Katie Nurse and her young son, Bernard, left Norfolk, England, to begin a new life in what the locals in Utah called Promontory Station, where the ceremonial driving of the "Golden Spike," connecting the Union and Central Pacific Railroads, furthered the development of the American West.

Traveling with nine trunks—three were lost and then found, and one was filled with hats—Nurse arrived at the station amid the locomotive's belch of black cinders and wondered, "Is this what I'm coming to?"

For some time before, Nurse had corresponded with fellow Englishman and friend Frederick Houghton, from Promontory. Upon seeing him, her fears were quelled. He was kind without guile. They married in 1911.[35]

A boomtown during railroad construction, Promontory Station settled into a small community comprising some twenty families. It became a housing and work camp for railroad employees who maintained the rails and a commercial center for burgeoning cattle ranchers seeking access to national markets. The station's "helper" engines boosted "trains up the steep Promontory grades." Its railway offered a "backup line" for those living north of the Great Salt Lake.

In 1894, a gentleman named T.G. Brown operated a successful general store, hotel and restaurant at the station's depot. He advertised "groceries, cigars, tobacco, boots and shoes" and "first-class meals, 50 cents." In 1907, he sold the enterprise to Houghton. Renamed the Houghton Store, its collection of offerings, including a post office, remained a welcome sight at the notable historic junction.

Inside the building, an expansive dining room with English-style furniture dominated the living spaces along with a large kitchen and pantry. Long-term boarders and overnight travelers discovered ample lodging. No indoor plumbing or heat existed, so the Houghtons gathered sagebrush to burn for winter and filled buckets with water brought in by train. According to section foreman Joseph Nelson, Katie Houghton was a fine cook who served roasts and brewed coffee that tasted "better than what they served on the railroad."

A refined—and fiery—woman, Houghton was known to bake eighty loaves of bread a week, roll out pies for the train engineer and baggage car crew, care for the sickly, feed the needy and somehow remain impeccably dressed whether cleaning silverware, mopping floors or traveling by horse and buggy.

In 1912, she became pregnant with their child, Bernice, and Frederick built the long-promised home, the Bungalow.

Located away from their primary residence at the store, "it was a pretty little blue house and the home of her dreams," Bernice Houghton Gerritsen wrote in 1973 memoirs, "but we only lived in it for two years because Mother felt Dad needed full-time help in the boardinghouse. She always expected to go back to live in the bungalow but never did."

Country life was challenging. The storeowner worked as a farmer and gardener, postmaster, justice of the peace, notary public, Sunday school teacher and custodian of Promontory's one-room schoolhouse. He grew Martha Washington vines to cover and cool the store's exterior. After a cow backed into the store and broke a window, he built a low fence, framed it with flowers and planted a box elder tree. Houghton doted on his children. There was a dog, Max, and a horse named Coley. For years, Houghton collected and saved buffalo nickels.

Diagnosed with stomach cancer in 1926, Houghton died within weeks.

"Mother cried," Gerritsen wrote, "but with the mail train due, she had a new task to do before planning his funeral."

The grieving widow purchased her husband's headstone with some buffalo nickels and bought farmland with others. She then immersed herself in business, didn't believe in credit, paid off all debts and happily "burned the mortgage."

In 1935, Houghton shuttered the store and moved to Ogden with her daughter. In 1941, Promontory's metal rails were stripped to aid the war effort. Promontory became a ghost town.

Houghton's tree still stands.

WOMAN'S LOVE CONQUERS MOUNTAINS, VALLEYS AND EVEN THE SHERIFF

Some say love can move mountains. Alice Iwamoto had to cross several to be with her beloved. The granddaughter of a samurai and a second-generation *Nisei*, Alice was born in 1917 and grew up in the coal mining camps of Latuda in Spring Canyon, Utah. Her father, Eiji, managed the Japanese camp. Her mother, Suga, cooked for the Japanese bachelors living in barracks.

"There was no end to what we did," Alice told me during a visit in her Salt Lake City home in 1985. "Mother was up at four-thirty every morning to feed the coal and wood-burning stoves before cooking breakfast for the boarders. I'd put together sandwiches."

When the eight o'clock whistle blew, the miners went to work "with carbide lamps on their heads and cold lunch buckets in hand."

The two women washed dishes; cleaned tables; scrubbed wooden floors with lye; heated the Japanese bathhouse, sanitizing it with a continuous flow of hot water; and laundered clothes by hand. "In those days, we didn't have washing machines or hot water faucets," Alice explained.

A Carbon High School graduate, Alice was attending Japanese school in Price when insurance agent and activist Henry Kasai spoke about the benefits of *baishaku nin*, the traditional Japanese marriage involving a "go-between."

Henry, twenty-six years her senior and a first-generation *Issei*, noticed Alice because she took issue with his notion that anyone could be a matchmaker. "I didn't believe a third party could understand what's best for other people," Alice said.

Henry was bilingual, civic-minded and encouraged goodwill between the United States and Japan. But the Iwamotos disapproved of him as a potential groom.

"They thought he was too old, had a reputation as a bachelor and went out with Caucasian women," Alice said. "They wanted to send me to Japan to find a 'more suitable mate,' but I wouldn't leave him to do that."

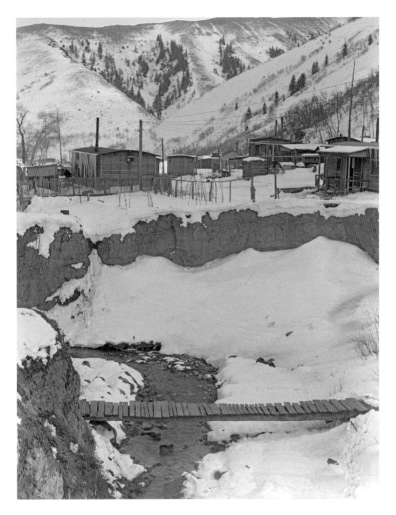

Snow on high in another Carbon County coal town called Consumers, photographed by Dorothea Lane for the WPA. *Library of Congress, FSA/ OWI Collection.*

The couple courted for two years, during which time "Henry told me to 'hurry and grow up,' and I made up my mind," Alice said.

On November 10, 1937, Alice penned a farewell note to her parents. Carrying scant provisions, she headed toward the hills and, if fate prevailed, Henry.

"My philosophy was to go as far as I could and leave my life to whatever was going to be the outcome," she said. "I walked and walked, crossed mountain tops, and went farther than I'd ever gone before."

Passing scrub oak stands and pine trees during the day, Alice reminisced about "chewing pine gum that was very bitter and eating sweet pine nuts." Exhausted by evening, she questioned whether she could go on. And she had no idea where she was nor that her frantic parents, the county sheriff and others were combing the hills for her.

"Like a miracle, out of nowhere I heard a dog bark and saw an elderly man walking along the mountainside," she said.

Mr. Cortez, who lived with his dog in a one-room cabin in the mountainous region between Helper and Price, offered the runaway a bucket of spring water for washing and a bowl of soup. He also promised to mail a letter to the only person Alice wanted to know where she was.

"I never told anyone, not even Henry, that I was planning to leave home," Alice said. "But I wrote that I'd wait three days for him. If he didn't come for me by then, I'd go back into the hills."

It was a surprised Henry who, running into his Salt Lake City office to catch up on some work, came upon Alice's letter. He drove 135 miles to Sweet Canyon and the end of a paved road, hiked the trail and found his bride. Three days later, Henry and Alice were married in Tooele.

"My parents didn't attend, and for a time we didn't talk," Alice said. Only after World War II, "when Henry was released from interment camp," did the estranged families reconcile, moved by a love story come true.

ALMOST CENTENARIAN USED FISTS, AND WORDS

The first time we met in his South State Street second-floor office in Salt Lake City, Harry Miller called me "kid." It was 1986.

His place was peppered with *Golden Age* newspaper proofs, Golden Gloves boxing reviews, war memorabilia and pictures of welterweights and young wannabes—youth that "could have gone wrong," he said, "if they hadn't the opportunity to build their character through organized sports."

Born in 1905, Miller grew up on the mean streets of New York, Chicago and Denver. His grandmother Hannah suffered with tuberculosis and resided at Denver's Jewish Consumptive Relief Society.

"She was a tall, thin, beautiful woman who wore all white clothes and carried a little bucket to spit in," said the longtime Utah print man

and publisher. "I can see her slowly peeling an orange, tapping me on my shoulder, saying 'Ari' [my birth name] and handing me a slice."

The family rented a three-dollar-a-month house and had to sublet a room. Miller's maternal grandfather Mordecai peddled with his horse Dolly and earned fifty cents a day. Once, he salvaged a 1910 Allison Candy Company baseball shirt that Miller said "was my life!"

Harry Miller's father came from Grodno, Poland, and worked as *mueller*—a bricklayer. "Small, physically strong, with hands always moving, there wasn't a time my dad wasn't laying bricks," his son said.

His mother rolled cigarettes by hand in a Russian tobacco factory. "She was a socialist, an intellectual who survived the pogroms of Russia and became an actively liberal person in America."

While the family lived in Chicago, Miller insisted his mother shop at "Klee Brothers, where for $2.95 you'd get a suit for Pesach [Passover] and a baseball bat to boot." If ballgames were his deliverance, baseball signals were a matter of *Yiddishkeit*.

"To hit a ball, we'd holler *derlang*, to throw one was *varf* and stealing second base, *ganveh*."

In his youth, Miller boxed as a flyweight, winning fifteen out of sixteen fights. He briefly managed a Piggly Wiggly basketball team and then moved to Utah.

"Many of us came here from Denver," he said. "Take Charlie McGillis from West Colfax. He became the circulation manager of the *Salt Lake Tribune* and had an impressive personality when it comes to, shall I say, promoting street sales. See, newspapers were the king of the walk, and Charlie never talked in circles."

In a 1911 bout held in Salt Lake's Manhattan Club, the two-fisted "Chick" McGillis went up against Ogden's favored lightweight Kid Harrison and broke two ribs but never backed down—securing a draw and ensuring his reputation.

"You might not think Jews were involved in these kinds of sports," Miller said. "But in the 1920s we had many, probably a byproduct of the depression. There was featherweight champion Louie "Kid" Kaplan, who couldn't speak a word of English; and the outstanding Hymie Garfinkle and Abie Mishkind."

By the 1930s in Salt Lake City, some forty softball teams filled White Park on North Temple across the street from the State Fairgrounds. A member of Congregation Montefiore Men's Club, Miller played in an all-Jewish team that included Harry Goldberg, Max Guss and Izzy Wagner.

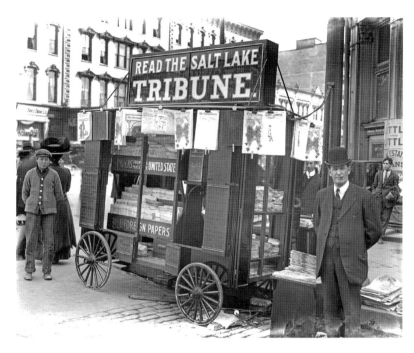

One of the most complete news wagons and electric signage of the day. Charlie (Chick) McGillis (right) went from fighting in the ring to establishing "Charlie's newsboys" on the best city street corners. *Utah State Historical Society*.

Harry Miller (second from left, first row) was one of the first Americans in Paris during the liberation. *Harry Miller*.

"We got good," he said, "and played against the best of them: the Ziniks and the Knight brothers."

Adept with words or fists to get his message across, in 1935, Miller published *Utah*, the state road commission magazine, until "the war started and gas was rationed." He enlisted in the Seventy-ninth Infantry Division, fought in five battles—was awarded five battle stars, a Bronze star and a Purple Heart—and entered Paris mere days before liberation.

Returning stateside, Miller established Lorraine Press, "used printing as a means to publish," promoted sports, raised a family and wrote of his war years. In 2005, I received a last call from him. "Hey, kid!" he laughed.

Two months shy of his 100th birthday, Harry Miller died having batted a thousand, never missing a single moment of life.

Born to Learn, Martha Ross Stewart Soon Chose Her Very Own Path

In July 1915, Martha Ross Stewart was born in Salt Lake City with a built-in penchant for learning that would influence her life and those of others for more than ninety years.

The middle child of Utah calligrapher Milton Ross and his wife, Harriet, she questioned everything without pause. During the dog days of summer in 1918, her mother hadn't the energy to keep up with her. Pregnant and exhausted by the dry summer heat, Ross handed the three-year-old *The Book of Knowledge*, and the precocious child was soon reading.

"The book was a source of entertainment and cultural shaping," her daughter Heather Stewart Dorrell said. "It was probably her first gleaning of a much larger world outside her immediate value system."

When Martha was fourteen years old and attending LDS High School, a private school run by the Church of Jesus Christ of Latter-day Saints, she took theology classes and decided—to the lifelong consternation of her father—she was not of the faith.

That summer, while vacationing at the family's cabin in Lamb's Canyon, she also met Justin Stewart.

In the 1890s, the brothers Scott and John Stewart surveyed land in Provo Canyon for the U.S. government to issue homestead claims and decided to make "the exquisite wilderness" a home of their own. In 1969, more than five thousand acres of land called Stewart Flat were sold to

Robert Redford and dedicated to environmental conservation and the Sundance Resort.

"John's son, my father, was a young employee of the Forest Service who rode fence lines for the county," Dorrell said. "Yodeling up and down the canyon, mother saw him on his horse and was a goner. Dad became the lodestar of everyday people and the love of her life."

Graduating early from high school, fifteen-year-old Martha enrolled at the University of Utah, studied literature and the arts and left with high honors at age nineteen. During the depths of the Depression in 1935 she taught at a local high school and then traveled east to marry her beloved on New Year's Eve in New York City.

Martha Ross Stewart was born to question. *Stewart Family Collection.*

Until he completed graduate school at Columbia University, the couple maintained a long-distance relationship. But once he returned to Salt Lake City, they lived in the Avenues, raised three children and, as humanists, joined the Unitarian Church.

"Father worked with the Office of Price Administration during World War II," Dorrell said. "He set up farm cooperatives throughout Utah and then became a lawyer."

Augmenting the family's income, Martha became a librarian. She worked at the Salt Lake City Library and Utah State Library for the Blind. When she became an expert researcher for the Utah State Historical Society, reporters from the *Salt Lake Tribune* in need of information were known to call the historical society and shout, "Get me Martha!"

Martha Ross Stewart was a fine artist in oils and watercolors. She illustrated children's books, made linoleum block prints, clipped paper cutouts and designed exquisite stained-glass windows.

From age seventeen, she wrote poetry cached in a binder. Some of the verses are wry, light and sharp with puns; others are autobiographical and discerning: "We search each other's shining eyes in amorous inspections/ And you don't know and I don't know we're finding small reflections."

Her son Peter said she "adopted a [way] to appear like a round peg fitting in to attain her goals of husband, family, home and community of friends while providing an outlet for her restless intellect."

For twenty-five years, Stewart hosted bi-monthly brunches at home to explore the veracity of life and ethics. A humanist salon composed of free thinkers, it included a who's who of Utah intellectuals, politicians, religious liberals, activists, newsmakers, historians, journalists, professors, psychologists and librarians.

Until her death at ninety-three, Stewart continually discovered herself and wrote with no-holds-barred candor:

> *Baring your Id, you state as fact*
> *Will help you find your Isness.*
> *And how I keep my soul intact*
> *Is none of your goddam business.*

Part XI

A LOVE AFFAIR
WITH SPEED

"BIG BILL" RISHEL THOUGHT ANYTHING WAS POSSIBLE ON A BICYCLE

*Part One: Handlebar Fever, Randolph Hearst and
a Coast-to-Coast Relay*

Ever since he was a kid, W.D. Rishel was captivated by speed, endurance, competition, feats of derring-do and strategy, most having to do with getting from here to there. Born in 1869 in Punxsutawney, Pennsylvania, Rishel traveled westward with his family—his father was in the carpentry trade—before soloing into Salt Lake City.

A newsie for the *Omaha Bee* in Nebraska, the youngster used his fists to hold on to the best-selling street corner. In Fort Collins, Colorado, he rode his own horse, carried a .22 pistol in a rough-hewn holster and ate wild game. In Cheyenne, Wyoming, he became a backyard acrobat with dreams of joining the circus. During high school, he worked out at a gym, was a heavyweight boxer, contended in long-distance swimming and temporarily shoveled coal for the Union Pacific Railroad.

He then caught "handlebar fever" and joined the Cheyenne Bicycle Club.

By the mid-1890s, thousands of American bicycle enthusiasts—known as "wheelmen," "pacemakers," "scorchers" and "cracks"—reveled in breakneck speed, competition and sport.

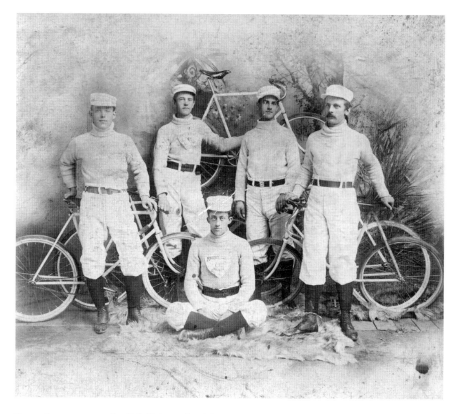

Preparing to race at the Salt Palace. *Special Collections, Marriott Library, University of Utah.*

Around the country, cycling club memberships soared. Riding regalia, from plug caps and knickerbockers to low shoes and racing shorts, flooded the market. Self-help books, such as *Bicycling for Ladies* by Maria E. Ward, included information on bicycle repair. Relay races, long-distance jaunts and rivalries were paramount.

Cheyenne, famous for its hard-packed ground and ferocious winds, was a mecca for bicyclists. According to his daughter Virginia Rishel, in *Wheels to Adventure*, Rishel rarely turned down a race.[36] Challenged to ride a mile in under two minutes with a "stiff wind behind him," club members selected a level road at Fort Russell and marked off the mile course.

Citing her father's account, the wheelmen "placed a signal man at the start and end of the mile, and a man with stopwatch in the middle to take my time." The young cyclist took a deep breath and set off. Completing the run in just over one minute and fifty-four seconds, Rishel became known as "Big Bill" and never looked back.

"Big Bill" Rishel lived for bikes and speed. *Utah State Historical Society.*

In 1895, the six-foot-three, 225-pound twenty-five-year-old with thick, dark hair; a square chin; and deep-set eyes set out for Salt Lake City, where bicycle fever was in the air. He published a bicycle magazine, joined the cycling milieu that included railroad magnate and future Utah governor Simon Bamberger and mine operator John Beck and was soon operating and promoting their new venture: Beck's Hot Springs Bicycle Track.

Riding in its first exhibition race, Rishel and Denver cyclist Harry Croll delivered Utah's first world's bicycle record.

In 1896, newspaper publisher and owner of the *San Francisco Examiner* and the *New York Journal* William Randolph Hearst, also an avid bicyclist, joined bicycle maker Stearns Manufacturing Co. to sponsor a 3,500-mile coast-to-

Racing. *Albion W. & Agnes Sharp Caine Collection, Marriott Library, University of Utah.*

coast relay race in which a Hearst publicity packet containing messages to be signed by state representatives would travel from San Francisco to New York.

Two hundred riders were expected to enter the contest, cover three hundred miles a day and make the journey from San Francisco to New York in twelve days.

Hearst contacted Rishel to organize the first leg of the trip into Nevada, Utah and Wyoming and manage its riders. Despite warnings of it being "suicidal," Rishel chose a route crossing Utah's challenging and volatile salt-and-mud west desert south of the Great Salt Lake into Salt Lake City. Most people thought he was mad. Ogden wheelmen were fit to be tied: a southern route would take their city out of the running.

In mid-July, Rishel and local cyclist Charlie Emise took a test run. Packing several sandwiches and two army canteens of water, along with an old hand-drawn map, they traveled by train to the northwest desert railroad town of Terrace. Leaving at 2:00 a.m. under a full moon and on a hard-crusted salt trail, the cyclists traveled over twenty miles per hour.

They suddenly encountered wet mud flats that instantly clogged their wheels and were forced to carry their bikes. Pressing on, they ran out of

water, deciphered the map and located the slow-dripping Cook's Spring near the Lakeside Mountains.

On their way, they passed skeletons of abandoned wagons and mule skulls. Marshes full of rampant mosquitoes greeted them at the Great Salt Lake. Twenty-two hours and one hundred miles later, the weary duo entered Grantsville in the southeast corner of the desert.

Undeterred, Rishel devised a strategy using the same southern route but providing enough water, rations, canvas shading and substitute riders. The Ogden wheelmen had another plan.

Part Two: The Great Bicycle Race of 1896 Just Missed Salt Lake City

Rishel believed the bicycle relay race would promote the capital city, stimulate business and attract hordes of spectators and dignitaries, including Utah's first governor since statehood, Heber M. Wells.

Ogden City's "crackerjack" wheelmen, however, were incensed. Such a trail, considered a quagmire at best and one that Rishel later confessed he would never do again for a million dollars, completely bypassed Ogden. Their city fathers, too, were outraged that they were snubbed. Editorials were published, accusations hurled and local newspapers had a field day.

In an open letter in the August 24, 1896 *Ogden Standard-Examiner*, Ogden wheelmen charged that Rishel "sacrificed distance and convenience." They proposed to Hearst a shorter route that would shave fourteen miles and save face. They sold the idea as "a relay race within a race."

Their plan was to post Ogden wheelmen near Terrace, hijack the Salt Lake packet, cycle around the north end of the lake into Ogden and head up Weber Canyon toward Echo and Rock Springs, Wyoming.

Apparently Hearst and his general manager, A.R. Grant, agreed to the plan, thinking it would fuel a healthy competition between old rivals. According to a follow-up story in the *Standard-Examiner*, "Each city will try for dear life to [hold on to the packet and] beat the other. It will be the most exciting feature of the great event."

Salt Lake wheelmen also devised a plan: one that involved guns, tire punctures, mishaps, misdirection and a strategy to steal back the race. That plan was derailed by a change of heart when a Salt Lake courier just kept pedaling.

According to Rishel, "The packet went through Terrace without a shot being fired." Relayed by an Ogden rider and taken to the next transfer, Rishel believed the conflict was averted.

Then, nature played its hand. Called the "Bedouin of the Desert" by a Hearst reporter, Rishel cycled on desert and mountain trails for miles and doubled as a substitute rider. But when heavy rains soured any possibility of following the southern route, he redirected the course to the north side of the lake, taking the relay race directly into Ogden.

While Rishel waited at Ogden's transfer site on Washington Street for his overdue couriers who would then take the packet south to Salt Lake City before resuming the route to Echo, he thumbed through morning dailies and was startled by headlines: "Ogden's Merry Bandits" and "Their Bold Coup."

The couriers never arrived in Ogden.

Eleven miles away, several wildcard Ogden wheelmen had taken matters into their own hands. Grabbing the packet from a Salt Lake courier, they left Ogden City high and dry and raced toward Echo just to best the Salt Lake wheelmen.

Grant rushed to the trail to ensure the packet's safety. A black ribbon was tied to Rishel's Yellow Fellow handlebars. Salt Lake City was indeed beaten. But the consummate sportsman took it on the chin.

Wiring his men to let nothing impede the relay's success and to take the packet, "however offered," his speediest rider picked it up and passed it on.

AN INCREDIBLE JOURNEY VIA MOTORIZED BIKE ACROSS 1903 AMERICA

On May 16, 1903, George A. Wyman set out to ride, push, prod, drag, patch and pedal his gasoline-powered, motorized bicycle from San Francisco to New York by way of the Sierra Nevada Mountains, Nevada's rugged highlands and Utah's salty West Desert.

Wyman's bike of choice was a new two-hundred-cc, one-and-a-half-horsepower California Moto Bicycle, designed and built by Roy C. Marks. Mounted on a traditional bicycle frame, the American-made model had wooden rims and was equipped with a leather-and-spring saddle and front and rear brakes. It promised speeds of up to twenty-five miles per hour.

The wheelman's epic journey—nearly four thousand miles in fifty days—was a first for coast-to-coast, motorized-cycle travel. A competitive cyclist, his story was published in the *Motorcycle Magazine*.

A Utah family prizes an 1890 motorbike/motorcycle; Joseph Barton Jr., on right. *Special Collections, Marriott Library, University of Utah.*

Nearly ten years before the historic Lincoln Highway was built, there were no printed maps or serviceable east–west routes but for the transcontinental railroad line that shadowed the early Oregon, Mormon and California trails.

Stowing gear and few amenities, the twenty-seven-year-old Wyman motored over steep hills and "ran full tilt into a patch of sand," landing ungracefully ten feet away. He bruised his muffler, became disoriented and was derailed by swollen rivers but finally located the Southern Pacific railway.

"The crossties of the roadbed make bicycle riding of any sort dangerous when it is not absolutely impossible," he wrote. "I walked the roadbed and 'bumped it' across the trestles."

Three days in, while "nursing" an overheated bike with oil every ten miles or so, Wyman made it across the Emigrant Gap in the high Sierra Nevada and stumbled upon a six-mile stretch he considered "the vilest road that mortals ever dignified by the term" and lost his oil can.

Floundering next in deep snow, Wyman took refuge in a series of slant-roofed snow sheds. He lugged his bike from one structure to the next.

Reaching Reno, he slept soundly in a hotel bed and departed under an overcast sky.

Alone in the middle of Lahontan Valley's Forty Mile Desert, Wyman wrote that his tire was punctured by "a fragment of a beer bottle," one of many most likely tossed from passenger trains. Plugging it with a two-inch wad and binding it with tire tape, he was relieved to ride on hard-packed sand abutting the rails but confounded by the loss of his second cyclometer. The first one had bounced off a Sacramento bridge.

Wyman bought gas and a third cyclometer in Lovelock. He pulled out his Kodak pocket camera to capture Humbold's grandeur. Several miles west of Winnemucca, he took a shortcut away from the railroad tracks and got stuck in sand dunes.

"This is the place where automobiles that try to cross the continent come to grief," he later wrote.

Heeding rail lines into the Great Salt Lake Desert toward the Central Pacific railroad town of Terrace, Utah, Wyman got a rare glimpse of the town's sixteen-stall roundhouse, eight-track switchyard and bustling population before it became a ghost town.

Wyman tended to frostbitten ears and sunburned eyes on the same day. Seeing a mirage, he raced toward a Conestoga wagon that didn't exist. But when an overnight rain hardened the desert floor, Wyman joyfully cruised

Women into bicycling; an adventurous soul takes on the motorcycle, Orderville, Utah. *Special Collections, Marriott Library, University of Utah.*

104 miles along the northern shore of the Great Salt Lake and roomed at a section house that offered clean sheets and a good mattress.

In Ogden, Wyman picked up a new set of tires and oil. He met bicycle shop owner and future car dealer Louis H. Becraft, noted in 1899 for being Utah's first to own a gas-powered, single-cylinder Winton. Wyman purchased new handlebars (after using a wooden stick for one hundred miles) and replaced ten wheel spokes. He also befriended S.C. Higgins, who offered hospitality and, sporting his own custom-built, gas-powered bicycle, accompanied Wyman on to the next set of rails.[37]

A CENTURY AGO, CARS STARTED RACING AT BONNEVILLE SALT FLATS

In August 2014, the Southern California Timing Association launched its sixty-fifth annual Speed Week on Utah's Bonneville Salt Flats. Some five

Ab Jenkins began his speed days racing a Union Pacific train from Salt Lake City to Wendover and besting it by five minutes. Here he is shaking hands with a friend before racing his "Mormon Meteor" on the Bonneville Salt Flats Raceway. *Special Collections, Marriott Library, University of Utah.*

hundred drivers from around the world were expected on the glittery white salt expanse with droves of avid spectators imbued with "salt fever."

But before Speed Week could begin, heavy rainstorms flooded the flats. The show was canceled. Racers and crews packed up and left town. Two Californians had to pull the plug on their attempts to set a Guinness world record. And border town businesses took an economic bath.

Despite the three inches of standing water, one milestone remained: Bonneville's one hundred years of speed racing on salt.

Conceived by *Salt Lake Tribune* automotive editor Bill Rishel, the former racing bicyclist, Bonneville became a reality in August 1914 when racecar idol Teddy Tetzlaff went full throttle to set a land speed record on brine near the old Salduro rail station.

"Rishel believed this race course [the predecessor to Bonneville] would rival the Indianapolis Speedway," wrote automotive enthusiast Robert Rampton. "Built on a surface with unlimited potential for speed, the venue would make Utah the center of the speed world to which automobile companies would flock to test machines and set records."

But to get paying spectators to travel the 115 miles from Salt Lake City to the speedway, Rishel spent years promoting construction of a new highway, now Interstate 80, that followed the Western Pacific Railroad grade. Promising endorsements by the American Automobile Association, he persuaded national racing promoter Ernie Moross—who had been successfully headlining car shows in Salt Lake City and Ogden—to join the effort in 1914.

In July that year, Western Pacific railed Moross's crew and equipment to Salduro. While racers "Terrible" Teddy Tetzlaff, Billy "Coal Oil" Carlson and Wilbur D'Alene and his Marmon Wasp traversed the salt pan and "ambushed" passing trains to the delight of their passengers, Salt Lake civil engineer Frank Jacobs surveyed the flats to create an official course.

The challenges were many. "Utah's high altitude and thin atmosphere caused carburetor problems, especially vexing among the temperamental Maxwells," Rampton wrote. "But surprisingly, the moist salt clinging to the tires caused no heat or chaffing to the expensive casings."

With the official race set for August 12, 1914, the *Salt Lake Telegram* reported that a Western Pacific excursion train, with "two Pullmans, two coaches and a buffet car," transported two hundred paying spectators at twenty-five dollars each. Included in the group were Utah governor William Spry and Salt Lake City mayor Samuel Park.

John Cobbs racing the "Railton Mobil Special" on the Bonneville Salt Flats Raceway. *Special Collections, Marriott Library, University of Utah.*

John Price and the Mormon Meteor III, recently acquired and restored by the Price Museum of Speed, on the Bonneville Salt Flats, September 2008. *John Price.*

Before arriving, Rishel grudgingly accepted the AAA's decision to sanction only a half-mile record attempt. "Mirages caused by the shimmering surface heat prevented the timers from seeing one another at a mile distance," Rampton explained.

At 2:00 p.m., the affable Moross greeted the gallery and announced the various cars and drivers through his pigskin megaphone.

Tensions ran high but never more so than during the finale, when Tetzlaff signaled the tow car to take him, mechanic Dominic Basso and the Blitzen Benz onto the salt.

The Benz began rough—before it and the crowd roared.

As Tetzlaff gained speed and changed gears, Basso worked the hand pumps to keep the oil and gas tanks pressurized.

Suddenly, the Benz's front end shuddered. "For a split second," Rampton wrote, "Tetzlaff considered aborting. Instead, crouching as low as he could safely go, he opened the throttle as far as it would go."

Traveling at 142.85 miles per hour, the Benz hurtled past the first flagman and then the second, covering a mile in 25.2 seconds."

"Besting the standing record by one-fifth of a second, it seemed Tetzlaff was the new Speed King of the World," Rampton wrote.

But sanctioned only for a half a mile, officially, he wasn't.

Part XII

RISING TO THE CHALLENGE

DEPRESSION-ERA CCC MADE AN IMPACT STILL FELT IN UTAH

During this country's Great Depression, thousands of banks failed, businesses shuttered and cities teetered on the brink of bankruptcy. By 1932, more than thirteen million people were unemployed. Unpaid credit swelled into foreclosures and repossessions. Farmers lost their land, equipment or both and city folks their livelihood and homes.

Shantytowns, often called "Hoovervilles," sprang up. Breadlines formed. People rode the rails in search of work. Others took to the streets. Thousands took their own lives.

Utah was hard hit. According to historian John McCormick, in 1933 the state's unemployment rate was "35.8 percent, the fourth highest in the nation." By spring, 32 percent of its residents relied on government relief.

In a battle to right the union, Democrat Franklin D. Roosevelt ran for president and, defeating the incumbent Republican Herbert Hoover, took office on March 4, 1933. He pledged a "new deal for the American people." Within his first one hundred days in office he established the federally funded Civilian Conservation Corps (CCC) as part of the administration's New Deal Coalition.

A public works relief project, the CCC offered training and jobs for thousands of unemployed, unmarried, unskilled physically fit young men to

generate financial relief for their families. The temporary program fostered the president's belief in environmental conservation and natural resource development on federal, state and local lands, parks and forests. It reinforced his goals for "relief" (jobs), "recovery" (economic growth), "reforestation" and "reform" (regulation of banks and railroads).[38]

In August 1933, nearly 300,000 enrollees ages eighteen to twenty-six worked in some 1,400 CCC camps across America. After Utah's first was built in Logan Canyon, 26 others became home to 900 Utah boys and 4,300 youths from the Midwest, the eastern seaboard and the American South.

Each worker was given a six-month contract with opportunity to reenlist for an additional two years. They worked forty-plus hours a week, earned thirty dollars a month—from which a mandatory twenty-five-dollar check was sent to their families—and were provided clothing, food, shelter and medical attention.

Unemployed "local experienced men" (LEMS) were hired as project leaders in carpentry, blacksmithing, agriculture, mining and road building. CCC enrollees attended high school classes and learned to drive trucks and operate heavy equipment. They took emergency training, rescue and firefighting courses and were valuable assets during Utah's severe drought.

"In 1934, in terms of firefighting hours logged by the CCC, nearly 12,000 man-days were [consumed]," Kenneth Baldridge wrote in the *Utah History Encyclopedia*. "Added to their regular work, the CCC force constituted a 5,500-man fire brigade, units of which could be mobilized anytime for forest fire suppression."

As part of the New Deal Program, Dr. Simon Moskowitz, a former New Yorker, worked in CCC camps near Kanosh and Kanab, Utah, before transferring to Perry, just outside Brigham City, where he and his wife eventually settled. *Anne Dolowitz.*

When a devastating blizzard hit Utah in December 1936, CCC crews braved sub-zero temperatures and deep snowdrifts to save thousands of stranded sheep and cattle from starvation. They evacuated sick people and brought food and supplies to isolated towns and ranchers.

Assigned to federal divisions and state departments, CCC crews worked on widely diverse projects. They planted trees to combat soil erosion, cleared irrigation channels, put in pipelines and terraced steep mountains. They rid streams of noxious weeds, protected wildlife habitats and improved bird refuges on the Bear River and in Ogden and Willard Bay, Utah. They built roads, bridges, reservoirs, canals and dams; added telephone lines and one thousand miles of fences; developed trails; and built cabins, recreational campgrounds and buildings in our national and state parks.

Throughout the CCC's tenure, 30 to 35 CCC camps were built at any given time, representing a total of 116 camps in twenty-seven Utah counties. Tallied collectively, more than 16,000 Utah boys, 746 American Indians, 4,000 personnel and 23,000 out-of-state individuals participated.

The CCC boys gained lifelong skills. They boosted Utah's economy and went home. An editorial in the July 3, 1942 *Salt Lake Tribune* surmised, "The [CCC] aided youth to get a new grip on destiny and obtain a saner outlook on the needs of the nation."

Eighty-one years on, the CCC's contributions to this state remain enormous.

1943 THEATER BLAZE TOOK LIVES OF THREE FIREFIGHTERS

During World War II, while many firefighters were serving in the military, the Salt Lake City Fire Department was understaffed, overburdened and limited to a small pool of experienced firefighters.

Wartime rationing stunted purchases of truck parts, tires and gasoline. Turnover was high. Morale was low. There were deep-rooted accusations of officer partiality and City Commission neglect in hiring staff and promoting public safety.

Tasked with organizing civil defense teams and collecting scrap metal, firemen worked long shifts with no equity in wartime pay. Even Mayor Ab Jenkins (the world land speed record holder who, with Augie Duesenberg, built the Mormon Meteor III race car and won the mayoral race without campaigning) could not break the commission's budgetary deadlock.

In May 1943, a devastating fire at the Colonial Theatre on 48 East 300 South demolished property, took the lives of three of the city's finest (firefighters Harry Christensen, Melvin Hatch and Theron Johnson) and incited a controversial probe.[39]

The Colonial, a three-story masonry structure later renamed the Victory Theatre, was built in 1908 by the entrepreneurial Auerbach family. Adjoined to storefront businesses and a hotel, the 130- by 80-foot theater was a landmark for stage shows, vaudeville and silent films. Its interior was drenched in fine fabric and ivory, gold and green color schemes softly illuminated by lights encased in frosted glass. The 1,800-seat capacity spanned the main floor, balcony, top gallery and box seats.

"From every seat, a proper view of the stage may be had," reported *Goodwin's Weekly* (October 31, 1908). Indeed, on opening night all eyes were on world-renowned opera singer Madame Nordica, who thrilled the full house with Wagner's *Wild Cry of the Valkyrie*.

In 1928, Al Jolson lit up sound and screen with the new, all-talking Vitaphone film *The Singing Fool*.

Unfortunately, as later discovered on May 19, 1943, the complicated building's structure was not up to recently established fire safety codes and presented hazardous conditions. According to fire historian Steve Lutz, the theater was closed for renovations when workman Bert Berch, climbing to the fly loft, smelled burning rubber. Spotting several auditorium seats on fire, Berch sounded an alarm at 8:24 a.m. and tried to douse the flames with the theater's standpipe hose.

When the first fire alarm crew arrived, led by acting battalion chief Don White, a second standpipe hose streamed into the blaze. Fire hoses and air lines were laid out. Tethered to a fireman's breathing apparatus (face mask), air was supplied through stationary, hand-cranked pumps. The length of air line determined the extent of a fireman's reach. According to some, there were never enough facemasks to equip an entire crew.

The uncontrolled fire began in the basement and charred it. Dense smoke billowed across the ceiling and mushroomed down from the balcony tier, which also housed the projection booth and equipment. Hose streams, directed overhead, attempted to cool down and prevent the hot gasses from bursting into flames.

By 8:35 a.m., a general alarm summoned the city's entire fire forces. Companies arrived with fewer firefighters than expected. Assuming command, assistant chief Lloyd Egan ordered upper exit doors, ventilators and windows opened. Water supplies and additional hoses were set out. The

fire, racing toward the foyer, roared up the theater's purely decorative but hollow columns into the balcony and headed to the timbered fly loft.

Some crews battled the flames from the outside. Melvin Hatch and his men fought the fire under the balcony. Overheated, fireman Ed Phillips handed his mask to Christensen and went out to work the pumps.

On neighboring rooftops, Denver and Rio Grande Railroad and Utah Ordnance Plant fire crews subdued flames ignited by radiant heat.

At 8:50 a.m., Chief LaVere Hanson arrived. Eight minutes later, the over-weighted balcony collapsed without warning. Trapped beneath the burning rubble, Christensen, Hatch and Johnson died of burns, injuries and smoke inhalation.

Each family received compensation. In 1943, a fallen firefighter's life was worth $5,423.23.

UTE CREW HAD THE RIGHT STUFF TO FIGHT WILDFIRES

On June 21, 1963, lightning strikes sparked series of wildfires in Dinosaur National Monument. One fast-spreading blaze had already consumed acres of wilderness land when the National Park Service called into action the newly established Northern Ute Indian Fire Fighters.[40]

According to the *Ute Bulletin*, Ute firefighter crews were sent to the Wyoming side of the mountain, dropped into the northern corner of the forest and, by early evening, were on the fire line.

"The boys fought the fire most of Friday night into Saturday and, after a short rest, continued," the *Bulletin* reported. "[By Monday], a weary group of men arrived in Fort Duchesne to tell of the first experience many had with a forest fire."

Eight days later, the Ute Indian firefighters quelled flames in San Isabel National Forest in Colorado. Within six months, the forty-two-member organization was called out to major "range fire disaster areas" from Colorado to California. By 1964, their roll call nearly doubled.

"Firefighting in those days was a 'call when needed' type of employment," said Kirby Arrive, Bureau of Indian Affairs fire management officer for the Uintah-Ouray Indian Reservation. "It was challenging and exciting work that appealed to a lot of tribal members trying to make money and support their families."

This page and next: These four images show Northern Ute Indian Fire Fighters from 1963 to 1974 who helped manage blazes on national parklands. Kirby Arrive, with the Bureau of Indian Affairs, said the challenge, excitement and pay attracted workers, as well as the connection the Ute people feel with nature. *BIA Uintah & Ouray Forestry Collection, Uintah County Library Regional History Center.*

It was also, he said, a genuine fit.

"The Ute people have a connection with nature," he said. "Fire is an element of nature intertwined in their culture, traditions and ceremonies. They understand fire, respect its role in life and have a great sense for what it could do, which, I believe, helped them as wildland firefighters."

The men had to be physically fit with strong backs, the ability to withstand heat and the staying power, if needed, to work more than twelve hours on a fire line.

"My husband, Robert, was sixteen years old when he started out fighting fires," said Joan Yazzie. "He did it for the money but then realized he loved the work and gained satisfaction from being good at it. They didn't have the restrictions firefighters have today. He'd leave for weeks at a time, take all his supplies, camp wherever he could."

Robert Yazzie would carry a small backpack pump—known as a "piss pump"—to a fire, as there were no water trucks. He'd work straight through until the fire was out.

The same was true for tribal natural resource ranger Michael Arrowchis, who said fighting fires was hard work, sometimes dangerous and just right for young men hankering for experience.

"I was sixteen years old, hired to do the job, so I needed to get the job done," he told me. Some fifty years later, Arrowchis remembers the chilling sound of a fire gone rogue.

"We were called to a fire at Bear Wallow on the north part of the reservation here, and just as we started, we heard a roaring so loud we didn't know what it was," he said. "Then the fire just exploded. It burned right up to the treetops and over and kept on going. We had to evacuate."

Before fibers such as Nomex were introduced in 1967, fire-resistant clothing and shelters were limited. Most firefighters wore what they had and were given helmets, goggles, boots and gloves. The two-faced, rake-and-hoe McLoed and the double-edged axe and grub hole Pulaski were standard hand tools.

Safety was mandatory and reinforced often by the late BIA forester Walter Sixkiller, in charge of crew operations and performance.

Marshall Colorow, who worked with Sixkiller, said safety and training meetings were held regularly. "Then we'd go into the fields to learn how to go about things," he said.

Over the next decade, the skilled Northern Ute Indian Fire Fighters served ten western states, earned national recognition and never missed a call.

"As a kid, I remember my father smelling like fire," Gina Sixkiller said from her home in New Mexico. "I used to think it was the most wonderful smell in the world because it meant Daddy was home."

Part XIII

OPENING SCENES

MAUDE ADAMS: UTAH'S "MOST ILLUSTRIOUS DAUGHTER"

In 1873, Maude Adams (née Kiskadden) made her first stage appearance in a fast-paced, theatrical farce held at the Brigham Young Playhouse in Salt Lake City. Called *The Lost Child*, the plot included a distraught father, busy restaurant and harried waiter. Maude was nine months old.[41]

As it happened, the original star (an infant) was colicky. Its parent had called it quits. Maude, with her nanny, was at the stage door. Her mother, Annie Adams, the stock company's leading actress, was watching in the wings. The second act was fast approaching. The theater manager was frantic—until he espied Maude. In one fell swoop, he picked her up and placed her on the waiter's platter; enter stage right.

The timing was perfect. Maude's wide-eyed, guileless performance charmed the audience. Her stage presence foretold a stunning future.

Theatrical producer Charles Frohman would manage Maude's rise to stardom. Playwright J.M. Barrie, enamored by her "piquant" grace and waiflike qualities, would make Maude his eternal Peter in *Peter Pan; or, the Boy Who Wouldn't Grow Up*. And Czech artist Alphonse Mucha would capture in oils her ethereal role as Joan of Arc.

Winsome, lithe and unfailingly talented, Maude became America's premier actress and an international sensation. An intensely private person

who donned so many personalities that she alluded to her own being as "the one I knew least."

Maude was born in Salt Lake City in 1872. Her mother, Annie, was of pioneer Mormon stock. Her father, James H. Kiskadden, was an Irish Gentile. The only living child of the well-known actress and "dashing" horseman in the mercantile trade, Maude's theatrical roots were in her genes.

Maude Adams, child actress, as featured in the January 9, 1909 *New York Star*. *From the* New York Star.

Moving to San Francisco with her family in 1877, the four-year-old took to the stage in earnest. She memorized one hundred lines to play the boy named Schneider in *Fritz, My German Cousin*. Within a decade, she had performed children's roles in twenty-six plays.

In 1883, Kiskadden died unexpectedly from pneumonia. Constant companions—her mother Annie was often away on tour—the father and child shared a lighthearted, protective and kind relationship. He was her "faithful" ally. She grieved for years.

Actress Maude Adams, born in Salt Lake City in 1872. *Library of Congress.*

When Maude was twelve, Annie sent her back to Salt Lake City to live with her liberal Republican grandmother and attend the Presbyterian-based Collegiate Institute that later became Westminster College. But Maude lived and breathed theater and at fourteen left for an apprenticeship with a theatrical company. Touring with her mother in 1890, the two women joined Frohman's stock company at New York's Empire Theatre. Under the producer's tutelage, Maude Adams performed numerous plays with matinee idol John Drew, including the smash hit *The Masked Ball*.

For J.M. Barrie's *The Little Minister*, Maude played the revised role of Lady Babbie in over 360 performances. In Edmond Rostand's play *L'Aigion*, she received twenty-two curtain calls for her lead role as Napoleon II. The first American woman cast as Peter, she acted in more than 1,500 stage performances of *Peter Pan* and made $20,000 a month.

A seasoned actress of immense wealth, Maude purchased a four-hundred-acre farm and estate on Lake Ronkonkoma, New York, with a summer home in Tannersville. Once suffering a nervous breakdown, she found solace and comfort among the sisters of Our Lady of the Cenacle and bequeathed her land to them as a gift.

Semi-retired in 1916, Maude worked on perfecting stage lighting with General Electric. She dabbled in Eastman Company's color photography and taught drama at Stephens College in Missouri. She then played Portia in *The Merchant of Venice* (1931) and Maria in *Twelfth Night* (1934).

Adams died shy of her eightieth birthday and was buried on the convent grounds. Her sightings in Utah are rare; a large portrait was found at the University of Utah's Fine Arts Museum. And James Nelson recollected in *Legends, Lore & True Tales in Mormon Country* that the Daughters of Utah Pioneers Museum (Salt Lake City) displays a "framed poster of the actress and faded show tickets"—possible memories of 1910 when Utah greeted Adams as its "most illustrative daughter" and she performed *What Every Woman Knows*.

VAUDEVILLE FLOP SID FOX DAZZLED UTAHNS WITH TV

In 1906, Sid Fox left St. Louis, Missouri, and headed west toward Denver.

"In those days, Denver was a typical mining town with a number of music halls and saloons," said the early Utah radio and television pioneer

and promoter in interviews archived at the University of Utah. "I got off the train, took my grip, and walked up 17th Street to look for a place of lodging and work."[42]

Fox, then seventeen, found a room for a dollar a day and sold printed business cards to some two hundred soiled doves—working girls representing themselves. But he really wanted to be a song and dance man. Collaborating with a piano man, he tapped his way into vaudeville and booked his act. His career was short lived. "I didn't have much of a voice," he said, "so I went into the film business."

He became a traveling salesman and promoter and wended his way to Utah.

Occupying two floors in Salt Lake City's downtown Walker Bank Building, Fox's foray into radio was through advertising a laxative called "Miracle Diamonds."

"Crystals from the Great Salt Lake," he said. "They looked like diamonds. Sparkled like diamonds. And when you dried them out and put them in a box, they poured out like diamonds." They were packaged with an illustration of a beautiful woman stepping out of a diamond, as one would a rosebud.

Fox hired a series of writers to produce copy for print media and radio promotion. Then he ventured into broadcasting. "Radio, television, I have to laugh," he said. "It all started when I couldn't make it in show business."

In 1927, Fox purchased the AM radio license account for KDYL, "the thirteenth commercial radio station in America," formerly owned by the *Salt Lake Telegram*. By 1930, the station's orchestra leader, Eugene Jelesnik, had become a household name.

In 1938, Fox aired the KDYL Playhouse in the Masonic Temple on First South and Second East Street. But after RCA introduced television at the 1939 New York's World's Fair, Fox declared: "Brother, television's the thing!"

Fox purchased a "television unit" from NBC, set up public demonstrations at the fashionable Paris Company and captivated forty-five thousand onlookers. By 1946, KDYL became Utah's "first independent television station to broadcast test patterns in the United States."

Within two years of experimental broadcasting, KDYL-TV ran twelve hours a week on a five-day schedule. Vaudeville stars like Jack Benny, Milton Berle, George Burns and Gracie Allen quickly embraced the new technology.

Even "dis is Jimmy Durante, in poyson" got into the act. In 1948, the American movie star, singer and comedian was escorted from Hotel Utah to the Utah State Fairgrounds by Salt Lake City mayor Earl J. Glade, Governor Herbert B. Maw and the Ute Rangers on horseback.

Left: A dapper Sid Fox with his wife, Miriam. *Special Collections, Marriott Library, University of Utah.*

Below: KDYL's Kangaroo Club. *Special Collections, Marriott Library, University of Utah.*

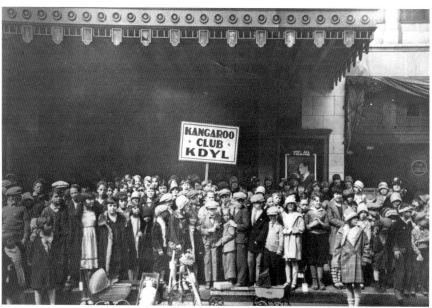

To the hot sounds of Eugene Jelesnik's twelve-piece orchestra and master of ceremonies, A. Wally Sandack, the prominent "Schnozzola's" KDYL-TV pitch for the American Cancer Society, Durante himself was seen by an avid populace that never left home.

In 1953, Fox sold his lucrative business to TLF Broadcasting, a subsidiary of Time Inc., and segued into new ventures.

"Wherever Fox went, he was dressed to the nines with a clean collar and spats and an entourage of followers," Salt Lake City businessman and late friend Ralph Tannenbaum told me years ago. "He was an exciting fellow, an innovative man with many ideas and a kind philanthropist. He was also a compulsive gambler."

Try as he could to break free, gambling held a firm grip. By 1970, Fox was broke—but not broken.

"A group of community members pooled their money every month to see Sid through," Tannenbaum said. "They put him up in the Belvedere Apartments in downtown Salt Lake City. Until the end of his life, he was dapperly dressed. Though, his monogrammed cuffs may have been slightly frayed."

In 1980, Sid Fox died at ninety-one years old. Who knows what the entrepreneurial "analog aristocrat" might have done with digital.

MARX BROTHERS HONED
A NIGHT AT THE OPERA IN UTAH

The Marx Brothers and company were taking the business of laughter seriously when they arrived at the Orpheum Theatre in downtown Salt Lake City to field-test material for a future film called *A Night at the Opera* before a live audience.[43]

Two years earlier under Paramount Pictures, the Marx Brothers' now classic film *Duck Soup* charmed many but, lacking a solid plot, riled critics and tanked at the box office. Despite previous movie successes, including *Animal Crackers*, *Monkey Business* and *Horse Feathers*, Paramount frowned, and the Marx Brothers looked elsewhere for work.

Groucho and Chico returned to the stage and broadcasting; Harpo embarked on a six-week tour of the Soviet Union.

The story goes that, over a friendly game of bridge, MGM producer Irving Thalberg and Chico Marx struck a new movie deal and the Marx Brothers were back in business.

Unlike *Duck Soup*, however, *A Night at the Opera* represents an operatic comedy and love story with sight gags, music, generous skits of spontaneous hilarity (you can catch the infamous stateroom scene online) and an everyday story line audiences could take to heart.

Working at breathtaking speeds while taking pokes at high society, the brothers race to the rescue of two young opera singers—a leading lady and her unrecognized yet highly talented tenor boyfriend. Madly in love, they are separated on stage and in life by a pompous European opera impresario who has other ideas for his star.

A Night at the Opera, written by James Kevin McGuinness, was adapted for film by George S. Kaufman and Morrie Ryskind. To ensure the movie's "laugh-worthiness" before committing any shtick to celluloid, Thalberg sent the script for a trial run in Seattle, Portland, San Francisco and Salt Lake City.

"We are kicking ourselves we didn't think of this before," Groucho said in the April 13, 1935 *Salt Lake Tribune*. "A successful comedy depends almost entirely upon audience reaction, and if anyone tells you he can sit in Hollywood and judge in advance how much Salt Lake or any other city is going to laugh at any given 'gag'—don't hesitate, put in a hurry call for the psychopathic ward. We expect our greatest help from Salt Lake, for it is our first stop…and we will get a definite idea of the script's value."

Ryskind attended the weeklong performance at the Orpheum's 1,160-seat vaudeville house designed by Salt Lake architect Carl M. Neuhausen. The *Tribune* ran ads: "The Marx Bros., on the Stage, in Person." Tickets sold for forty cents for matinees, fifty-five cents for evenings and ten cents for kids. The theater was packed.

Ryskiund recorded audiences' reactions, timed laughs, analyzed groans and reworked the script for the next day's show.

That April 17, the *Tribune* reported that failed gags were "'blue-penciled' so that by the time the organization has been around the four-city circuit the writers and producers will know pretty well just what and what not to include in the final script for a bang-up picture."

The film was a $3 million hit—and Groucho's favorite.

From 1947 to 1961, Robert Dwan (my sister-in-law Judith Dwan Hallet's father) directed Groucho's *You Bet Your Life*, the radio/television quiz show in which the consummate comic's stunning timing and rapid-fire improvisation captured national ratings.

In his retrospective, *As Long As They're Laughing*, Dwan described Groucho as an intensely private man, whose mother, Jewish immigrant Minnie née Schoenberg, embodied determination and resolve.

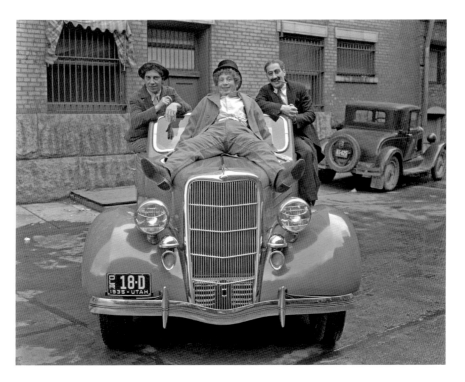

The Marx Brothers leave them laughing at Salt Lake City's Orpheum. *Utah State Historical Society.*

In 1958, Groucho invited Dwan and young Judy to accompany his family to Minnie's hometown in Dornum, Germany, in search of her roots. Stunned, they discovered Schoenberg and every other Jewish name had been stricken from the town's records.

Days later, they were escorted to Hitler's bunker, where, Dwan wrote, a somber Groucho climbed to the top of the rubble, "stood for a moment and danced his eccentric, frenetic Charleston. It was not a casual gesture."

WORLD WAR I AND MAUD

STRONG-WILLED AND INDEPENDENT MAUD FITCH

On April 6, 1917, the United States joined the Allied forces to defeat Germany and the Central Powers in what was then called the Great War (1914–18). More than two hundred bilingual female telephone operators, called "Hello Girls," were recruited to serve abroad.[44]

An initial corps of four hundred nurses was sent to France to work in base hospitals. And nearing the war's end, Maud Fitch, a thirty-five-year-old society gal from Eureka, Utah, traveled to Manhattan to join the Woman's Motor Unit of Le Bien-etre du Blesse. She qualified as an ambulance driver, purchased her own truck and sailed to France to do her bit.

"To think at last I shall get into the very vortex of the greatest conflict in the history of the world," Fitch wrote in a letter to her parents reprinted in historian Miriam B. Murphy's 1990 *Utah Historical Quarterly* article, "If Only I Shall Have the Right Stuff: Utah Women in World War I."

Born in 1882, Maud was strong-willed and independent. She was a fine athlete and an expert automobile driver. Her father, Walter Fitch Sr., was a wealthy Utah mine owner who developed the Chief Consolidated Mining Co. in the Tintic Mining District and the nearby Fitchville community. An advocate for his daughter's ventures, Fitch bought Maud's ambulance truck to take to the front. He paid in advance for

six months' worth of oil and gas and most likely the thirty dollars per month required for upkeep and repairs.

Although Maud hoped to drive for the Red Cross, she eventually joined the Hackett Lowther Unit, a private corps of British and American women serving the French Third Army. Among their tasks was to transport the wounded from front line medical units to evacuation hospitals.

Maud often worked long shifts, sometimes thirty hours at a clip. She was known to catnap in back of the ambulance and, she wrote, "stroll about the hills with the guns at the front hammering in our ears."

In the October 5, 1918 edition of the *Salt Lake Tribune*, the *London Mail* reported, "These

Maud Fitch jumped into the "very vortex of the greatest conflict in the history of the world." *Utah State Historical Society.*

[ambulance] women have performed the work of men. They have fulfilled their dangerous duties unflinchingly."

Transporting the wounded from the war zone was no mean feat.

"An aviator just fell about a half a mile over [the airfield] and I had to go after him and take him back, cross-country over a terrible stretch," Maud wrote in the October 7, 1918 issue of the *Tribune*. "At one time in a potato patch, I [got] stuck as too many doctors had got in with him. With a wild prayer, I was out of the hole in only a second, and then I had to make a horrible race for the hospital, four kilometers [2.4 miles] away, and over such a road! If I jarred him, he would die. If I didn't make it in time, he would die. I shall dream that four kilometers all the rest of my life. But I got the poor thing there alive."

According to Murphy, Maud "thrived on dangerous 'front work.'"

During one night rescue, Maud drove five wounded soldiers through heavily shelled areas, bribing Allied sentries with cigarettes to stop troops, trucks and traffic so she could motor through to the hospital.

She assisted at a barrage, which was "thrilling beyond anything else." she wrote. After another flawless rescue attempt driving under heavy artillery fire to save lives, she received a gold star.

Maud was as fearless under fire as she was experiencing life. An accomplished horsewoman, she rode a cavalry horse through the woods, swam in streams, danced with soldiers, fine-tuned her ambulance, chauffeured a French colonel, joked with peers and fired a 74-milimeter field gun.

After the war, Maud returned to Eureka, married mine superintendent Paul Hilsdale and raised a son, also named Paul. Living well into her nineties, Maud never lost her indomitable spirit or her pack of Chesterfields. Who knew how many other roads she would have to cross?

Part XV
A MATTER OF SURVIVAL

FRIGHTENING TIMES

Part One: A Young Jewish Girl's Life Changed in Ways Unimaginable

In 1928, Liesel Shineberg was born in her family's ancestral home of Aachen, Germany. Located near the borders of Belgium and Holland, Aachen is known for mineral springs, spas, medieval architecture and Charlemagne's imperial Palatine Chapel. For years, Aachen Jews led productive lives as German citizens. During World War I, many served in the German army. When the Nazis came to power in 1933, the city became one of disbelief for its Jewish residents—and five-year-old Leisel's "world began to change."

Shineberg, née Stern, was born to a "life of privilege, comfort and happiness," the eighty-six-year-old Ogden resident wrote in her unpublished memoirs.[45]

Her father, Max Stern, owned a textile factory. Although his wife, Anna, died during the 1928 influenza epidemic shortly after giving birth, Stern's second wife, Minna, was a devoted mother to Leisel and her older sister, Lotte. The Sterns lived in a fashionable household that included Erna and Adele, their cook and nursemaid. They thrived in extended familial camaraderie. Minna emphasized courtesy and correctness coupled with exercise, healthy foods and fresh air.

Liesel Shineberg with father, Max Stern, before her world changed. *Liesel Shineberg.*

On January 30, 1933, Adolf Hitler became chancellor and head of the German government. In March, the Nazi Schutzstaffel, or SS, established the notorious concentration camp at Dachau. By April, Jewish-owned stores were boycotted. German citizens were warned "not to buy from Jews." Jewish doctors, lawyers and civil servants were forbidden to practice. Quotas were placed on "students of foreign race," including German Jews who had been part of the country's populace for more than one thousand years.

In Aachen, day-to-day activities were mostly undisturbed. But eventually, striving to maintain normalcy for their children, the Sterns couldn't postpone fate.

"In an effort to raise money for his army, Hitler instituted *Eintopfsonntag*, which translates to one-pot cooking on Sundays," the Ogden resident wrote. "In every household, the money saved from making one meal was collected. In Jewish homes, the 'donation' was doubled."

Adele and Erna abruptly left. "They were with us for all of my conscious childhood memory, but the government announced that to protect young women from 'lascivious' Jewish male employers, Jews could only hire maids over the age of fifty," Shineberg wrote. "We were all saddened by these events, kept in touch as much as we could, and when each one married, my father gave them lovely weddings for their loyal service."

Liesel attended kindergarten at a Montessori school. She was then enrolled in a Jewish primary school where she was often called on to read by visiting government officials investigating Jewish schools for subversive teaching.

"They would hand me a book with marked pages containing lines about 'bad Jews' being Germany's 'misfortune,'" she wrote. "It was frightening, I was afraid to make errors, and when the strangers left, I would have to hurry to the bathroom."

In 1938, ten-year-old Shineberg and two other Jewish students entered the fifth grade at the public Victoria School. The teachers wore brown uniforms banded with Nazi emblems. The Jewish students, seated in the back row, quickly learned what to expect.

"It happened daily," Shineberg recalled. "The door would open, a teacher would step inside and shout 'Out!' at us and we'd leave. The door would close. We could hear the class saying, 'Heil Hitler.' Then the door would open and we'd return to our seats. If we were tripped, we apologized for being in the way."

On November 9, 1938, violent pogroms against Jews called *Kristallnacht*, or Night of Broken Glass, raged through Germany, annexed Austria and parts of Czechoslovakia. Dozens of Jews were killed, and more than thirty thousand were arrested. Some 250 synagogues were torched and several thousand businesses destroyed. Jewish cemeteries, homes and schools were vandalized. The death knell had sounded. No one was safe. Not even in the isolated city of Aachen.

Liesel was late to class and racing up the metal stairs two at a time when she ran into a teacher.

"I whispered, 'I'm sorry. I didn't mean to.' He grabbed me by one arm and slapped me so hard across the face I fell backward down the stairwell. I heard heavy boots clatter and tried to get up. He struck me hard again, and [ordered me] home immediately."

Liesel left, tears checked, understanding there was no going back.

Part Two: Avoiding the Crowds

Leaving the school grounds, Liesel walked rapidly. She cautiously circumvented the nearby plaza and avoided crowds.

"Jewish children knew not to call attention to ourselves," she wrote. "We were aware of an invisible curtain of animosity, but I didn't know what motivated that teacher to hurt me."

When the Nazis took power in 1933, anti-Jewish propaganda was disseminated through films, theater, the arts, schools, radio, books and newspapers.

Suffering from a toothache, Liesel had an infected molar broken by a non-Jewish dentist who charged a high fee and refused to administer an analgesic, saying that Jews didn't feel pain.

Passing a kiosk, she saw a caricature depicting a Jewish man as humpbacked and lecherous, with oversized teeth and a rat-like face. She overheard a customer saying, "Jews like him would be taken care of soon."

Finally relieved to turn onto their street, Shineberg saw her stepmother standing out on the apartment's second-floor balcony. Minna had heard rumors and, worried about her husband's safety, was looking for him to come home. Already distraught, she was stunned by the sight of Liesel: coatless, cold and black and blue.

"She put her arms around me and I cried while explaining the confusing thing that had happened," Shineberg wrote. "Then the doorbell rang, which was strange, and it was Daddy, pale but smiling, and hugging us tightly."

Needing to speak privately to his wife, Max Stern sent his daughter to the neighborhood bakery to buy her favorite doughnuts: raspberry-filled Berliners.

The baker, relieved to hear Stern was home, added a loaf of bread and hard rolls to the order. Glancing around to see if anyone noticed, and hurrying Liesel to the door, he said it was a present for her father. Looking through his storefront window, the butcher, too, suddenly appeared from his shop holding a bag of spicy sausages just for her father. When Liesel arrived home with the generous bounty, she asked her parents what was really happening.

"I questioned 'Are THEY coming after us?' because even though my parents were trying to shelter me, I knew the word, *Konzentrationslager* (concentration camp) and the thought I might be included was beginning to connect in my young mind."

Working at the textile factory that morning, Stern and other Jews had been arrested. Herded into a synagogue, they were forced to collect the temple's valuables for the Reich. Windows were smashed. Religious books were burned; the men were beaten and humiliated, and the synagogue was set on fire, trapping those left inside. Fortunately, the "prisoners" escaped through a side door, and Stern was grateful to be home.

"From then on, Mother and I stayed indoors and left the apartment only for short trips to the few stores where we were allowed to shop," Shineberg wrote. "My father could no longer ignore what was happening and investigated every possible avenue of escape."

One night after celebrating Chanukah earlier in the month, Liesel's parents packed her clothes and a new wooden flute, a gift, in an overnight case. When a "stranger's" car appeared outside their building, the Sterns placed their daughter in the back seat next to her cousin, Werner Ganz. They kissed her goodbye and watched as the driver sped away to Holland.

Some time later, a homesick Shineberg tried playing her flute, but no sound emerged. Taking apart her instrument, she discovered stuffed inside

the slender tube were diamonds and a note from her parents: "In case of emergency, sell the diamonds. We hope to see you soon but the future is uncertain. We love you."

Part Three: Lotte's Arrival and a Family's Escape

Smuggled out by family friends, the children were given temporary Dutch status and taken to the Amsterdam apartment of Max's sister, Frieda Reiss. Then, with their youngest daughter temporarily out of harm's way, Max and Minna hastened to tie up their affairs in Aachen and ensure the safety of their older daughter, Lotte, who was living 335 miles away in Berlin.

Lotte was strong willed and talented. Seventeen years old and attending art school in the country's capital, she carried a false birth certificate stating that she was Catholic. She was also extremely deaf—a liability in Germany no matter religion or race. According to the U.S. Holocaust Memorial Museum, more than 275,000 adults and children "deemed unworthy of life" by the Nazis were "murdered because of their disabilities."

Lotte did not hear the Berlin riots: the sounds of destruction, the shattering of glass or the vicious plunders. What she saw were SA (Assault Division) soldiers and Hitler Youth troops—wearing civilian clothes—break into Jewish-owned businesses, ransack merchandise, paint anti-Semitic slogans on storefronts and beat terrified shop owners.

Lip-reading as thugs screamed "Jude"—Jew—she knew it was only a matter of time before she'd be discovered.

"As soon as she could, my sister walked to the railroad station and bought a second-class ticket to Aachen," Shineberg wrote. "She was sitting in a window seat when she felt someone—a Nazi army officer in full uniform—sitting next to her. Fortunately for Lotte, he did not realize she was deaf. As he chatted looking directly at her, she nodded and smiled. When he got off the train at the next station, she heaved a long sigh of relief."

Reunited with her family, Lotte learned they had twelve hours to leave their house or be arrested. Furthermore, they were required to relinquish their valuables to the Third Reich, hand over the family mill and walk to the border.

Permitted two suitcases each, the Sterns reached the Dutch border town of Vaals. There, they were examined and identified as Jews—although Max folded the passports to obscure the large "J" emblazoned on the page—and allowed in.

By 1939, more than thirty thousand refugees inundated the Netherlands. Detention centers were created from old bases. The Sterns were taken to an abandoned army post in The Hague.

Liesel waited three months before she could see them.

"I will never forget," she wrote. "My parents and Lotte were standing behind a barbed wire fence waiting for us. Mother was thin and harried looking. Yet with everything that had been lost, she managed to carry with her a piece of my past: a favorite doll."

Once Frieda Reiss found an apartment for the Sterns, they were released from detention. One day, a tiny box held together by rubber bands mysteriously arrived at the Stern home containing several pieces of Minna's jewelry—"we never knew who sent it"—and one of Max's brothers, Newton Stern, called with good news.

Onboard the SS *Volendum*, the Sterns sailed to America with the Ganzses. Liesel tasted shredded wheat for the first time, and the world she knew began to change again, this time for the better.

A Jewish Family's Escape from Nazi Germany

By the summer of 1938 in Nazi Germany, Jews had already lost most of their civil rights. They were required to register their property and forbidden to work in any commercial, industrial or government service. Physicians' licenses were revoked; lawyers were barred from practicing law. Jewish men and women with Aryan-sounding first names were "obliged" to add the middle name of *Israel* or *Sara* on identification cards, and on October 5, all Jewish passports were invalidated until the red letter "J" was stamped on them.[46]

For five-year-old Hans Joachim Praiss (John Price), life in Spandau, Germany, was "normal." He attended public school, toted a leather knapsack on his back, snuck into his father's movie theater with friends, devoured pastries and was only mildly perplexed when one parent or the other accompanied him the two blocks from home to Hebrew school.

"My father was a German citizen, a middleweight prizefighter in his youth, strong willed and silent," said the Salt Lake developer and former ambassador. "There were early warning signs that Jews were in danger, but I think he didn't want my brother Wolfgang or me to worry about it."

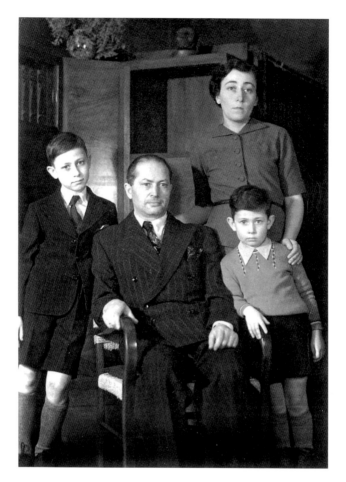

The Praiss family when business thrived. *Left to right*: Wolfgang, Selmann, Margarete and Hans. *John Price.*

Selmann Praiss invested in a city block of stores in a primarily Jewish district of Spandau. He hired many relatives and rented out shops. "The building had a grassy courtyard in the middle and apartments on the second floor where we lived," Price remembered.

The family enterprises, including men's clothing, dry goods and a haberdashery, thrived until 1936–37, when economic restrictions and the boycott on Jewish businesses sounded the death rattle.

"People tried to convince my father to leave," Price said. "He had helped two brothers immigrate to America. He had seen relatives suddenly disappear. But he believed Germany was going to oust Hitler. It didn't work out that way."

177

On November 9, 1938, Nazi party officials, the Sturmabteilung (SA) terrorist militia and members of Hitler Youth unleashed a wave of violent anti-Jewish pogroms called *Kristallnacht*, the Night of Broken Glass, throughout Germany and annexed Austria and areas of German-occupied Czechoslovakia.

They beat, killed and imprisoned hundreds of Jews. Torahs and synagogues were torched.

In Spandau, the grand 296-seat synagogue built in 1895 was reduced to rubble.

Carrying bats, crowds stormed into one Jewish-owned store after another, including the Praisses'. They smashed glass storefronts, looted merchandise and marked walls, display cases and broken goods with glaring yellow stars of David.

The Praisses were in their apartment. "The sounds were frightening," Price recalled. "My mother [Margarete] quickly closed the curtains and turned off the lights. My father covered our heads and prayed. We hid like we didn't exist and fortunately they didn't have ladders."

In the aftermath of the terror, Margarete swept up the shattered glass. Selmann boarded broken shop windows. He applied for insurance that

Selmann Praiss's passport. *John Price.*

never came and paid a fine. Forced to wear a yellow star sewn to their outer clothing, they stayed close to home. Realizing then there was no going back, Selmann began to plan a way out.

"My father had a non-Jewish friend and neighboring shopkeeper named Herr Trautschold, who had police connections and managed to get passports and visas for us," Price said. "My father must have paid an exorbitant amount of money to bribe the authorities in exchange for these papers. But at home nothing was ever said or discussed. One night, he just told us to pack for a day trip, and by early next morning we were gone."

On April 8, 1939, Margarete removed the identifying yellow stars from their clothing. Carrying little suitcases, several paintings sheathed in butcher paper and a concealed cache of family valuables to be sold as needed, the "normal" family boarded a train for the five-hour journey to the seaport city of Bremerhaven and the exit port to the North Sea.

There, a banana boat returning to Panama—one of the last freighters out—was waiting to take them to freedom.

JEWISH IMMIGRANTS SURVIVE WORLD WAR I AND NAZI PERSECUTION

Part One: That Horse was My Destiny

There's something about heroic tales of courage that embody our country's past—especially when bolstered by *Yiddishkeit*, immigrant stories of determination and verve. Take Fred Linden (Fritz Lindenstrauss), who led his family out of Nazi Germany and Shanghai to freedom in Salt Lake City.[47]

Born in 1895 in Prenzlau, the capital of the Uckermark District in northeastern Germany, Linden spent his youth surrounded by fields, meadows and woods. He sailed with friends in Lake Uckersee and cultivated a lifelong love of mountain climbing and cross-county skiing.

Linden's mother, Johanna, was twice a widow. Her first husband died young, leaving her with two girls. Her second husband, Joseph Linden, thirty-two years old, succumbed to typhoid fever when Fred was barely one year old and his brother, Curt, was a toddler. Joseph had owned a men's clothing store.

Johanna married a kindhearted gentleman, Max Rosenthal, and raised her family and kept the store going.

"I had a very good childhood, a loving mother vigorous and caring, and a stepfather who was also very good to me," Fred said in interviews and memoirs archived at University of Utah's Marriott Library.

In 1910, the fifteen-year-old left school to begin a career in textiles and sales. Following in his brother's footsteps, Linden apprenticed at a department store in Cammin, Pommerania, and in early 1914 found work in Stettin, near the Baltic Sea.

"It was a big city offering theater, opera, boat excursions and forests not too far," he said.

But by August 1914, Germany declared war on Russia and France.

"Curt had to go into the army right away," Linden said. "I'll never forget watching his regiment march to the railway station and walking side by side with him to bid farewell."

In 1915, Linden was drafted into the Field-Artillery Regiment No. 38. The following year, his brother was killed in action.

"It was a terribly hard blow for us," Linden said.

A cannoneer trained to ride horseback, Linden's fate was altered by a shied horse.

"Our howitzers were drawn by horses," he said. "Cleaning out the stables, I came too close to one horse, was kicked a hard blow to my belly and knocked unconscious."

Transported to a military hospital, Linden spent months in painful recovery—and learned that the edgy steed saved his life.

"That horse was my destiny," he said. "While recuperating, my regiment was transported to the Russian frontier. Not one soul survived."

Once healed and reassigned, Linden delivered munitions closer to the front. "We rode by night and suffered many casualties," he said. On November 11, 1918, armistice was declared. A year later, Linden made his way home.

Returning to his trade, Fred skillfully climbed the mercantile ladder. Then, in 1933, Hitler became chancellor of Germany.

"As a Jew, I couldn't work anywhere except in Berlin," he said. "In contrast to smaller cities where Jews were being persecuted and even transported to concentration camps, Berlin was an oasis."

Linden opened a shop and made a sale within hours. "The customer wanted material for a bride's dress—it was an omen for the good," he said. He met and married Ruth Salomon. They had a son, Kurt Joseph.

"We lived fifteen minutes from our store and felt homelike," Linden said. "My wife was a wonderful companion and partner. Our business was flourishing."

But there was no negotiating with the Nazi regime.

"I applied for immigration, often, but couldn't get visas," Fred said. After November 9–10, 1938, there was no going back.

During Kristallnacht—the two-day, state-sanctioned, violent attack against Jewish communities in Germany—Nazi storm troopers destroyed thousands of Jewish-owned stores and homes, set fire to synagogues, killed Jewish individuals and arrested and deported some thirty thousand Jews to concentration camps.

"Returning to open our store the next morning and seeing the shattered windows, swastika-painted walls and destroyed merchandise, I boarded the door," Linden said.

"My father became a hunted man," Linden's son, Kurt, told me from his home in Massachusetts. "He spent many evening riding the subway to avoid being caught."

Part Two: Escape to Shanghai

Almost too late, Linden purchased tickets to Shanghai. He smuggled funds to relatives in England and stood in line, relinquishing everything else to the Nazi-regime.

"More than saddening, it was the anger and depression to be powerless," he said.

On April 18, 1939, traveling by rail to Italy, the Lindens were ordered off the train, meticulously searched and miraculously released by German border police at Brenner Pass.

They spent an uneasy night in Genoa and were grateful to board the Italian liner *Giulio Cesare*, a "refugee ship of the East," departing for Shanghai.

In 1933, an estimated seventeen thousand German and Austrian Jewish refugees escaped to Shanghai followed by several thousand more after Kristallnacht. Greeting them at the port, the American Jewish Joint Distribution Committee offered housing, food and clothing.

"The Hongkou District in Shanghai was a designated area for Jewish refugees," Linden said. "The Wayside Heim, which the committee had assigned us, was a warehouse set up for fifty families with bunk beds divided only by curtains. It was a most appreciated refuge after having escaped Nazi Germany."

Once settled, Linden told his wife and son, "We have to think about making a living."

Typical photograph of the Bund region of Shanghai. *Lichenheim Family.*

Using his money from England, Linden rented a huge, two-story bombed-out structure. He employed refugee workmen and created a "European style" boardinghouse for Jewish immigrants. But bowing to Shanghai's staggering inflation, he eventually lost the house, but not his good cheer.

"No matter how difficult things were in Shanghai, my father put an optimistic twist on everything," Kurt said. "He made it even pleasurable."

"We moved to a smaller home with a storefront window," Linden said. "Ruth was an excellent dressmaker and we were in business."

In 1940, when the Japanese closed Shanghai's "open door" policy, Fred received desperate letters from close relatives and neighbors in Germany imploring his help. Complying with the only caveat left open—property ownership had its rights—Fred was able to bring all twelve *mishpocheh*, or family, and friends to safe harbor.

In 1947, the Lindens left Shanghai and immigrated to Utah where, Linden said, "the mountains beckoned"—and where they resumed their trade.

Ruth opened a dressmaking shop. Linden worked at ZCMI. They became U.S. citizens in 1953. And traversing the state so much like his youthful home, Fred took to nature and lived to be 102 years old.

WORLD WAR II

YOUNG UTAH PILOT MADE HIS MARK
IN WORLD WAR II

With less than twenty-four hours of advanced fight training and no aircraft carrier experience, Utah-born Emmett Davis launched his Curtiss P-36 combat aircraft from the deck of the USS *Enterprise* and landed in Wheeler Field on the island of Oahu, twelve miles north of Pearl Harbor.[48]

"The flagman gets you to rev up your engine, and as the bow of the ship goes down, he says, 'Go!' and you go full throttle. It looks like you're diving into the ocean, but by the time you get to the end of the ship, the bow backs up and you're launched," Davis told KUED-Channel 7 for its *Utah World War II Stories*.

That was in February 1941, one of the first times an army air corps pilot ever took off from the deck of a fleet ship at sea and "one the scariest two or three seconds I've ever had in my life," he said.

Ten months later, on December 7, Davis woke up to World War II.

"Just before eight o'clock Sunday morning, I looked out the window and saw a Japanese bomber diving down on the flight line," he said.

A quarter mile away at Wheeler Field, billowing black smoke rose skyward. Adjacent hangars were engulfed in flames, and some 150 planes were in peril.

Davis—who earned the moniker "Cyclone"—pulled on his flight overalls, met a fellow officer, jumped into his convertible and sped to the airfield. Shot at twice by Japanese fighter pilots, the officers made it to the hangars unscathed.

Davis pulled three airplanes to safety and was taxiing a fourth for takeoff when someone shouted there were no guns on board.

Breaking into the locked armament depot, Davis and another officer grabbed six machine guns. Two .50-caliber guns went into the fuselage "synchronized to shoot through the propeller," and two .30-caliber guns were fitted into each wing.

As they were loading the guns with ammunition, a "Val" fighter plane flew over them.

"We saw a rear gunner sitting in the back of his dive-bomber grinning not more than fifty feet above us," he said. Strafed by bullets, the two men were unharmed—saved, Davis said, by the "miracles of war."

Within hours, more than 350 Japanese fighter, bomb and torpedo planes killed more than 2,500 American soldiers and sailors, wounded 1,100 more and destroyed twelve American naval vessels, eight of the Pacific Fleet's battleships and more than 200 aircraft.

Flying out of Wheeler, Davis was ordered to escort two B-18 bombers toward Pearl Harbor. Reaching the perimeter, he quickly retreated. "Every

Emmett "Cyclone" Davis, pictured in an F-86, helped introduce the first F-84 and F-86 jets into the Korean conflict. *J. Tucker Davis.*

gun in the U.S. Navy opened fire on anything that flew," he said. Instead, he led three more missions that fateful day, scouring the ocean north of the island in search of the Japanese fleet.

During the war, Davis, who retired a decorated colonel, survived malaria, crash landings and battle. He flew 267 combat missions and led 264 of them, including a P-38 "low-level, high speed" napalm-bombing mission on Kumamoto. On his last mission, he participated in a small but memorable part of the Japanese surrender.

On August 19, 1945, Japanese envoy lieutenant general Torashiro Kawabe and his sixteen-man delegation departed from Tokyo Bay. They flew to Ie Shima en route to meeting General Douglas MacArthur in Manila to implement the protocols for formal surrender.

Ordered to intercept and protect the group from potential gunfire—the Japanese surrender planes, unarmed Betty Bombers, were painted white with green crosses—Davis accompanied them with three squadrons of P-38s and two B-25 reconnaissance planes.

"We demonstrated the landing direction at the airfield in Ie Shima, [and] put them on a C-54 transport," said Davis. "Escorted by our Eighth Fighter Group, they went on to Manila."

On September 2, 1945, peace was officially declared.

RETIRED UTAH JUDGE RECALLS WYOMING'S WORLD WAR II JAPANESE INTERNMENT CAMP

After Japan attacked Pearl Harbor on December 7, 1941, the United States imposed restrictions on approximately 120,000 men, women and children of Japanese ancestry living in California, Oregon and Washington—coastal areas designated "war zones of the Pacific frontier."[49]

Within months, America's Japanese residents were forced to surrender their homes, businesses, possessions, civil liberties and rights to wartime hysteria and "racially motivated fear"—their evacuation and internment sanctioned by U.S. Executive Order 9066.

Taking what they could carry, forty thousand *Issei* (first-generation Japanese immigrants denied citizenship by legislation), seventy thousand second-generation American-born *Nisei* and scores of third-generation *Sansei* were sent to hastily constructed assembly centers. They were then transferred to one of ten internment camps in this country, including

the Topaz camp in Utah, and with no due process of law, held prisoner behind barbed wire.

Such was the experience of the Uno family.

Raymond Uno was born in 1930 in Ogden, Utah. His father, Clarence Ihachiro Uno, emigrated from Japan to America while young and worked at a relative's import/export business on the West Coast. When America entered World War I, he volunteered to serve in the Forty-second Rainbow Division of the American Expeditionary Forces. Sent to Le Havre, France, he transported ammunition to the front lines.

At war's end, Clarence was honorably discharged. He relocated to Ogden; married his bride, Osaka; began a family; opened a business; and applied and reapplied for citizenship for more than fifteen years. On June 24, 1935, President Franklin Roosevelt signed the Lea-Nye Act granting citizenship to approximately five hundred U.S. Army World War I veterans of Asian ancestry.

"My dad was Utah's first Japanese naturalized American citizen," Raymond told me from home in Salt Lake City. That longed-for standing was short lived.

After struggling to keep his business afloat during the Depression, Clarence moved his family to El Monte, California, in 1938, and worked as secretary for the San Gabriel Valley Japanese Association.

An ideal job for a bilingual veteran, Clarence understood how to help the Japanese people in the community. He served as sergeant-at-arms at the Commodore Perry American Legion Post 525 in Los Angeles. According to *Wyoming Samurai* by Mike Mackey, he also worked on El Monte, California's "selective service registrant's advisory board, assisting Japanese American draftees through the registration process." And he was chief registrar for draft calls.

Citizen Uno was resolutely patriotic. Following the Japanese attack, the FBI scoured Clarence's home for contraband. Transferred to and "processed" at the overcrowded Pomona Assembly Center, the family was given a numbered badge instead of a name.

They spent three months living in areas similar to horse stalls. In August 1942, they were transported on troop trains "with the blinds drawn all the way" from California through Arizona, Texas and Colorado into northwest Wyoming, to a "rattlesnake-infested wasteland" called Heart Mountain. Still, Clarence remained loyal.

He "processed" new people, organized a United Service Organization (USO) and registered draft-age Nisei. The U.S. 442nd Regimental Combat

Team, composed of fourteen thousand Nisei soldiers, became the most decorated for its size, loss and valor.

Heart Mountain held a population of more than eleven thousand. Japanese farmers raised farm animals, introduced new crops, cultivated eight hundred acres and harvested some two million pounds of produce.

"But I remember the incarceration," Raymond said. "Being behind barbed wire fences at the bottom of the hill, watch towers above, search lights, and armed guards aiming in, ready to shoot."

In August 1943, Clarence died in his sleep.

"You don't forget a father's death, a mother's hardship and the isolation of never eating together as a family or living under the same roof," said Raymond. "The difficulties successful businessmen must have endured existing day to day with no purpose, the psychological tragedies that pushed some people to reject their culture. It tore our family apart."

Returning to Ogden in 1945, Osaka Uno worked at Esther Hall, a Methodist women's boardinghouse. Fifteen-year-old Raymond lived with neighbors on Twenty-fifth Street in downtown Ogden.

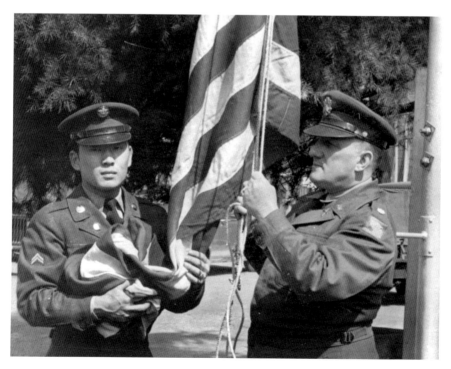

Raymond Uno, in the U.S. Military Intelligence Service. *Uno Family.*

He became a gandy dancer, working the rails for the Union Pacific Railroad. Then, the twenty-year-old served in the U.S. Army Military Intelligence Service as an interpreter, translator and interrogator in Japan. He went on to college. Eventually, he became a judge.

"I've been involved in civil rights issues for many years of my life, and it's not over," said Judge Uno, who has retired.

"Every generation needs to learn tolerance," he said. "Everyone deserves a fair shake."

COMMON GROUND WITH BASEBALL

IN THE COAL TOWN OF HELPER, BASEBALL WAS MORE THAN A PASTIME

Purportedly created by Abner Doubleday in Cooperstown, New York, in 1839 and set to rules by Alexander Cartwright in 1845, what would become our "national pastime" entered American life. In the rural mining and railroad town of Helper, Utah, it was that and much more.[50]

Helper, known as the "Hub of Carbon County," was named for its "helper" engines that assisted freight trains in making the steep climb to Soldier Summit at 7,477 feet.

According to historian Philip F. Notarianni, in the 1900s, the town was also home to "sixteen different nationality groups [from Italians, Finns, Austrians and Chinese to Greeks and Japanese] that represented merchants and laborers, influenced the town's social landscape and took to American baseball as a way of gaining community and cultural acceptance."

"Besides," he recently confided, "nearly every kid—even I—played baseball."

"My father, Pete, had nothing to do with baseball," retired postmaster, columnist and sports announcer Walter Borla said from his home in Helper.

"He worked in the coal mines and always said, 'You should be working because you're certainly not going to eat that baseball.' But for kids of foreign heritage, baseball was an outlet. It was a way to fit into the American

culture, blend with different nationalities and religions and learn how to play together and get along."

During the Great Depression (1929–39), Borla's father and other Italian, Austrian and Greek stonemasons worked for the Works Projects Administration (WPA). They built a rock wall on the left side of the American Legion field that was later designated Gardner Field.

Borla remembers playing as a twelve-year-old on that "historic" field.

"When sod was put in, we had the only completely grass playing field in eastern Utah, a wooden-covered grandstand right behind home plate and lights installed for night ballgames," he said. "We played on Sundays. We didn't have uniforms but wore a cap from the local business sponsoring our league. Those who were good players would go into the semi-pro leagues—very competitive teams that were provided uniforms and equipment, except for their baseball bat and glove."

Ballgames played with teams named Helper Merchants, Bingham Steelers, American Fork Steelmen, Brigham City Peaches, Provo Timps and Pinney Beverage of Salt Lake City drew large crowds, and the games were broadcast over local radio stations.

Utah's 1943 Junior Baseball Champs, pictured in "Helper" jerseys. *Front row, left to right:* Joe Rolando; Jim Kavanagh; LeGrande Jones; Raymond Rachele, mascot; Alan Voll; Hollie Sillitoe; LaMar Hansen; Walter Borla; and Arden Aplanalp. *Back row, left to right:* Jack Busato; Tom Migliaccio; Kenneth Dimick; Max Pessetto; George Pizza, team manager; Tony Tonc; Jim Ballinger; and Robert Ramsey. *Western Mining and Railroad Museum.*

"This was done by telegraph," Borla wrote in a 2007 Carbon County Historical Society article titled "Baseball in Helper."

"An operator of the box ticked in the progress of the game to an announcer miles away who re-created the game from the telegraphic reports. This process meant radio reports would be almost two innings later than the actual occurrence." Heading downtown with friends, Borla would relive the last innings over the car radio.

Coal companies, which took baseball as a positive way to become involved, also sponsored leagues.

"There was no compensation for coal league players, but some of the coal camps would import players by getting them good jobs, often outside the mine," Borla explained. Sometimes the competition was so great between coal camps a man might be playing for one camp, and the next day he'd be playing elsewhere because he was offered a better job. It was about employment."

In 1943, Borla played on the Helper American Legion team that won the state championship. In 1944, he played with Carbon High School and finished in second place in a statewide competition. After his army service, he played several years in a coal league before marrying his wife, Josephine.

After World War II, Helper initiated an annual fundraising celebration called "The Days of 49." While law enforcement turned its backs, slot machines, blackjack and games of chance provided funds for numerous improvements, including the beloved ballpark.

At age eighty-nine, Borla, honored with a little league park named after him, still speaks in a voice that makes us see and experience every whiff, short fly, knuckler, stolen base and grand slam that turned baseball into community.

NOTES

Part I

1. Juanita Brooks, *On the Mormon Frontier: The Diary of Hosea Stout, 1844–1861* (Salt Lake City: University of Utah Press, 1982). Also see *Deseret News*, November 15, 1851.
2. Harold W. Felton, *James Beckwourth, Negro Mountain Man* (New York: Dodd, Mead & Co., 1966).
3. Grace McClure, *The Bassett Women* (Athens: Ohio University Press & Swallow Press, 1985). Also see Doris Karren Burton, *Dinosaurs and Moonshines* (N.p.: Uintah County Western Heritage Museum, 1990); Everett L. Cooley's 1959 interview with Josie Bassett, archived at the University of Utah, Marriott Library, Special Collections; and BLM Cultural Resources Series (Utah: No 7).
4. Gregory K. Dreicer, ed., *Between Fences* (Washington, D.C.: National Building Museum and Princeton Architectural Press, 1966). See the 1985 "Grouse Creek Cultural Survey," Folk Collection 21, Utah State University. Also see the barbwire display at the Cowboy Grub Restaurant, Salt Lake City, Utah.
5. See "The Bassett Women and Queen of the Outlaws Take On Rugged Brown's Park" section in Part I, 17.

Part II

6. See "Faces of Murray" by the city's centennial commission, 2003.
7. According to historian Ron Coleman in "African Americans in Utah" from the online Utah History Encyclopedia, while "Brigham Young never intended that slavery flourish in Utah he did accept the biblical explanations utilized by proslavery apologists to justify the enslavement of blacks. Black slaves were bought and sold in Utah…The dawn of freedom that came during the course of

the Civil War marked the beginning of a new era of expectation for Utah blacks as well as African Americans throughout the United States."

8. Eileen Hallet Stone, *A Homeland in the West: Utah Jews Remember* (Salt Lake City: University of Utah Press, 2001); Leslie Kelen and Eileen Hallet Stone, *Missing Stories: An Oral History of Ethnic and Minority Groups in Utah* (Salt Lake City: University of Utah Press, 1996).

9. Eileen Hallet Stone, "The Traveling Salesman," *Utah Holiday Magazine*, September 1985; Eileen Hallet Stone, ed., Joel Shapiro interview by Leslie Kelen, Salt Lake City, June 20, 1982, Jewish Archives, University of Utah, Marriott Library Special Collections.

10. Bingham Canyon's yearbook and journals: Arilla Bullock Jackson, *Copperfield* (Salt Lake City: Publisher's Press, 1984); Marion Dunn, *Bingham Canyon* (Salt Lake City: Publisher's Press, 1973); and Scott Crump, *Bingham High School: The First 100 Years (1908–2008)* (Salt Lake City: Great Mountain West Supply, 2008).

11. Hallet Stone and Kelen, "Greek Community" in *Missing Stories*.

12. Ted Speros interview with author, 1993.

13. Helen Z. Papnikolas, "Magerou, the Greek Midwife," *Utah Historical Quarterly* 39 (Winter 1970).

14. See Hallet Stone, "Keeping Kosher in Vernal," in *Homeland in the West*, 147–51.

Part III

15. Unpublished manuscripts of Eveline Brooks Auerbach, loaned by collector Stan Sanders, Salt Lake City; unpublished manuscript pages and drafts of Samuel Auerbach's diary, also loaned to the author from the private collection of Stan Sanders, Salt Lake City; author's conversations with Freida Lee Auerbach.

16. Eleanor Swent and Joseph Rosenblatt, *EIMCO: Pioneer in Underground Mining Machinery and Process Equipment, 1926–1963* (Berkeley: University of California Press, 1992). See interviews with Joseph Rosenblatt by Gregory T. Thompson and Allan D. Ainsworth, University of Utah Marriot library.

Part IV

17. See Hallet Stone and Kelen, *Missing Stories*, 210–214. In 1991, the Louies closed the King Joy Café. Married for nearly forty-six years, Harry Louie passed away in Salt Lake City on March 9, 1996.

18. See Hallet Stone and Kelen, "African-American Community," in *Missing Stories*; archived photographs at the University of Utah, Marriott Library Special Collections.

19. See Hallet Stone and Kelen, "African-American Community," in *Missing Stories*; F. Ross Peterson, "Blindside: Utah on the Eve of Brown v Board of Education," *Utah Historical Quarterly* 73, no. 1 (Winter 2004); Helen Z. Papanikolas, *Peoples of Utah* (Salt Lake City: Utah State Historical Society, 1981).

Part V

20. See LDS Women of God, www.ldswomenofgod.com and Women's Democratic Club, www.wdcutah.org.
21. Peter Carlson, *Roughneck: The Life and Times of Big Bill Haywood* (New York: W.W. Norton & Co., 1983). See also William Haywood, *The Autobiography of Big Bill Haywood* (New York: International Publishers, 1920); and J. Anthony Lukas, *Big Trouble* (New York: Simon & Schuster, 1997).
22. See Patricia Lyn Scott and Linda Thatcher, *Women in Utah History: Paradigm or Paradox?* (Logan: Utah State University Press, 2005); Joanne L. Goodwin, ed., *Encyclopedia of Women in American History* (Armonk, NY: M.C. Sharpe, Inc., 2002); Miriam B. Murphy's History Blazer, February 1996, online Utah History to Go.
23. Helen Z. Papanikolas, "Toil and Rage in a New Land: The Greek Immigrants in Utah," *Utah Historical Quarterly* (Spring 1970).
24. John R. Sillito, "Women and the Socialist Party in Utah, 1900–1920," *Utah Historical Quarterly* (Summer 1981); Mari Jo Buhle, *Women and American Socialism, 1870–1920* (Urbana: University of Illinois Press, 1983); *Salt Lake Tribune*, July 21, 1914.
25. Doris Stevens, *Jailed for Freedom* (New York: Boni & Liveright, Inc., 1920).

Part VI

26. Robert Baskin, *Reminiscences of Early Utah* (Salt Lake City: R.N. Baskin, 1914); John Gary Maxwell, *Robert Newton Baskin and the Making of Modern Utah* (Norman: University of Oklahoma, 2013).
27. See *Beaver County News*, July 21, 1920; and Gaylon Caldwell's article "Utah's First Presidential Candidate" in the *Utah Historical Quarterly* (October 1960).
28. Beverly B. Clopton, *Her Honor the Judge: The Story of Reva Beck Bosone* (Ames: Iowa State University Press, 1980). See also the 1977 KUTV documentary *Her Honor the Judge*, co-produced by Diane Orr and Judith Dwan Hallet.

Part VII

29. See Eileen Hallet Stone's brochure, *Walking Tour of Historic Sandy* ([Sandy, UT]: City of Sandy, 1991). The Mingo mine was one of the largest producers of melts—gold, silver and lead—and a major employer of people in the Sandy area. It closed in 1900.
30. The E.O. Wattis House restoration won the 2009 Utah State History Outstanding Achievement Award. Architect, CRSA; contractor, Home-Tech, Inc.
31. For more on Newhouse, see Hallet Stone, *Homeland in the West*, 101–105; "Newhouse's New Business District," *Salt Lake Architecture*, May 2009, saltlakearchitcture.blogspot.com (accessed December 13, 2015).

Part VIII

32. For more on Sweet Candy Co., see Hallet Stone, *Homeland in the West*, 314–19.

PART IX

33. Jeffrey Carlstrom and Cynthia Furse, *The History of Emigration Canyon: Gateway to Salt Lake Valley* (Logan: Utah State University Press, 2003); also see the National Real Estate and Investment Co.'s 1913 booklet *Summer at Pinecrest and Emigration Canyon*.

34. Linda H. Smith, *A History of Morgan Country* (Salt Lake City: Utah State Historical Society.) Special thanks to Morgan County assistant historian Cissy Toone and to Weber Sate University Stewart Library.

PART X

35. See Gerritsen and Nelson 1973 interviews, University of Utah, Marriot Library Special Collections (Promontory, 35).

PART XI

36. Virginia Rishel, *Wheels to Adventure: Bill Rishel's Western Route* (Salt Lake City: Howe Brothers, 1983).

37. Many thanks go to Robert L. Rampton and Michael Hallet for their historical motorcycle expertise.

PART XII

38. See "The Civilian Conservation Corps. Selection of Enrollees for the Civilian Conservation Corps (Utah)." Reprinted from First Biennial Report of the Utah State Department of Public Welfare, 1936–38, 99–103 newdeal.feri.org/ccc/ccc008.htm (accessed December 13, 2015).

39. Steve Lutz, "1943 Victory Theatre Fire Ignites Salt Lake City Firestorm," *Utah Historical Quarterly* (Fall 2011).

40. Special thanks to the northern Ute Indian Fire Fighters and to Larry Cesspooch, Ingrid Wopsock, Richa Wilson, Kenneth Baldridge, Gina Sixkiller and Tana Sixkiller Pool.

PART XIII

41. See digitized copy of Ada Patterson, *Maude Adams: A Biography* (New York: Meyer Bros. & Co., 1907); also see references in the New York Public Library for the Performing Arts.

42. See Sid Fox's autobiography, MS 559, University of Utah, Marriott Library Special Collections.

43. Robert Dwan, *As Long as They're Laughing: Groucho Marx and You Bet Your Life* (Baltimore, MD: Midnight Marquee Press, Inc., 2000).

Part XIV

44. Miriam B. Murphy, "If Only I Shall Have the Right Stuff: Utah Women in World War I," *Utah Historical Quarterly* 58 (1990).

Part XV

45. Also see U.S. Holocaust Memorial Museum papers.
46. John Price, *When the White House Calls: From Immigrant Entrepreneur to U.S. Ambassador* (Salt Lake City: University of Utah Pres, 2011).
47. See Fred Linden's interview and autobiography at University of Utah, Marriott Library Special Collections, Jews in Utah Collection, Box 3, Folder 1. Special thanks to their son, Dr. Kurt J. Linden.

Part XVI

48. Emmett Davis and his son J. Tucker Davis telephone interviews with author, August 2015; J. Tucker Davis unpublished papers. Decorated forty-five times, Emmett "Cyclone" Davis served in the air force for twenty-three years and began his second career at Hughes Aircraft Co. On November 3, 2015, at age ninety-seven, the "great warrior" died.
49. Raymond Uno interviews with author, 2006 and 2015. See also, Mike Mackey, *The World War II Warriors of Heart Mountain* (N.p.: Western History Publications, 2015).

Part XVII

50. Walter Borla telephone conversation with the author, November 2015. See Philip F. Notarianni, "Helper—The Making of a Gentile Town in Zion," in *Carbon Country: Eastern Utah's Industrialized Island* (Salt Lake City: Utah State Historical Society, 1981). Special thanks to the Western Mining and Railroad Museum, Helper, Utah, and to Karen Carlson, whose grandfather (Arthur Jesse Kirkham) worked for the Utah Railway and whose father (Keith Kirkham) lived in Hiawatha, Martin and Helper.

INDEX

ABOUT THE AUTHOR

A transplant from New England, Utah-based writer Eileen Hallet Stone's award-winning projects include issues of equity, community stories and ethnic histories. Her collected work in *A Homeland in the West: Utah Jews Remember* was developed into a photo-documentary traveling exhibit for the 2002 Winter Olympic Cultural Olympiad Arts Festival

George Janecek.

in Salt Lake City. Her earlier book *Missing Stories: An Oral History of Ethnic and Minority groups in Utah*, co-authored with Leslie Kelen, has been extensively used by Utah educators to diversify the curriculum. Her commentary is featured in the 2015 documentary film *Carvalho's Journey*. Her 2013 book *Hidden History* was her first with The History Press. She writes a "Living History" column for the *Salt Lake Tribune*; has a son, Daniel Gittins Stone; and lives with her husband, Randy Silverman, in the lively Sugar House area of Salt Lake City.